Danskøya

Bolshoy Zayatsky

Elliðaey

Helgøya
Bolshoy Tyuters ● Fort Alexander

Cézembre
Gavrinis

Torre Scola

Isola dei Cappuccini

Dragonera

Shillay ● Gruinard
Hirta ●
Mingulay ● ● Loch an Eilein
● Castle Stalker
Scarba ●
● Cara

Inishmurray ● ● Devenish

Great Blasket ● Innisfallen
Skellig Michael ● ● Stack Rock Fort
Thorne Island Fort ● St Catherine's
No Man's Land Fort ●
Samson ● ● Île du Large

Madonna del Monte
Poveglia ● ● Sveti Grgur
● Goli Otok
● Baljenac
Sveti Andrija ● ● Daksa
● Mamula
Gaiola ●
● Delos
● Isola delle Correnti
Comino ● ● Spinalonga

D1546912

ABANDONED
ISLANDS

ABANDONED ISLANDS

CLAUDIA MARTIN

amber
BOOKS

Published by Amber Books Ltd
United House
North Road
London
N7 9DP
United Kingdom
www.amberbooks.co.uk
Instagram: amberbooksltd
Facebook: amberbooks
Twitter: @amberbooks
Pinterest: amberbooksltd

ISBN: 978-1-83886-115-5

Project Editor: Michael Spilling
Designer: Keren Harragan
Picture Research: Justin Willsdon

Printed in Malaysia

Contents

Introduction

Across the globe, there are many hundreds of abandoned islands, ranging in size from Canada's Devon Island, at 55,247 sq km (21,331 sq miles), to rocky islets such as Wales's Stack Rock Fort, only just large enough for a teetering fortification. Some islands were abandoned when settlers were defeated by the hostile forces of nature, in the form of bitter cold, never-ending typhoons,

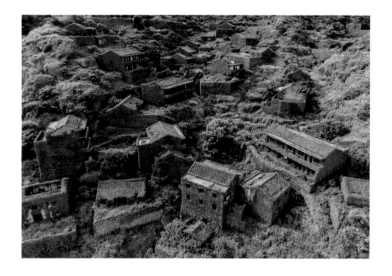

volcanic eruptions or disappearing freshwater. Other islands, from Micronesia's Nan Madol to Ireland's Inishmurray, were populated for hundreds or even thousands of years before war or invasion forced farmers, merchants, monks or chiefs to flee for their lives. For many islands, there was no sudden dramatic ending but rather a slow depopulation as, family by family, islanders left for an easier or less isolated life elsewhere. The world's abandoned islands are monuments to the pride of long-forgotten kings, to the over-reaches of industrialists and to the extraordinary struggles of ordinary people.

ABOVE:
Houtouwan, Shengshan, China
The villagers of Houtouwan departed in search of better education and
opportunities, leaving nature to take back control.

OPPOSITE:
Devon Island, Nunavut, Canada
It was the Arctic climate of windswept Devon Island that defeated all attempts
at settlement, both by Inuit hunters and Canadian Mounties.

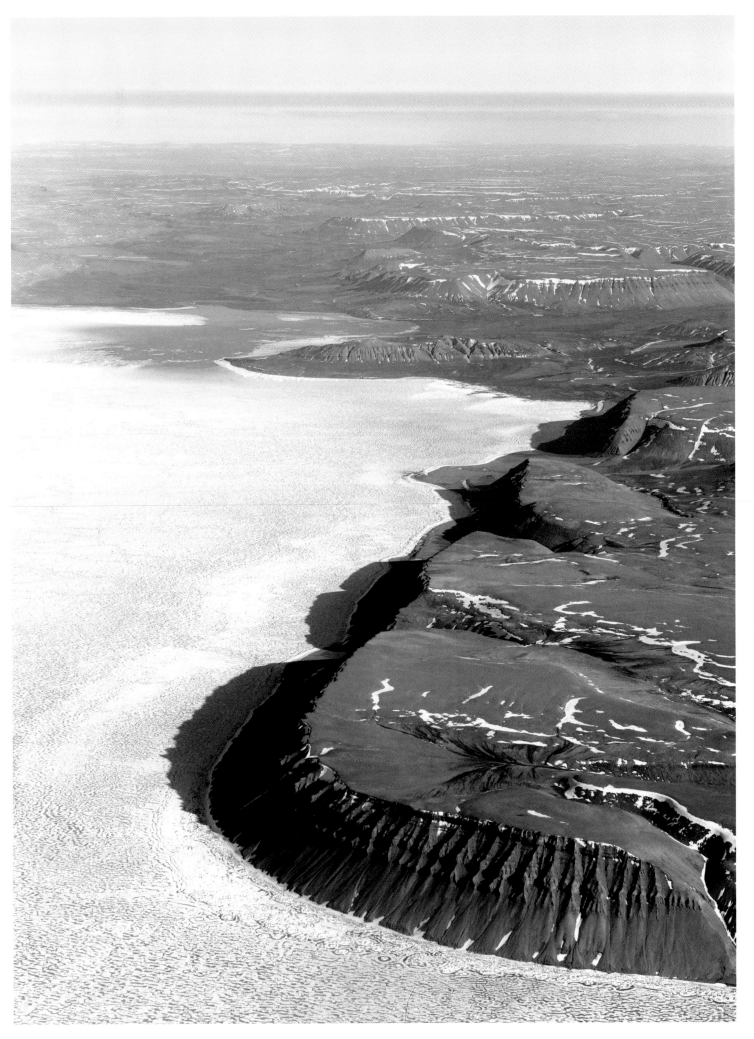

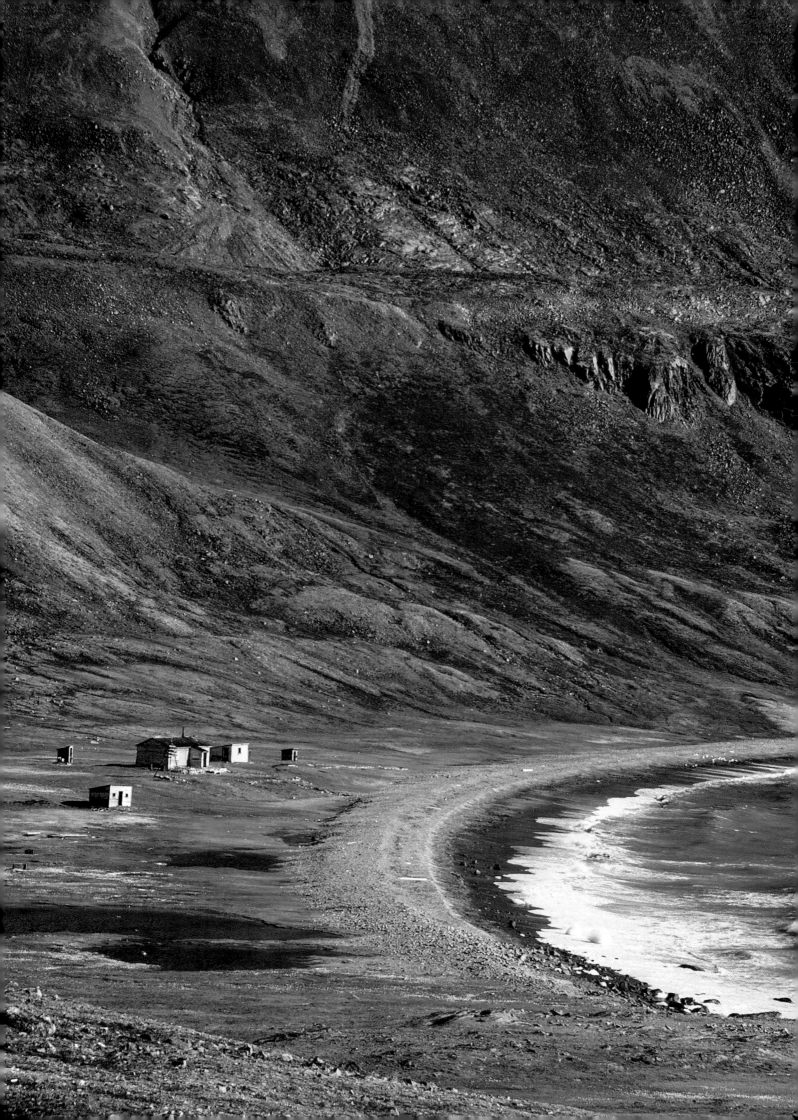

North and South America

Isolated by crashing waves and surging ocean, islands have always been a natural choice for institutions from which escape must be prevented at all costs. Many of America's abandoned islands once housed prisons, leper colonies, immigration inspection stations and quarantine hospitals. Eventually, many of those institutions closed thanks to social change, developments in medicine or, more prosaically, the high cost of maintaining an island colony. Among the most notorious inhabitants of these abandoned islands were Al Capone, who played banjo in the Alcatraz prison band, the Rock Islanders; and Colombian serial killer Daniel Camargo Barbosa, who was held on the island of Gorgona before his escape on a raft of logs tied with vines. A far more ethically questionable imprisonment was that of cook Mary Mallon, so-called Typhoid Mary, suspected of infecting 53 people with typhoid and quarantined on New York's North Brother Island until her death in 1938. Imprisoned on French Guiana's Devil's Island, Alfred Dreyfus was purely the victim of a famous miscarriage of justice. In contrast, we will never know the names of the thousands of victims of the Atlantic slave trade who were left to die on the quarantine island of Klein Curaçao in the Dutch Caribbean.

OPPOSITE:
Devon Island, Nunavut, Canada
In the Arctic Archipelago, Devon Island is the largest uninhabited island in the world, with an area of 55,247 sq km (21,331 sq miles).

Devon Island, Nunavut, Canada
Although there is evidence of Paleo-Inuit settlement, Devon Island has been populated only briefly in recorded history. In the mid-20th century, Dundas Harbour was settled by Inuit hunters and, later, by the Royal Canadian Mounted Police. Both parties abandoned the outpost due to the extremely icy and windy conditions.

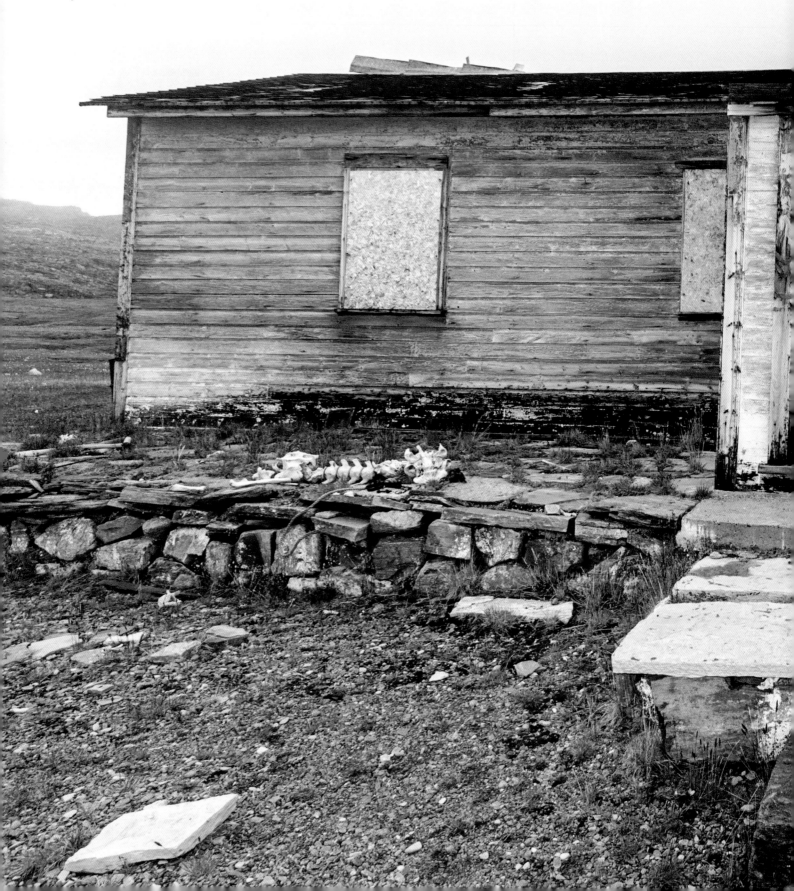

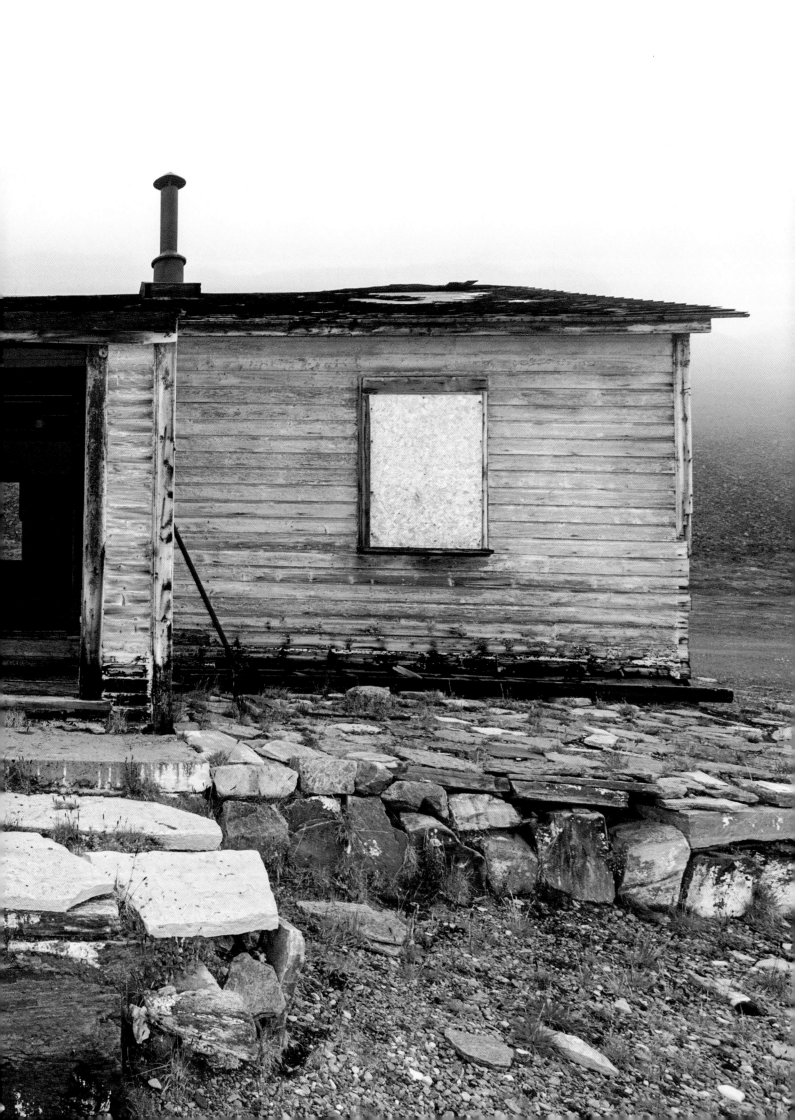

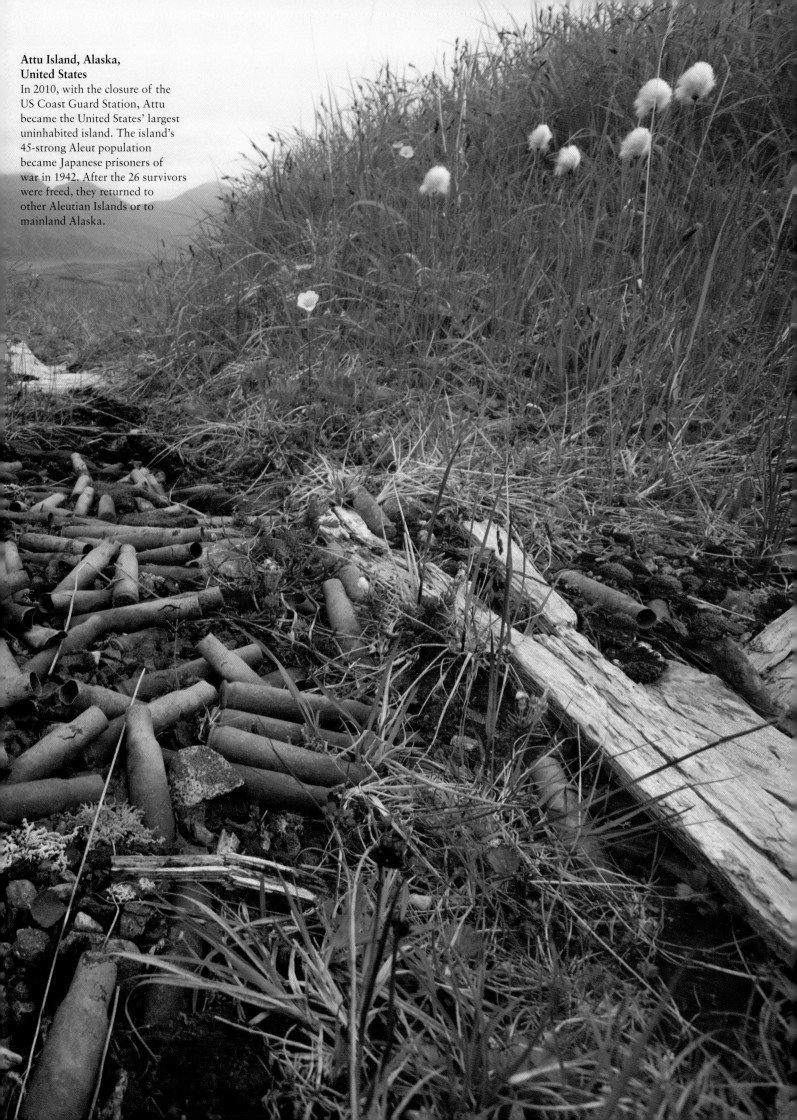

Attu Island, Alaska, United States
In 2010, with the closure of the US Coast Guard Station, Attu became the United States' largest uninhabited island. The island's 45-strong Aleut population became Japanese prisoners of war in 1942. After the 26 survivors were freed, they returned to other Aleutian Islands or to mainland Alaska.

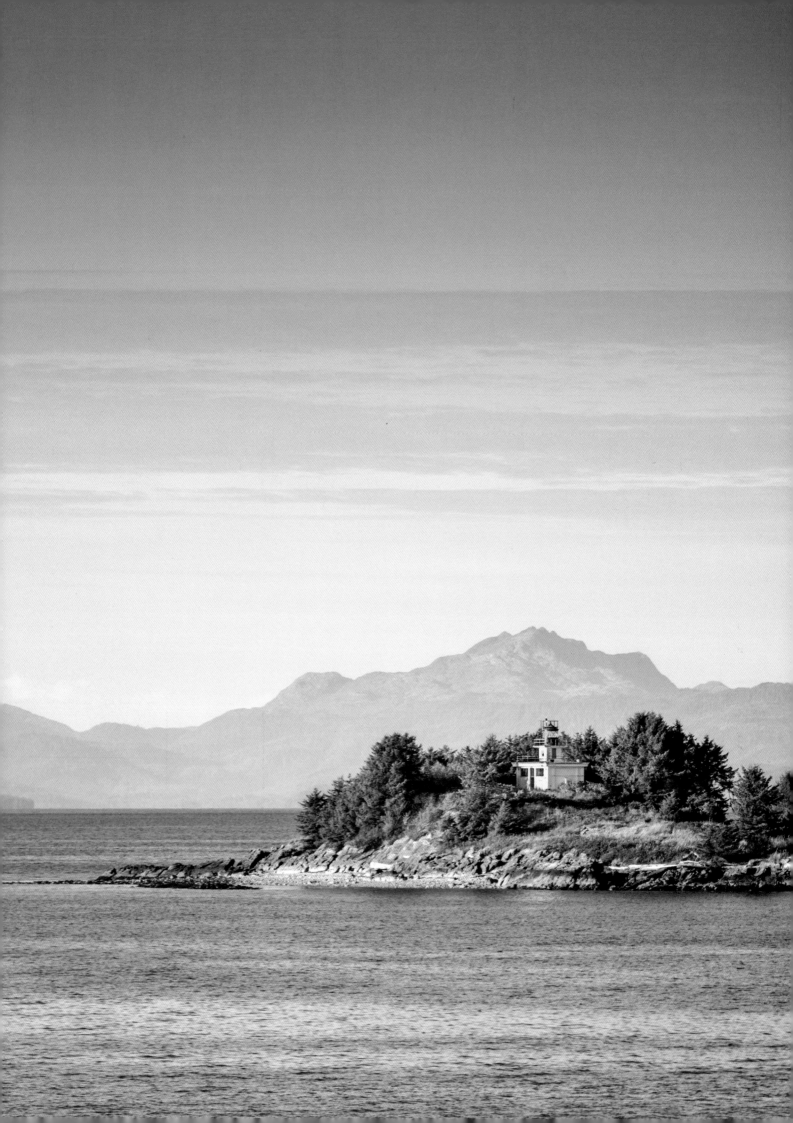

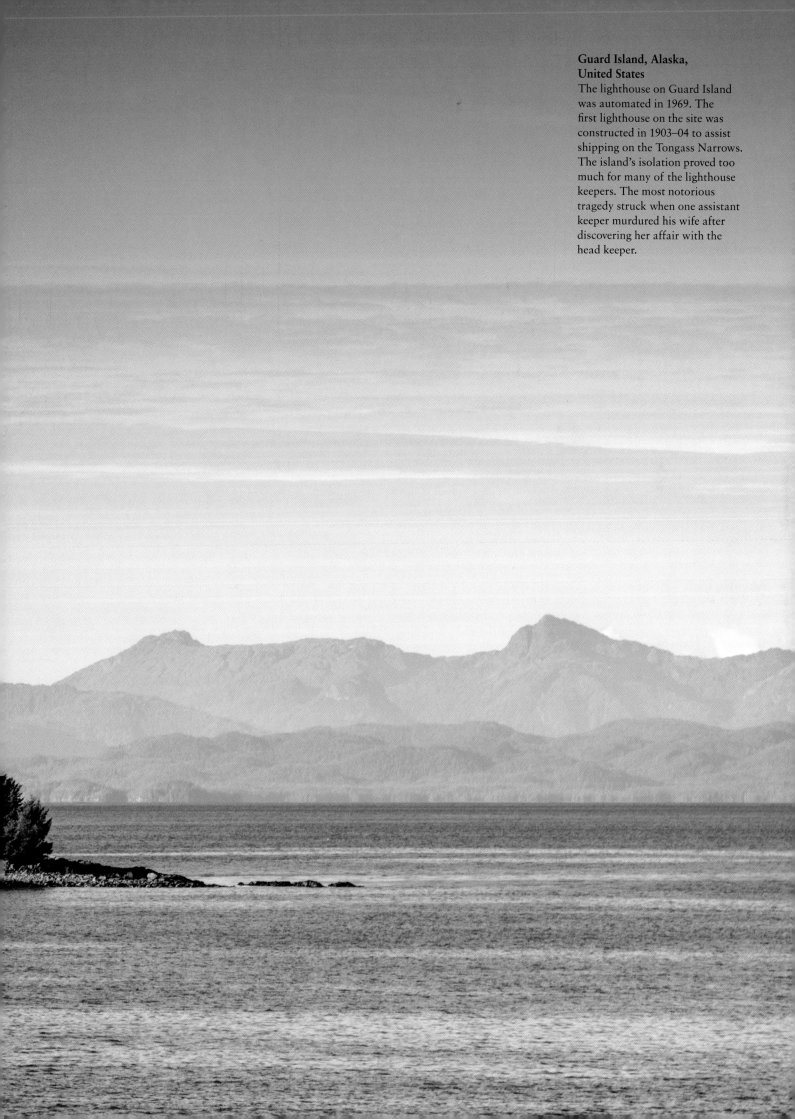

Guard Island, Alaska, United States
The lighthouse on Guard Island was automated in 1969. The first lighthouse on the site was constructed in 1903–04 to assist shipping on the Tongass Narrows. The island's isolation proved too much for many of the lighthouse keepers. The most notorious tragedy struck when one assistant keeper murdured his wife after discovering her affair with the head keeper.

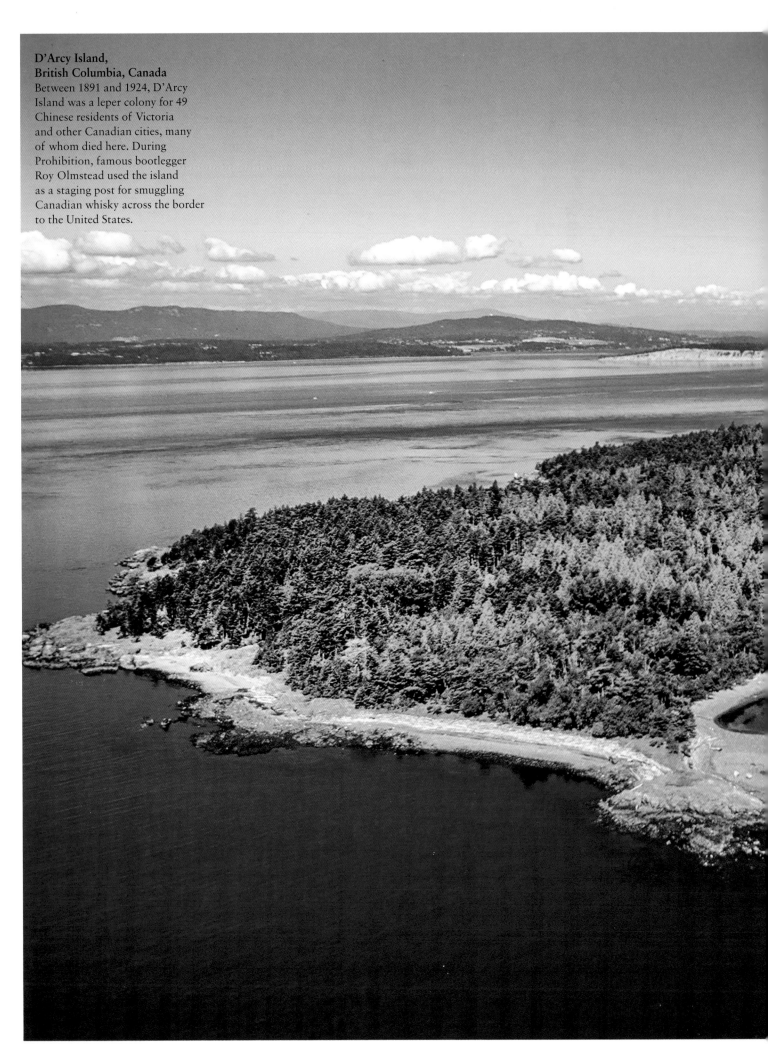

**D'Arcy Island,
British Columbia, Canada**
Between 1891 and 1924, D'Arcy Island was a leper colony for 49 Chinese residents of Victoria and other Canadian cities, many of whom died here. During Prohibition, famous bootlegger Roy Olmstead used the island as a staging post for smuggling Canadian whisky across the border to the United States.

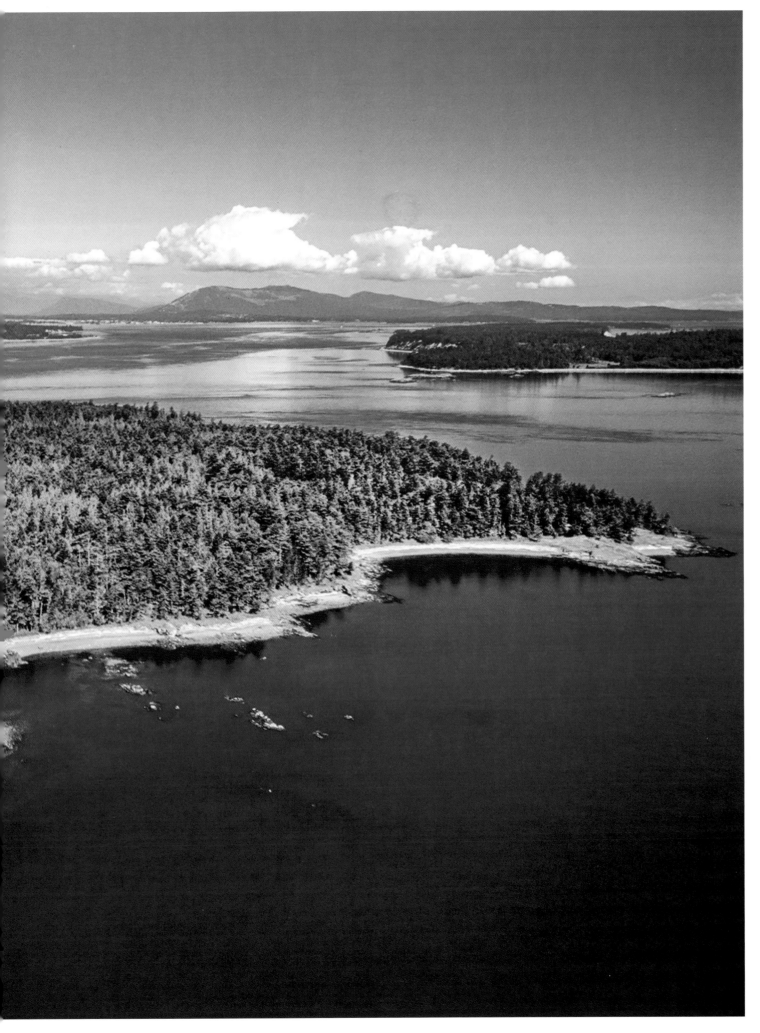

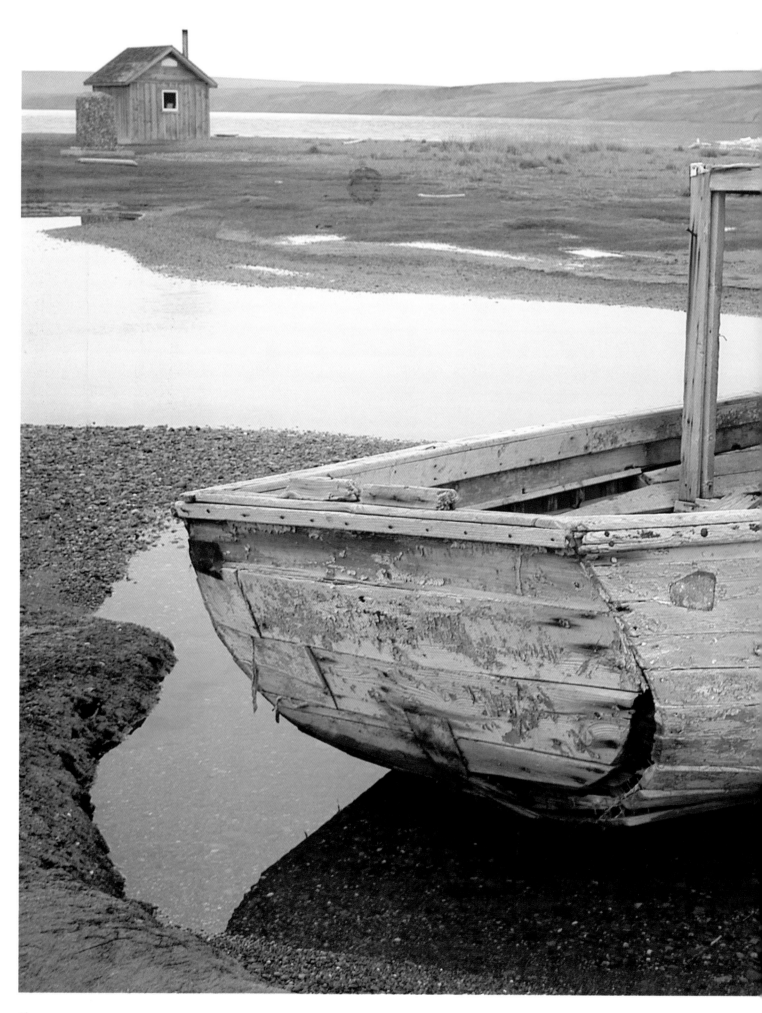

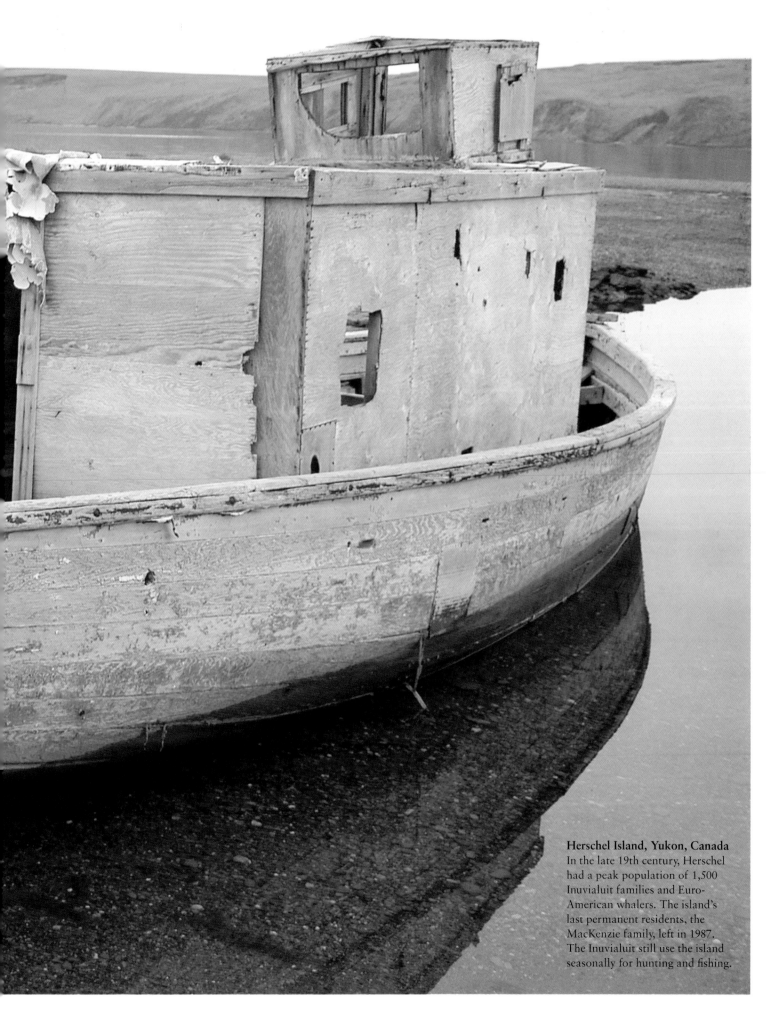

Herschel Island, Yukon, Canada
In the late 19th century, Herschel had a peak population of 1,500 Inuvialuit families and Euro-American whalers. The island's last permanent residents, the MacKenzie family, left in 1987. The Inuvialuit still use the island seasonally for hunting and fishing.

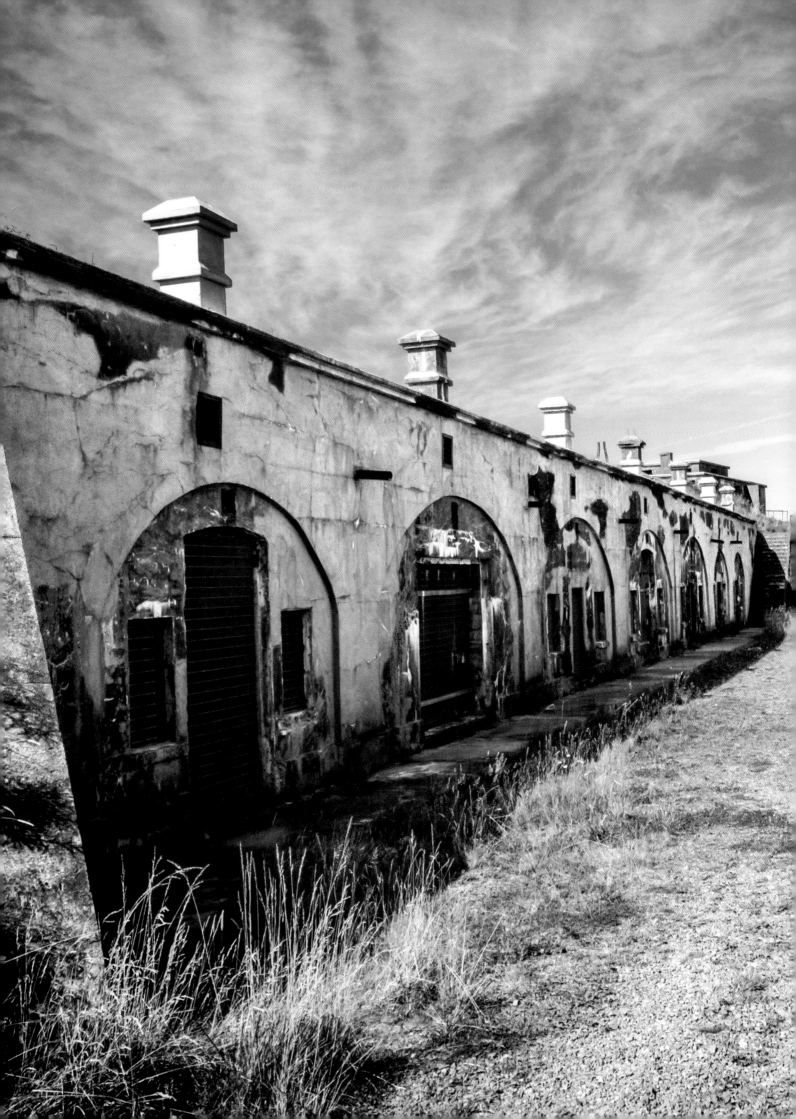

LEFT:
**McNabs Island,
Nova Scotia, Canada**
Purchased by Peter McNab in the
1780s, this island was home to
the McNab family until 1934.
Disused buildings on the island
include Fort McNab (pictured), the
original McNab home, and the
AJ Davis Soda Pop factory, which
made a drink called 'Pure McNab'.

BELOW:
**L'Île-aux-Marins,
St Pierre and Miquelon**
Settled by the French during the
17th century, this island was
abandoned in the 1960s when the
last permanent residents left for
the nearby island of St Pierre.
The islands form part of a French
overseas collectivity, home to
around 6,000 French citizens.

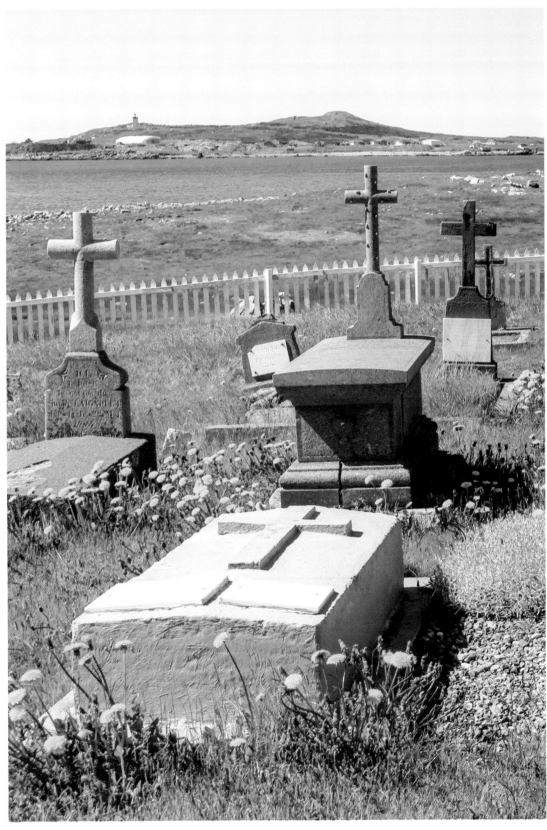

**Caribou Island,
Ontario, Canada**
In the late 19th century, Lake Superior's Caribou Island was stocked with caribou and set up as a private hunting preserve. One winter in the 1920s, when the lake froze over, the caribou walked off the island and the preserve was abandoned. In 2018, six caribou were transported to the island, where a small but growing herd remains.

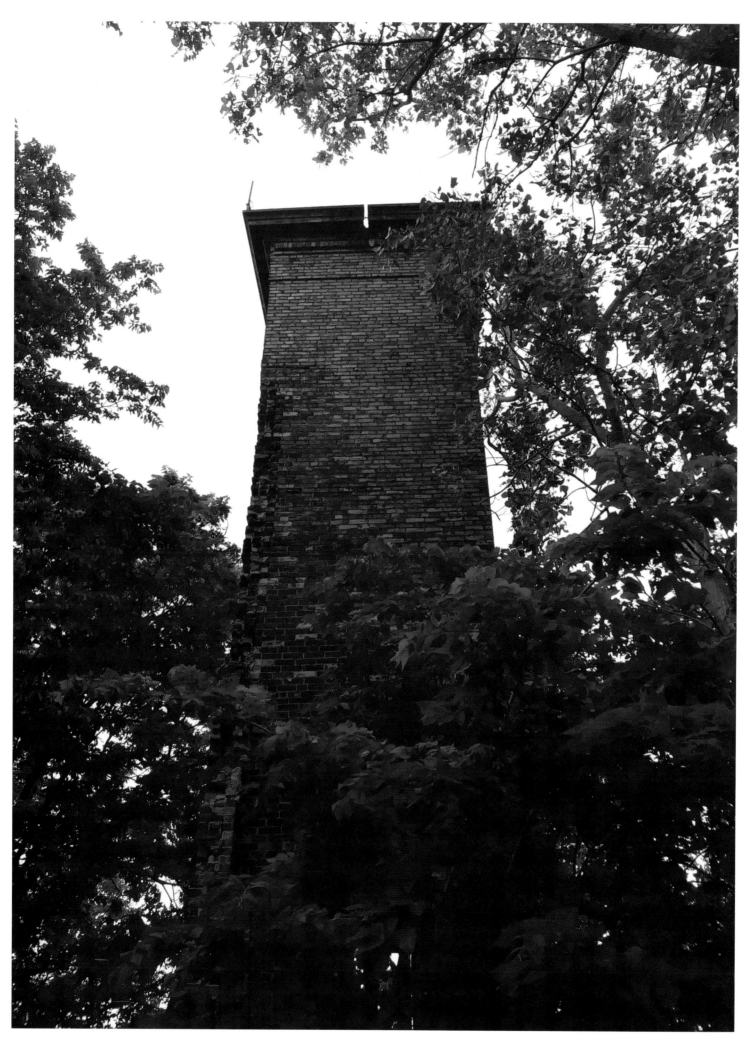

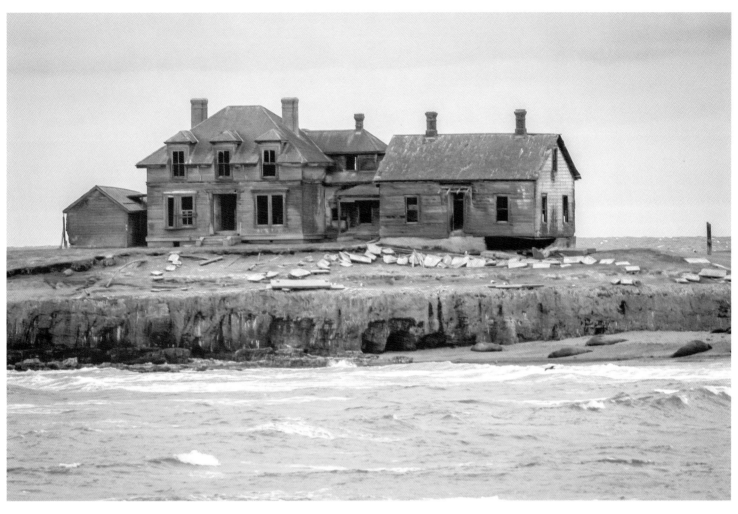

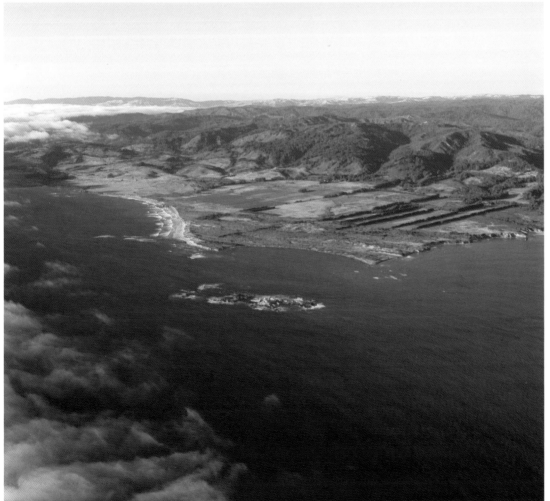

OPPOSITE:
Turtle Island, Michigan and Ohio, United States
Divided between the states of Michigan and Ohio, Turtle Island lies in Lake Erie. The Turtle Island Light (pictured) was decommissioned in 1904, shortly before the island was sold into private ownership. The island was named after the 18th-century Miami chief Mihšihkinaahkwa, which means 'Little Turtle'.

ABOVE AND LEFT:
Año Nuevo Island, California, United States
Today home only to breeding populations of northern elephant seals and Steller's sea lions, Año Nuevo boasts the ruins of a lighthouse and foghorn station. The island was named by Father Antonio de la Ascensión, chaplain to the Sebastián Vizcaíno expedition of 1602–03.

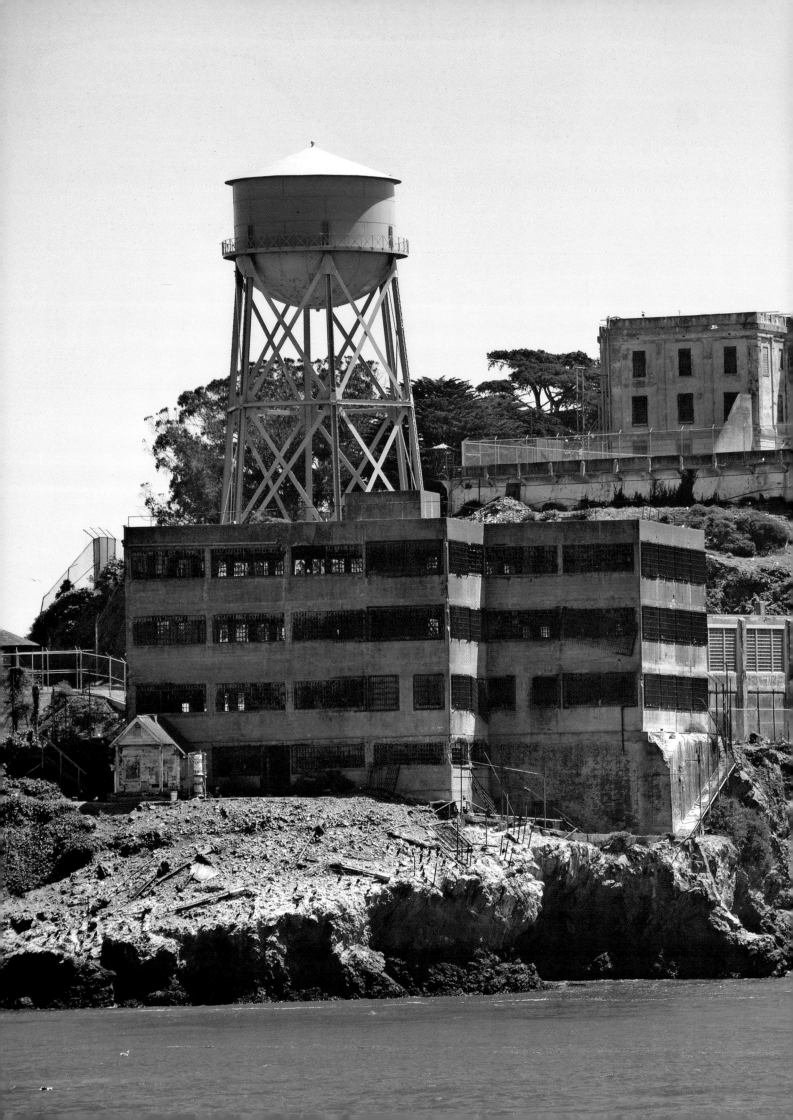

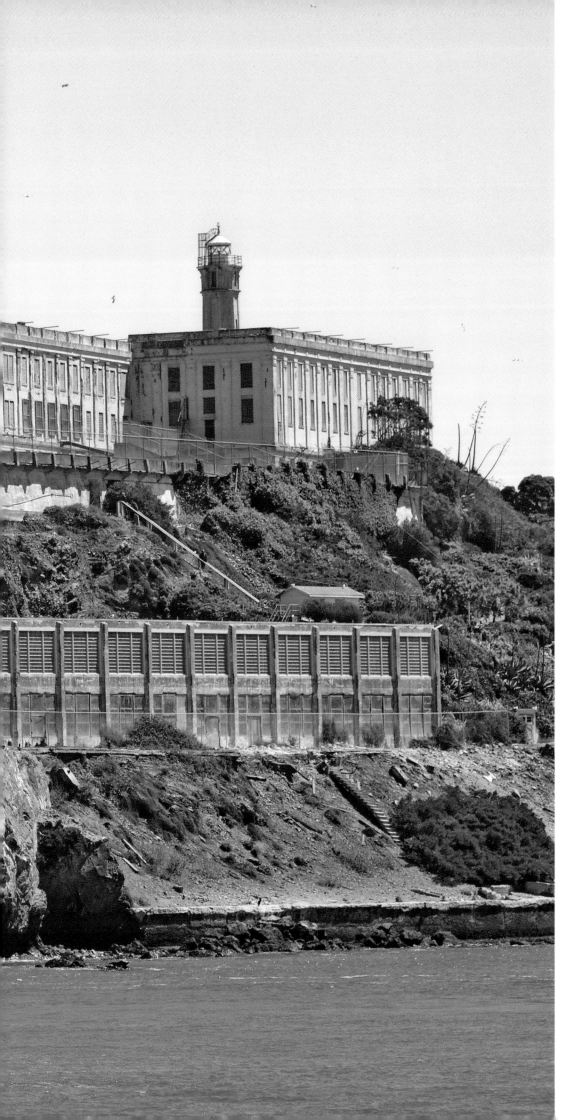

Alcatraz Island, California, United States
Around 2km (1.25 miles) off the coast of San Francisco, Alcatraz Island was the site of a federal prison between 1934 and 1963. Strong currents made escape by swimming nearly impossible, with only one prisoner, John Paul Scott, known to have reached the mainland alive. He fell into hypothermic shock and was almost immediately recaptured.

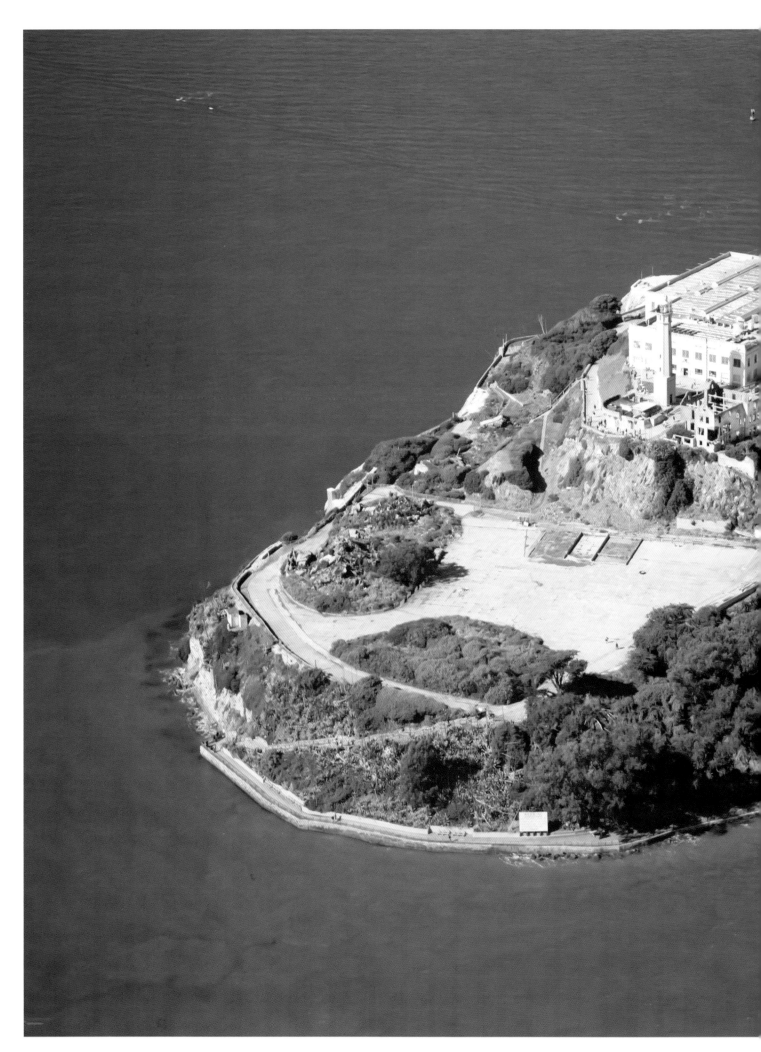

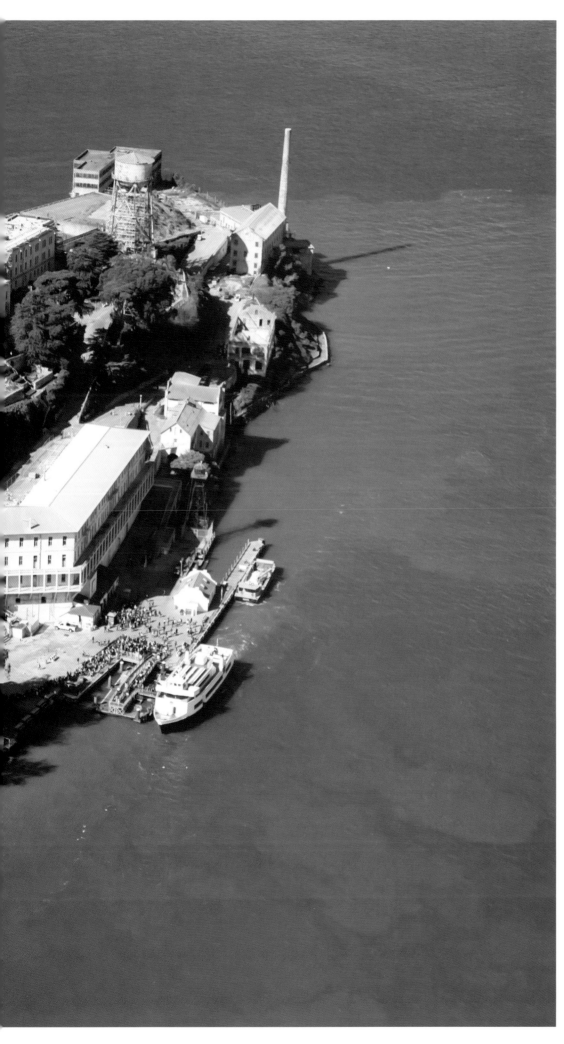

Alcatraz Island, California, United States
During its 29 years of service, the Alcatraz federal penitentiary housed prisoners including the gangster Al Capone and murderer Robert Franklin Stroud, known as the 'Birdman of Alcatraz' for his work on ornithology. Today, visitors can stroll among the cell houses, workshops and lighthouse, which was the first on the west coast of the United States, from 1853.

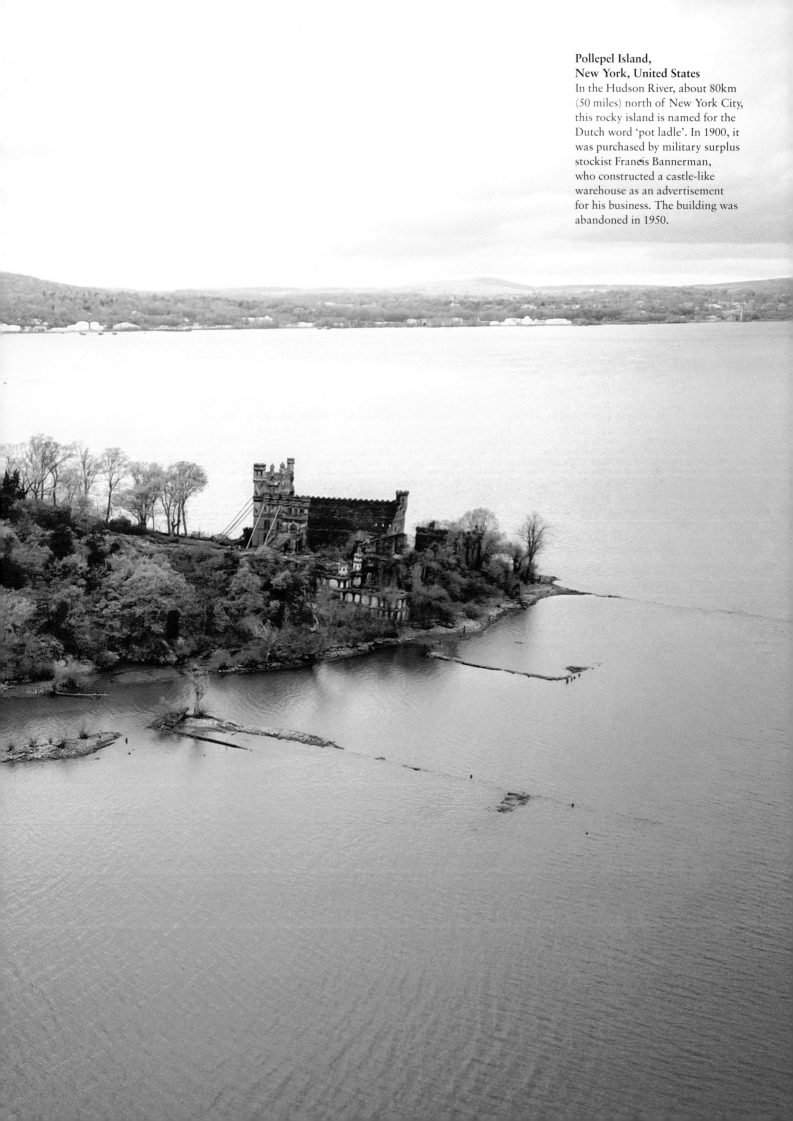

**Pollepel Island,
New York, United States**
In the Hudson River, about 80km
(50 miles) north of New York City,
this rocky island is named for the
Dutch word 'pot ladle'. In 1900, it
was purchased by military surplus
stockist Francis Bannerman,
who constructed a castle-like
warehouse as an advertisement
for his business. The building was
abandoned in 1950.

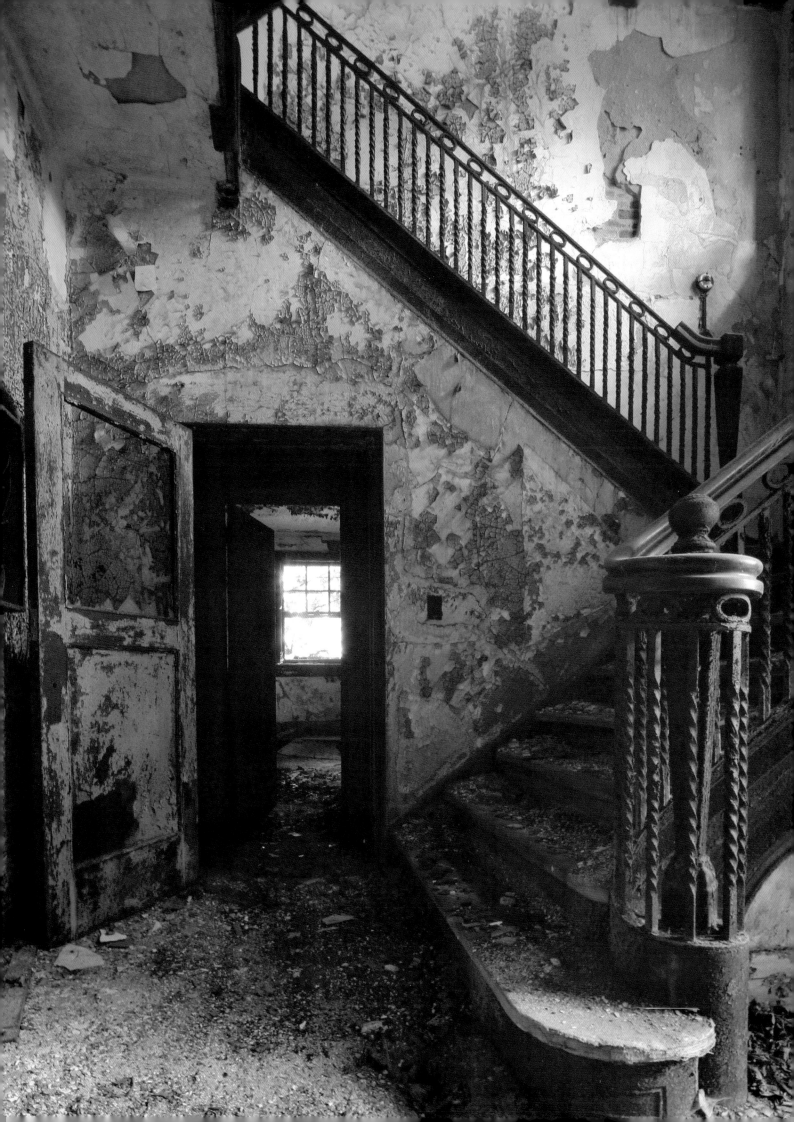

ALL PHOTOGRAPHS:
**North Brother Island,
New York, United States**
The East River's North Brother Island was the site of the Riverside Hospital for quarantinable diseases from 1885 to 1945. For 23 years, Mary Mallon, known as 'Typhoid Mary', was forcibly quarantined here due to being a suspected superspreader of Salmonella typhi.

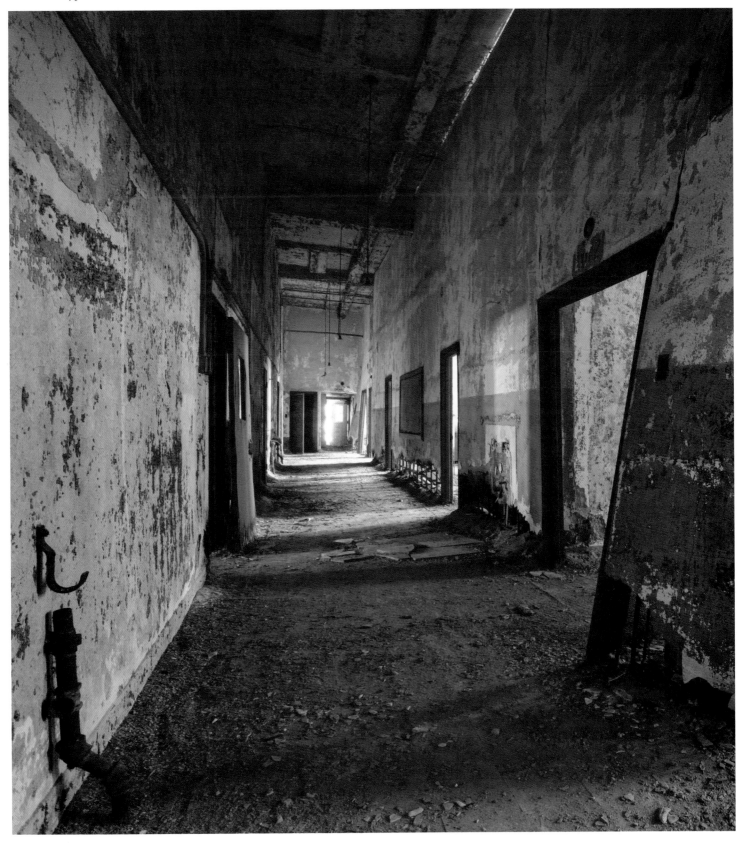

Hart Island, New York, United States

The remains of at least 850,000 people lie on Hart Island, the site of New York City's potter's field, a burial place for those who are unclaimed, homeless, poor or victims of epidemics and pandemics, including COVID-19. The island's abandoned buildings have been used as a prison camp, a psychiatric institution, a boys' reformatory and, finally, a drug rehabilitation centre that closed its doors in 1977.

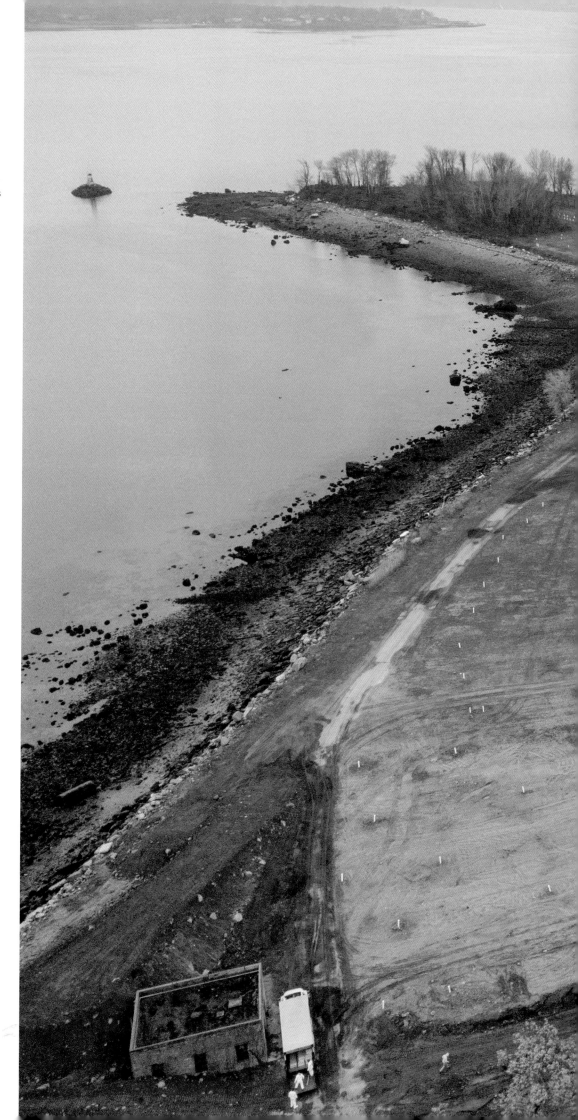

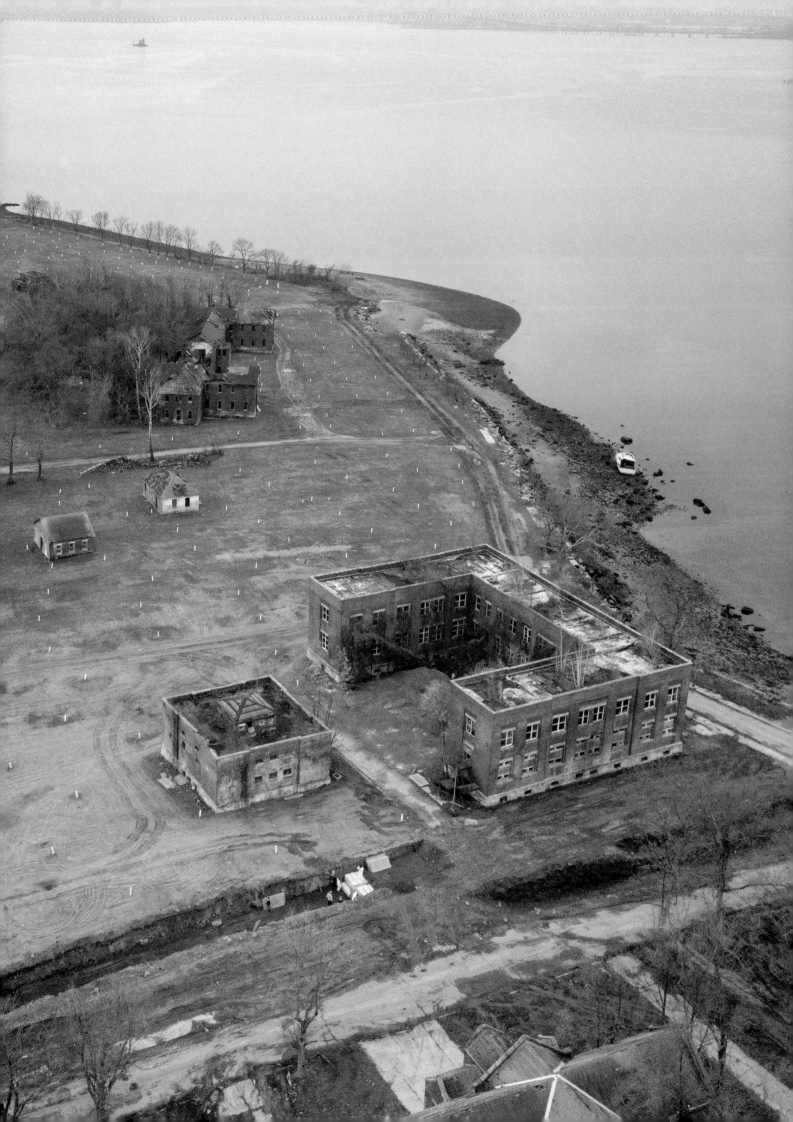

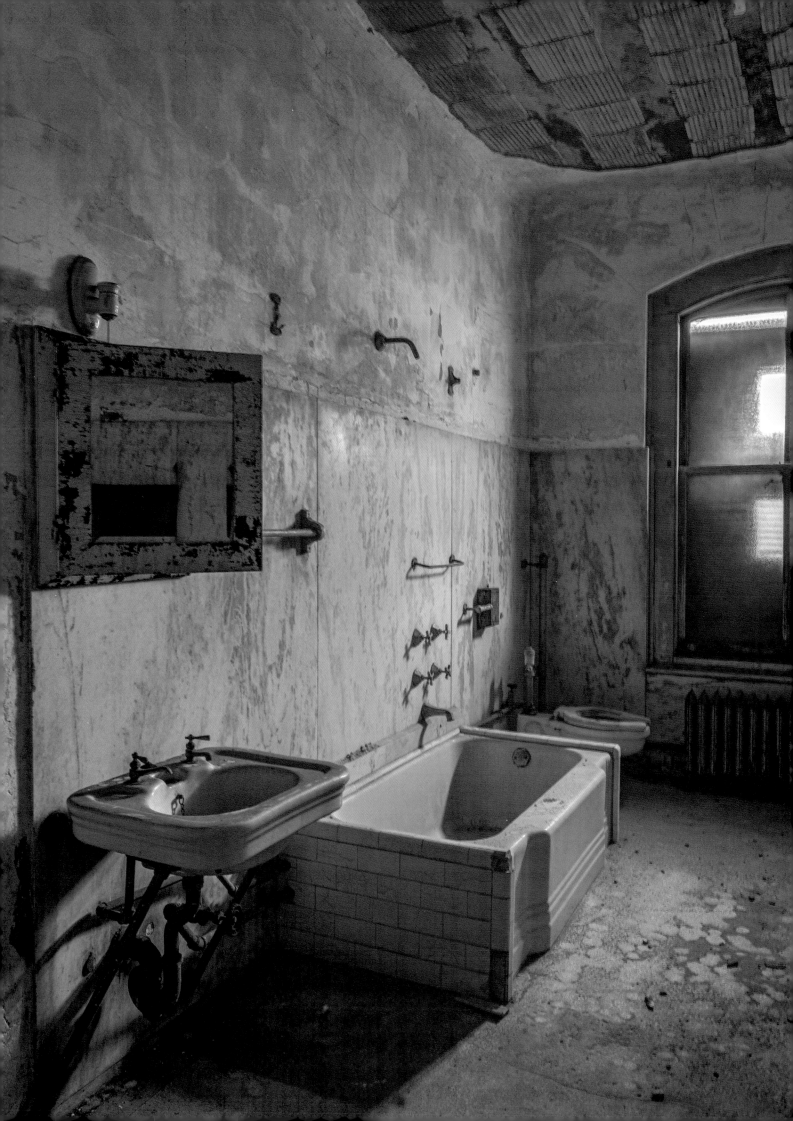

ALL PHOTOGRAPHS:

**Ellis Island,
New York, United States**
In Upper New York Bay, Ellis
Island was once the busiest
immigration inspection station
in the United States. The first
immigrant to pass through was
17-year-old Irishwoman Annie
Moore, in 1892. Before the centre's
closure in 1954, the island saw
more than 12 million arrivals,
mostly third-class passengers
who faced lengthy medical and
legal checks.

OVELEAF:

**Fort Carroll,
Maryland, United States**
This hexagonal artificial island
was constructed by Robert E. Lee
in 1848–50 to defend Baltimore.
The fort was abandoned in
1921. In 1958, Baltimore lawyer
Benjamin Eisenberg bought the
island, but his plan to build a
casino never materialised.

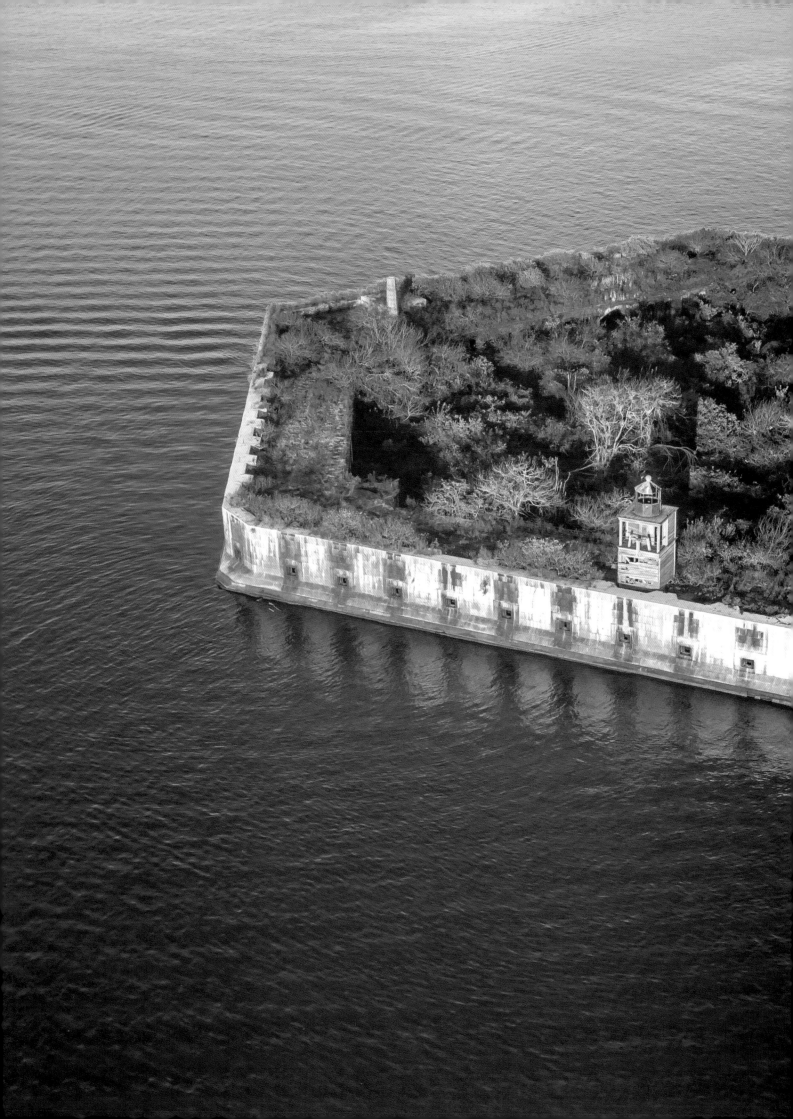

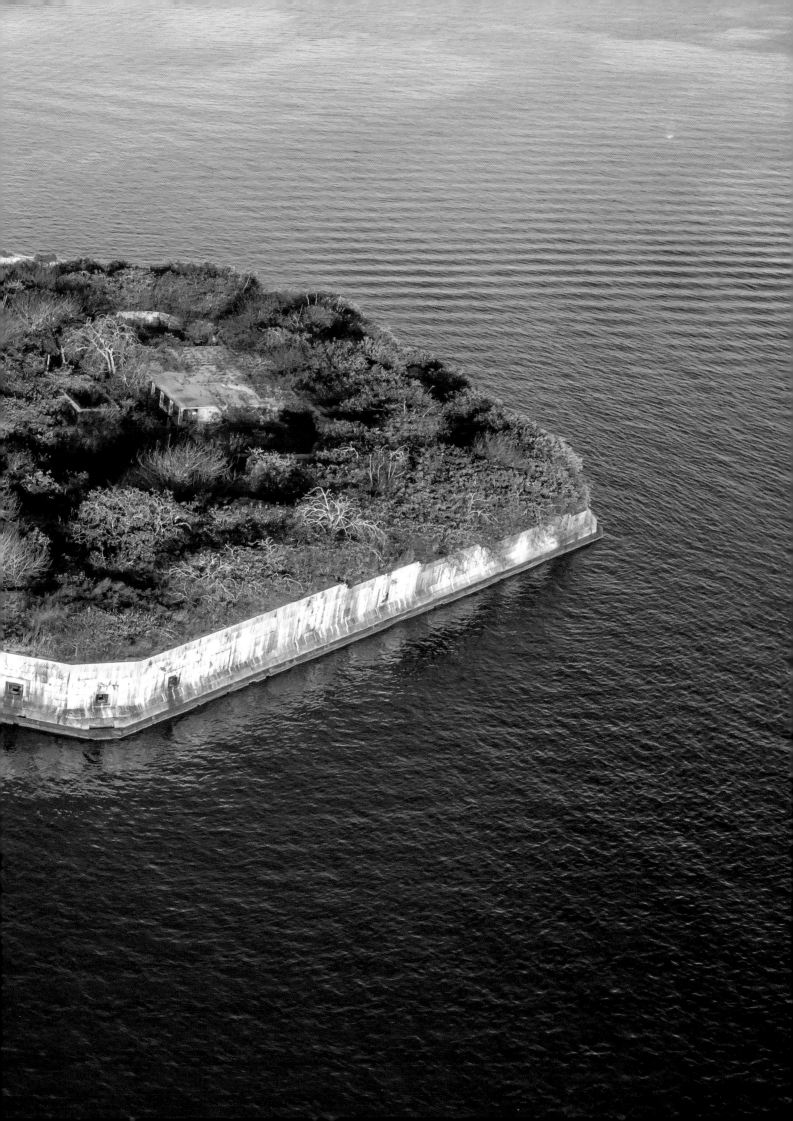

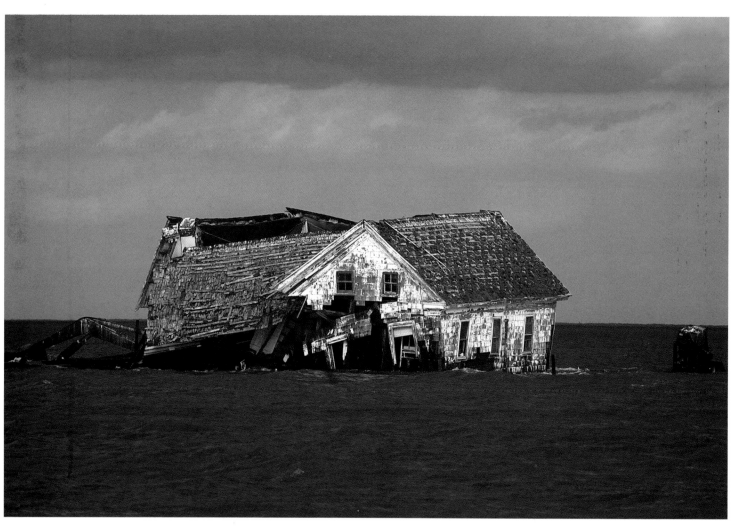

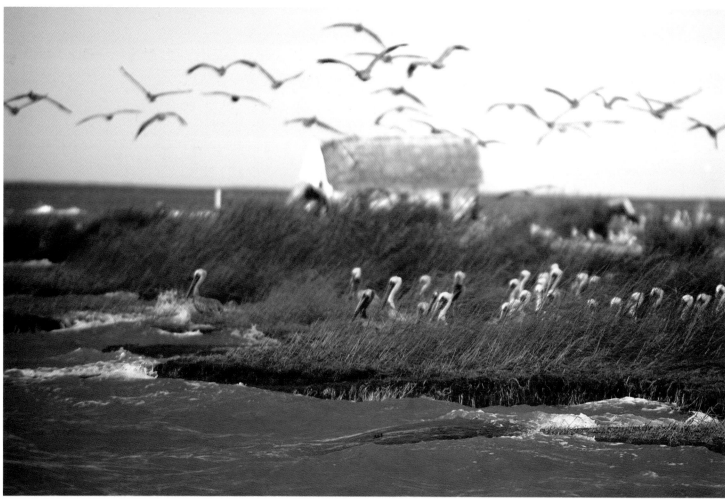

ALL PHOTOGRAPHS:
**Holland Island,
Maryland, United States**
Settled in the 17th century,
Holland Island had 360 residents
by 1910, with 70 homes and a
church, school and stores. In
1914, the island began to suffer
from erosion by storms and tides.
Walls were built in an unsuccessful
attempt to protect homes, but in
1918, the last family had to leave
for the mainland. In 2010, the last
remaining house (pictured top left)
collapsed into the ocean.

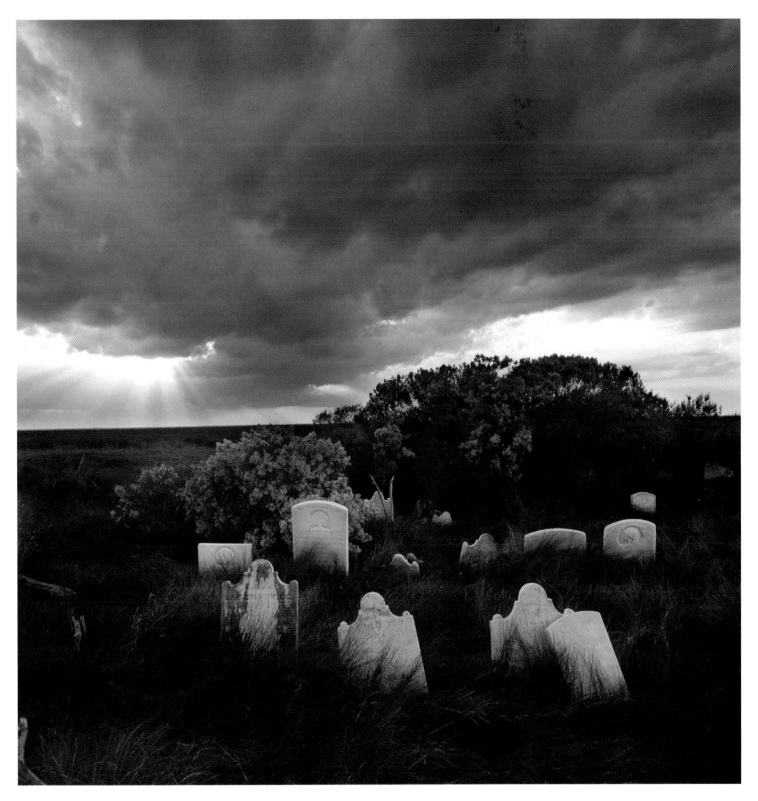

Cumberland Island, Georgia, United States

In 1971, most of Cumberland Island was sold to the federal government by the Carnegie family of industrialists. Since then, the Cumberland Island National Seashore has protected the island's coastal flora, as well as fauna including feral horses and hogs, American alligators, white-tailed deer and nine-banded armadillos.

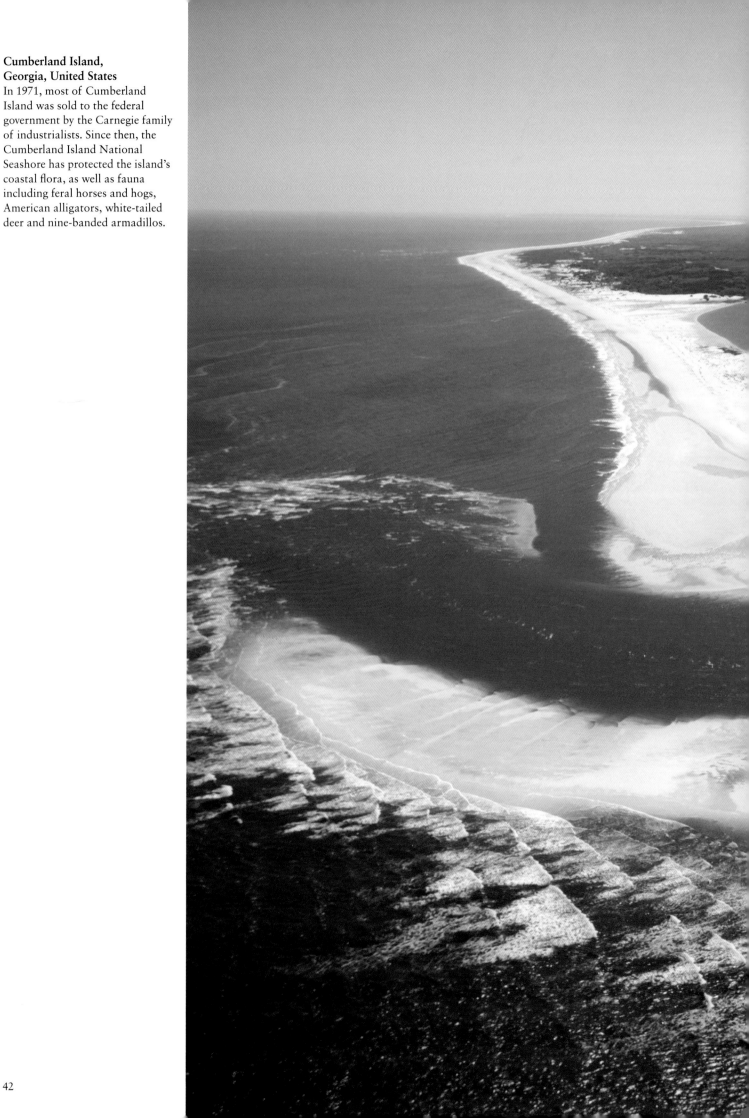

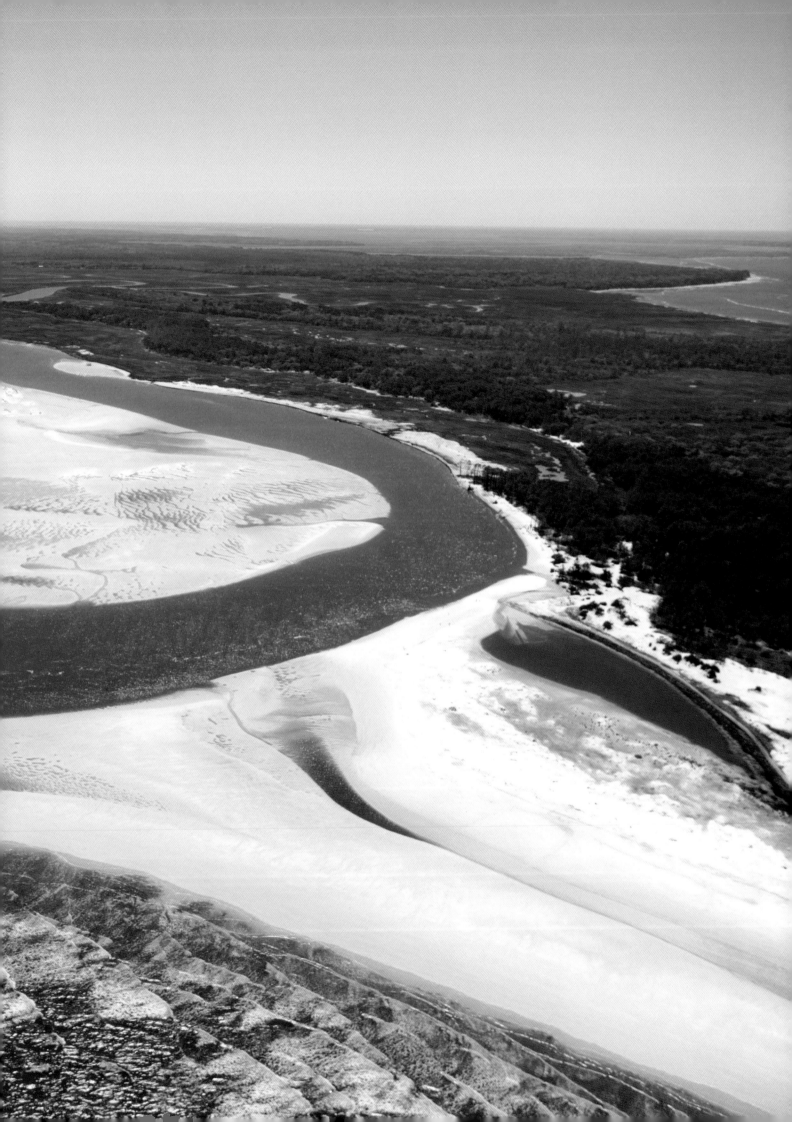

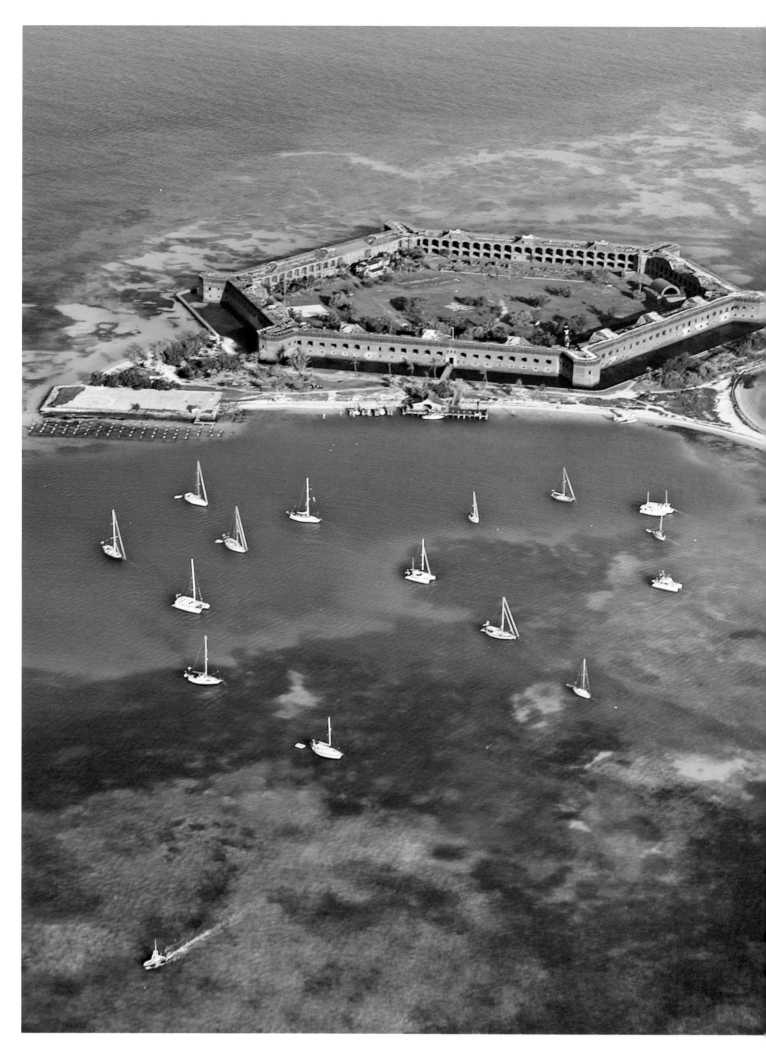

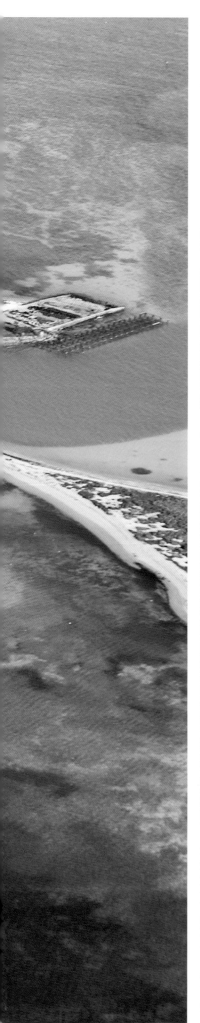

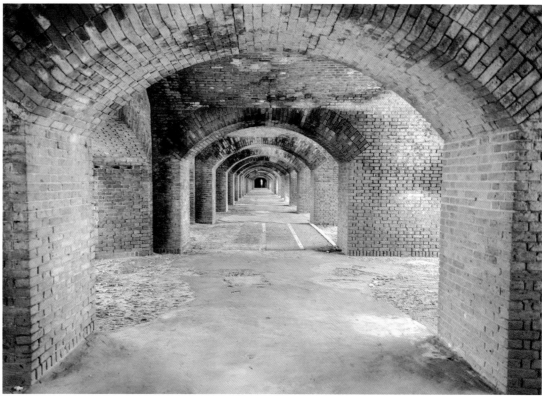

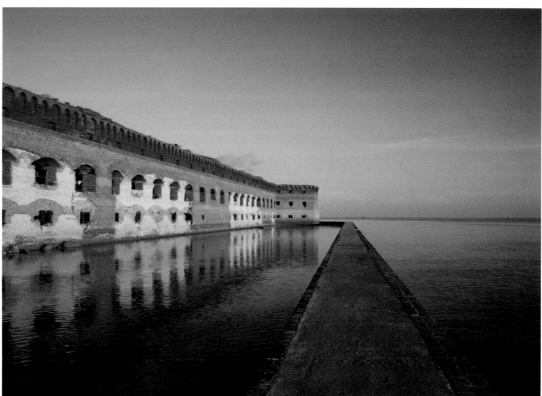

ALL PHOTOGRAPHS AND OVERLEAF:
Fort Jefferson,
Florida, United States
In 1846, construction began on
this 65,000 sq m (700,000 sq ft)
fort on Garden Key, in the Lower
Florida Keys, to defend the
Gulf Coast and shipping in the
Caribbean. Abandoned in 1906,
the fort is built from 16 million
bricks, making it the largest brick
structure in the Americas.

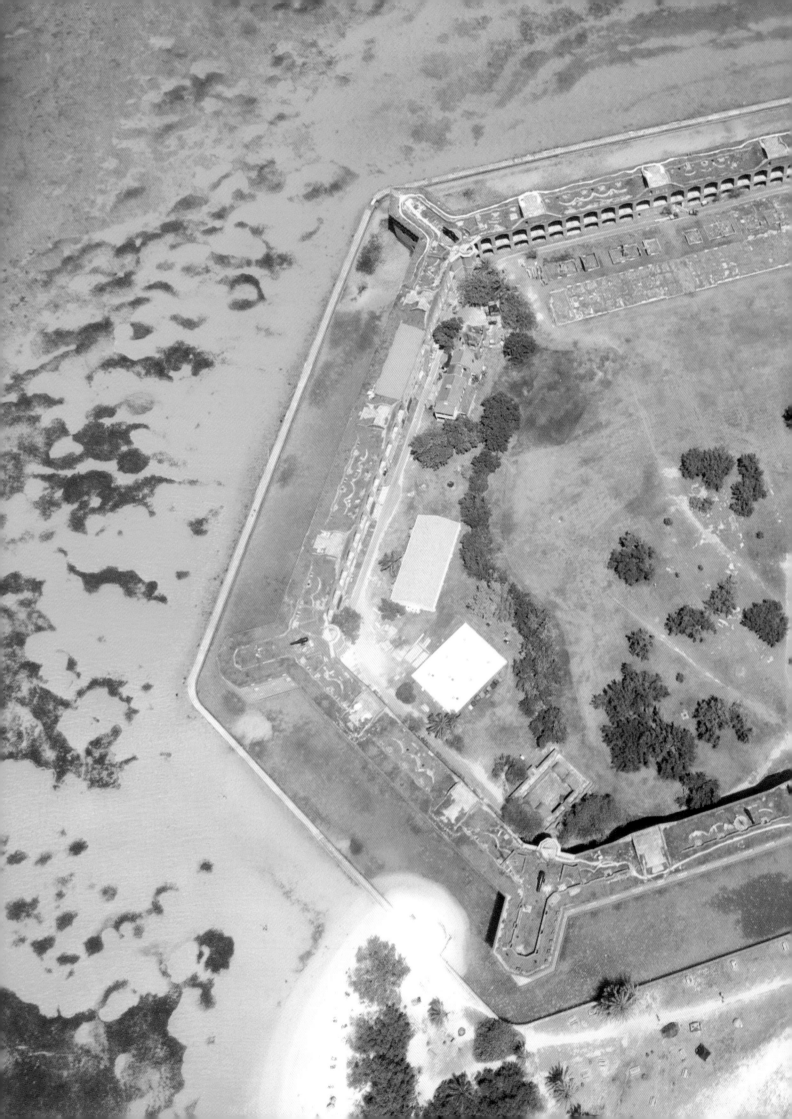

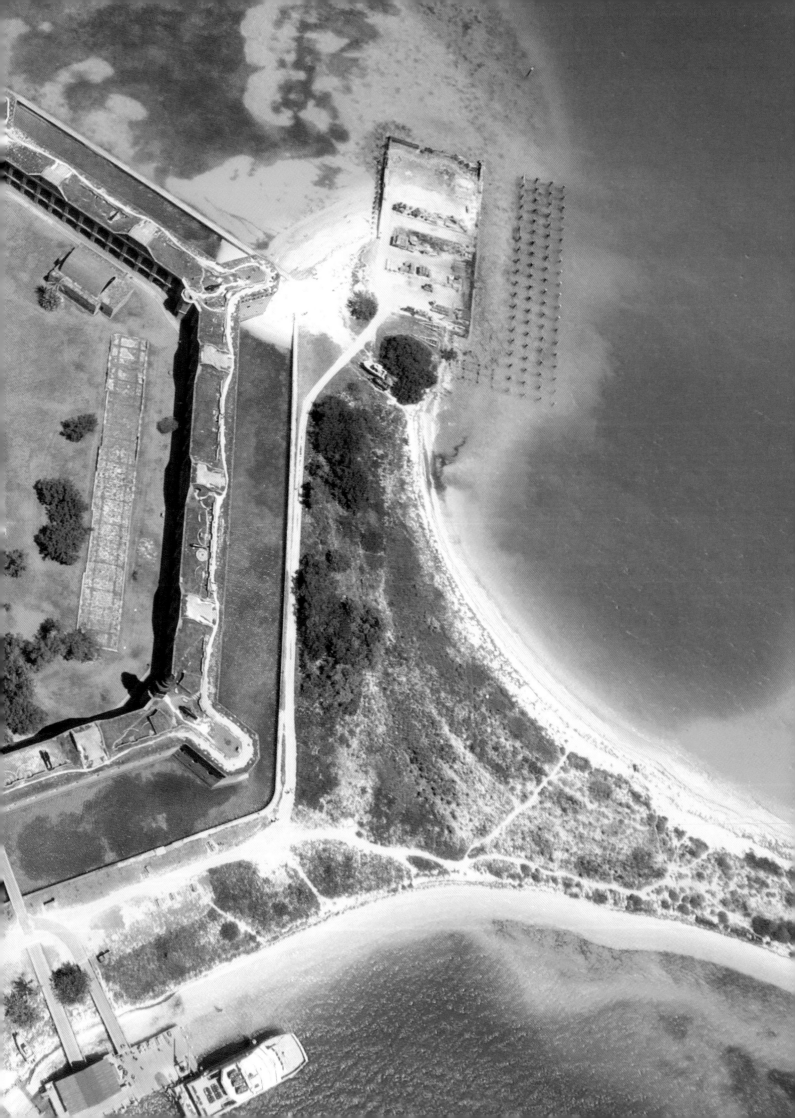

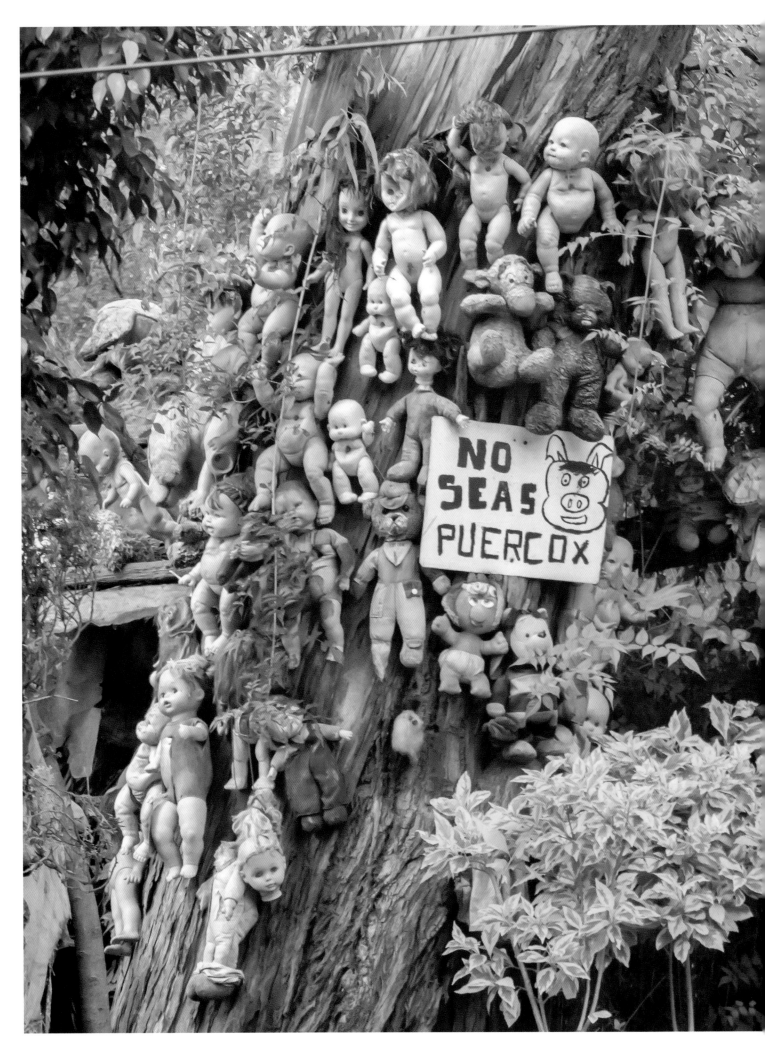

LEFT:
La Isla de las Muñecas, Mexico
'The Island of the Dolls' is a *chinampa*, an artificial island, built on Laguna de Teshuilo in Mexico City. From the 1950s, hundreds of dolls were hung from the island's trees by its owner, Julián Santana Barrera, to frighten away the spirit of a girl who drowned nearby.

BELOW AND OVERLEAF:
Devil's Island, French Guiana
From 1852 to 1953, Devil's Island was the site of a French penal colony, where Captain Alfred Dreyfus was imprisoned. The Jewish army officer was convicted of treason in 1894 for allegedly selling military secrets to the Germans. Public support led to his full exoneration in 1906.

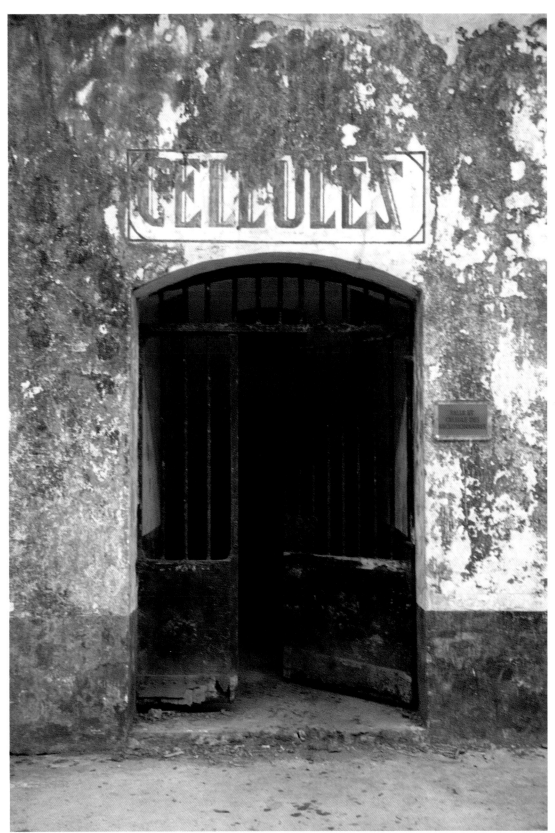

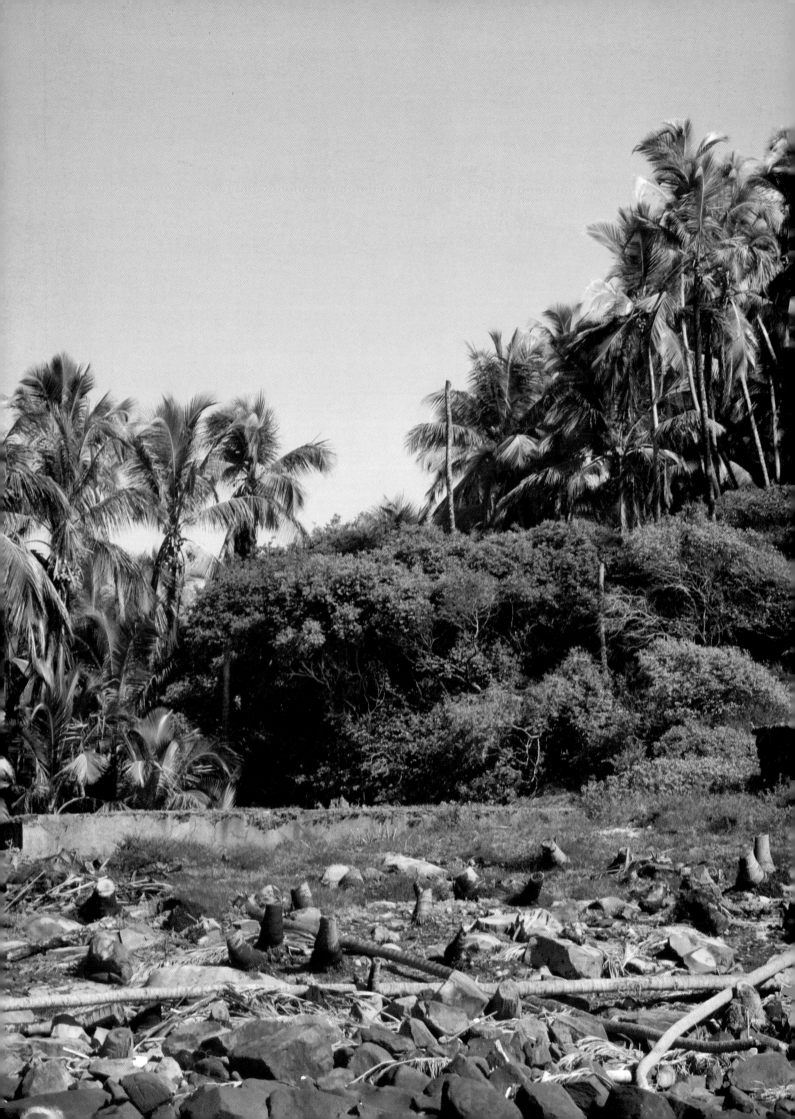

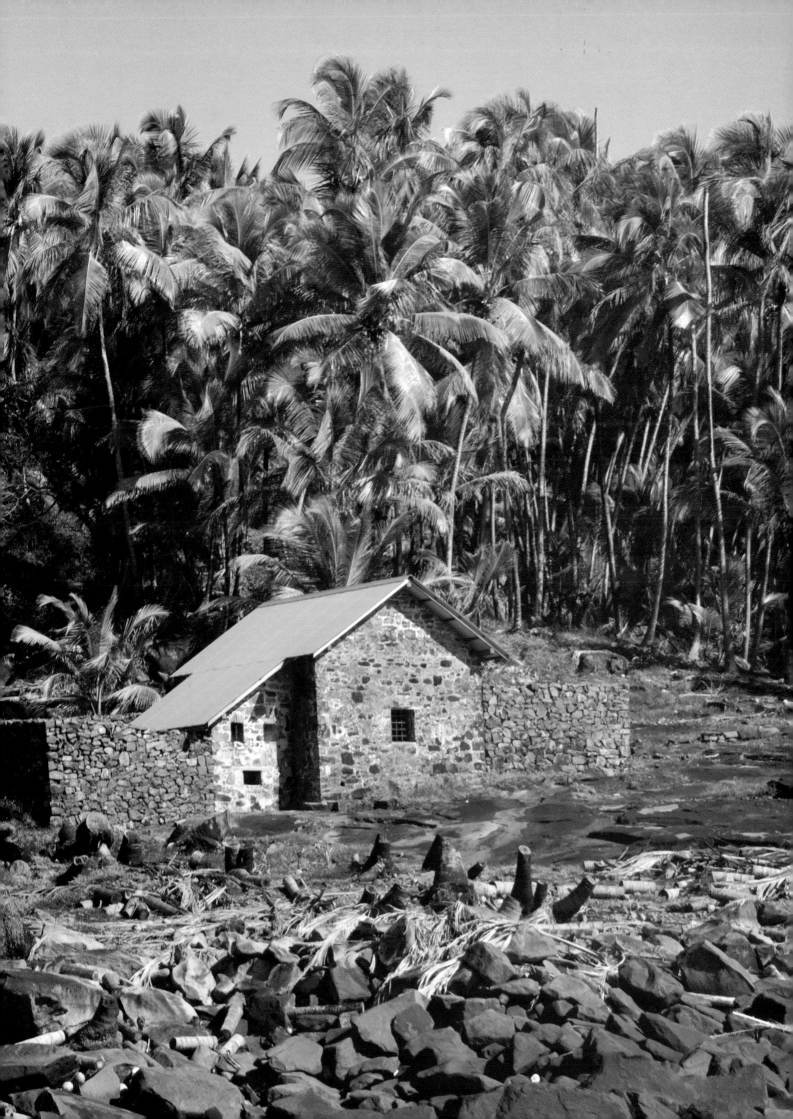

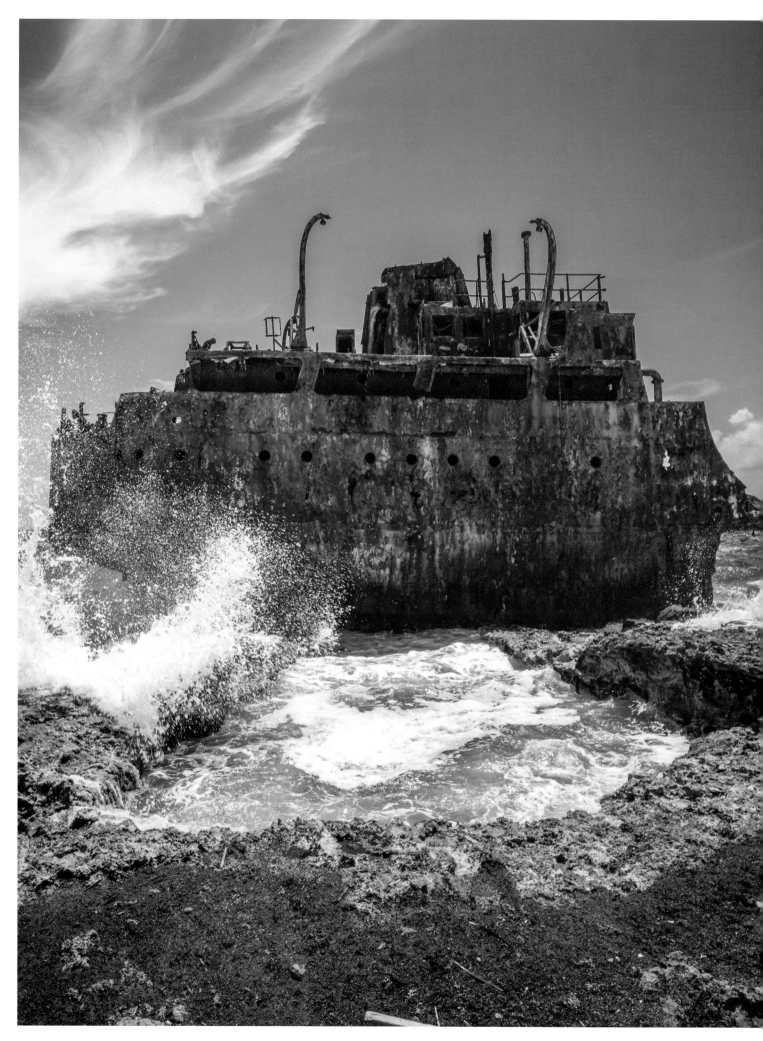

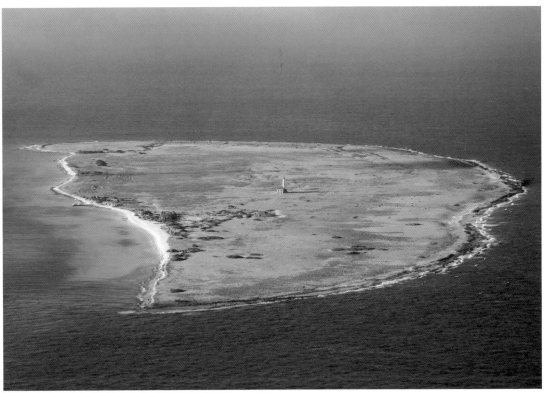

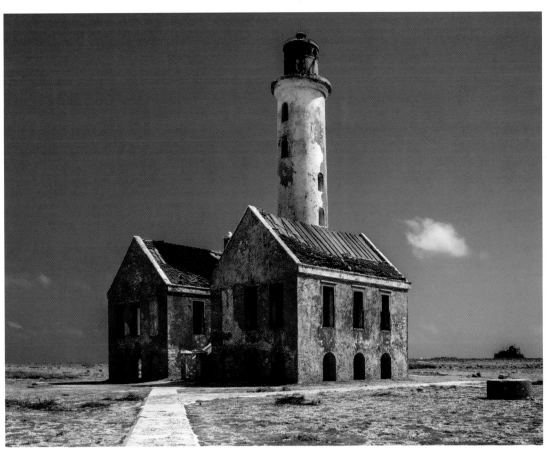

ALL PHOTOGRAPHS:
Klein Curaçao, Curaçao
From 1662, the Dutch West India
Company used Klein Curaçao to
quarantine enslaved Africans who
had fallen sick on the Atlantic
crossing. Many thousands of men,
women and children died on the
island. Today, the windward side
of Klein Curaçao is littered with
the rusting hulls of wrecked ships.

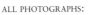

ALL PHOTOGRAPHS:

Gorgona Island, Colombia
From 1959 to 1984, Gorgona Island housed a notoriously violent high-security prison. The buildings are now almost hidden by tropical forest, where a pure blue lizard, the endemic and highly endangered blue anole, is found. The jungle also hides one of the world's deadliest venomous snakes, *Bothrops asper*, responsible for the majority of snakebites in its range.

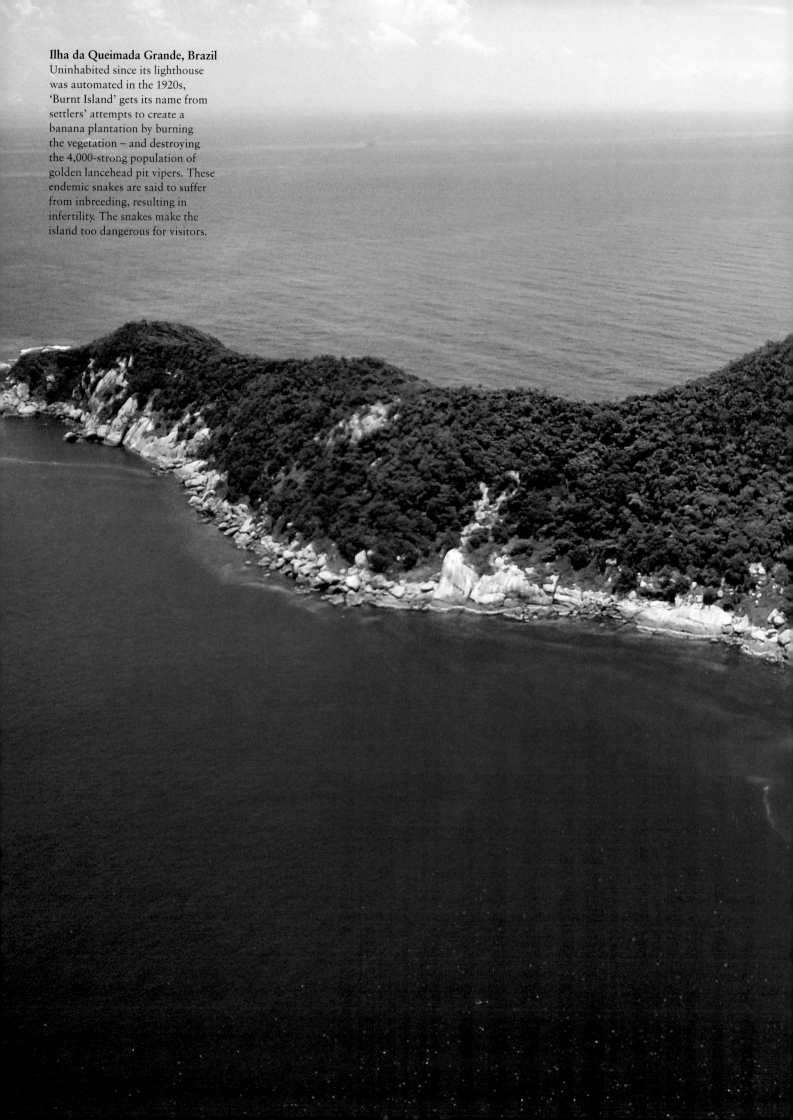

Ilha da Queimada Grande, Brazil
Uninhabited since its lighthouse
was automated in the 1920s,
'Burnt Island' gets its name from
settlers' attempts to create a
banana plantation by burning
the vegetation – and destroying
the 4,000-strong population of
golden lancehead pit vipers. These
endemic snakes are said to suffer
from inbreeding, resulting in
infertility. The snakes make the
island too dangerous for visitors.

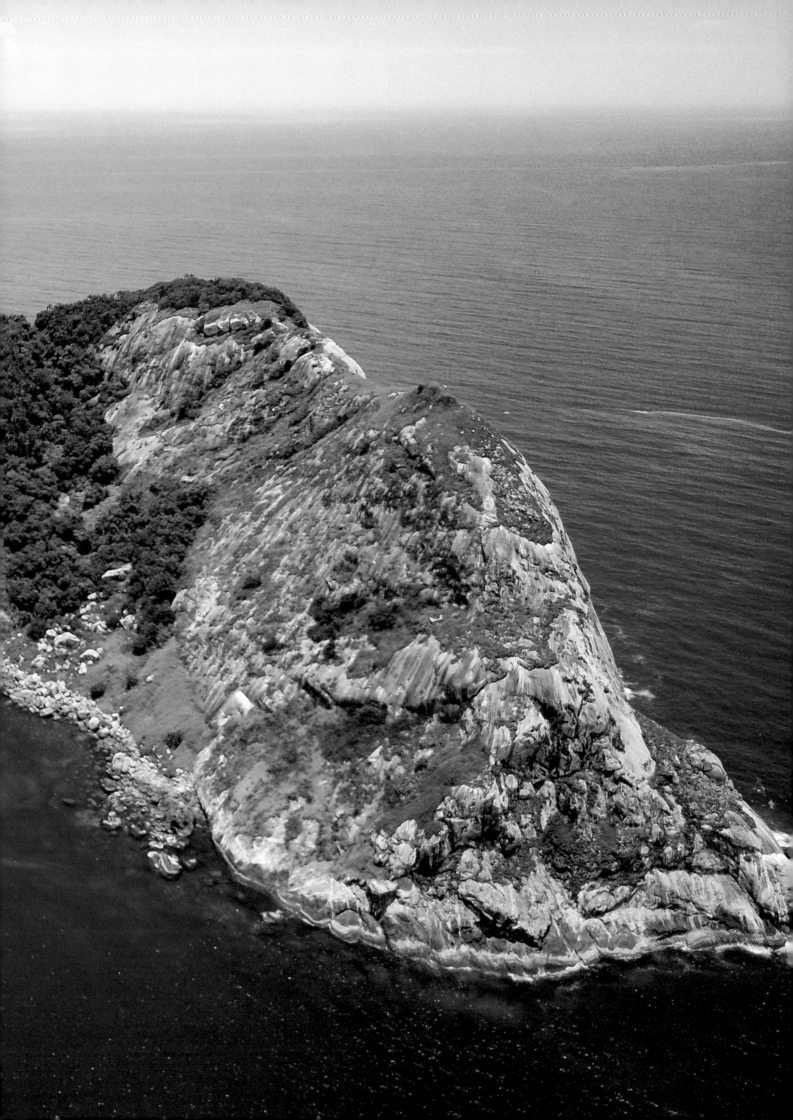

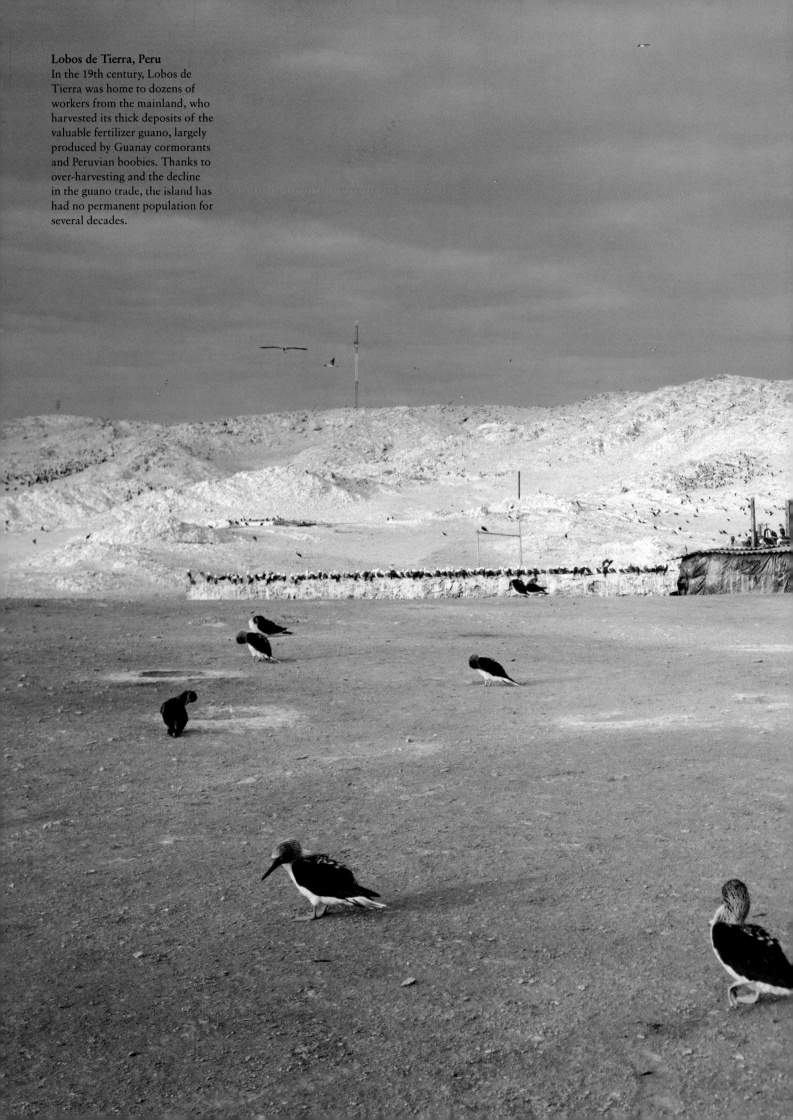

Lobos de Tierra, Peru
In the 19th century, Lobos de Tierra was home to dozens of workers from the mainland, who harvested its thick deposits of the valuable fertilizer guano, largely produced by Guanay cormorants and Peruvian boobies. Thanks to over-harvesting and the decline in the guano trade, the island has had no permanent population for several decades.

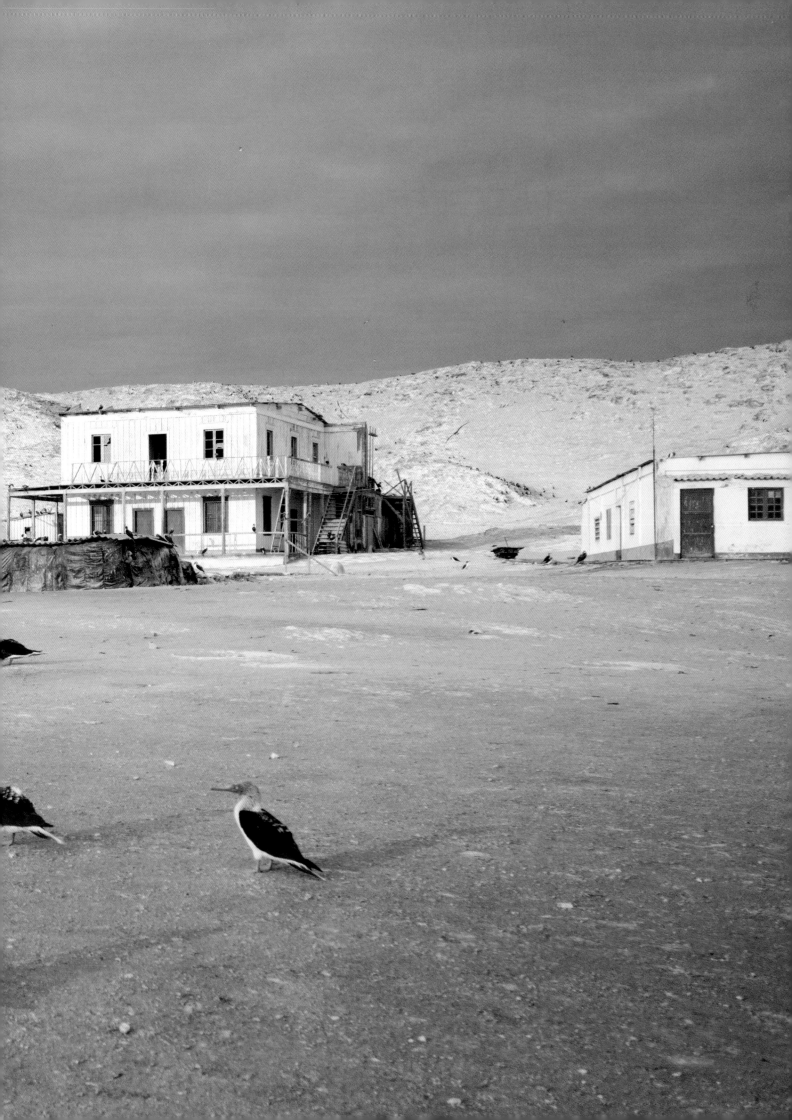

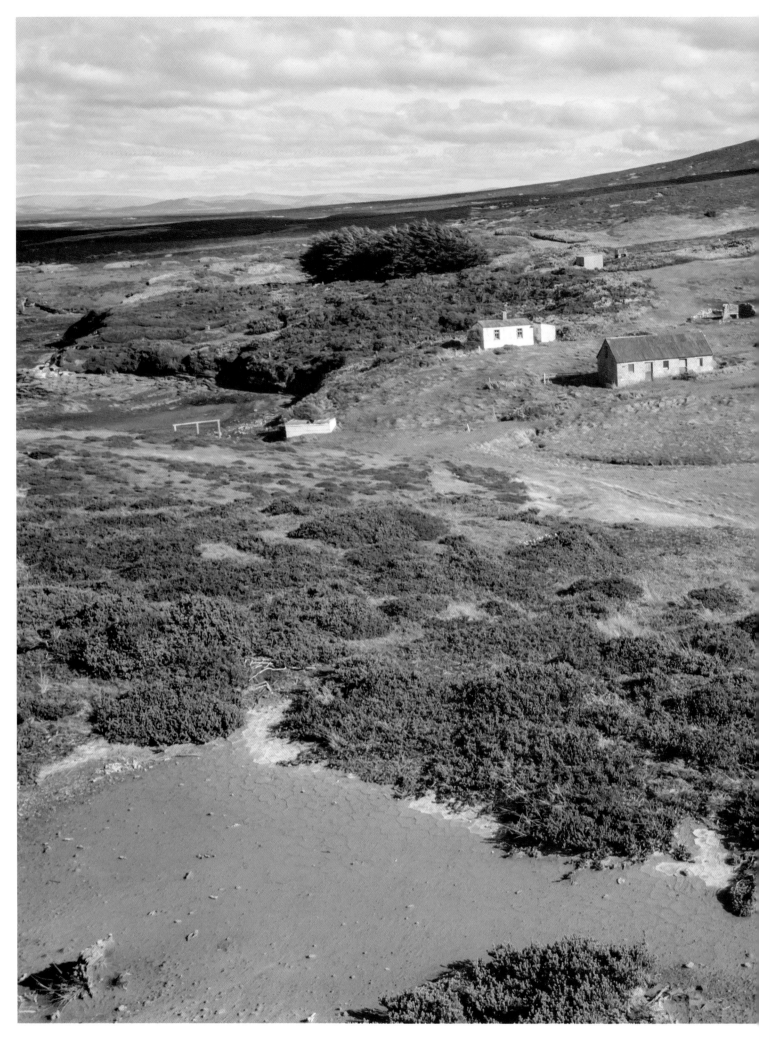

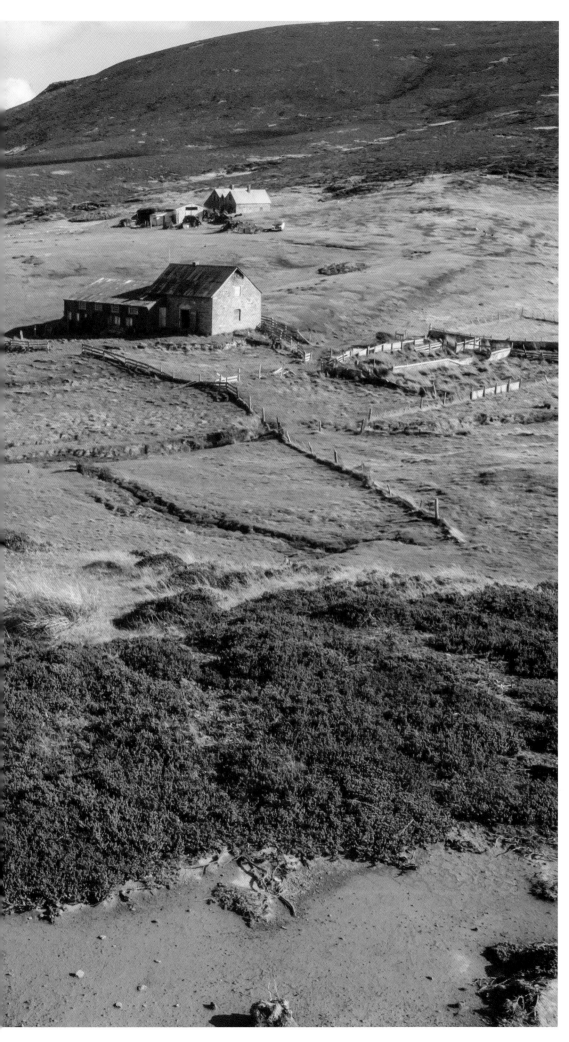

Keppel Island, Falkland Islands
From 1859, English missionaries from the South American Mission Society persuaded several Yaghan people from Tierra del Fuego to move to uninhabited Keppel Island, where they were taught English and farming techniques. Their settlement was later taken over by European sheep farmers, but has been uninhabited since 1992. Today, the island is a nature reserve known for its three species of penguins: gentoo, rockhopper and Magellanic.

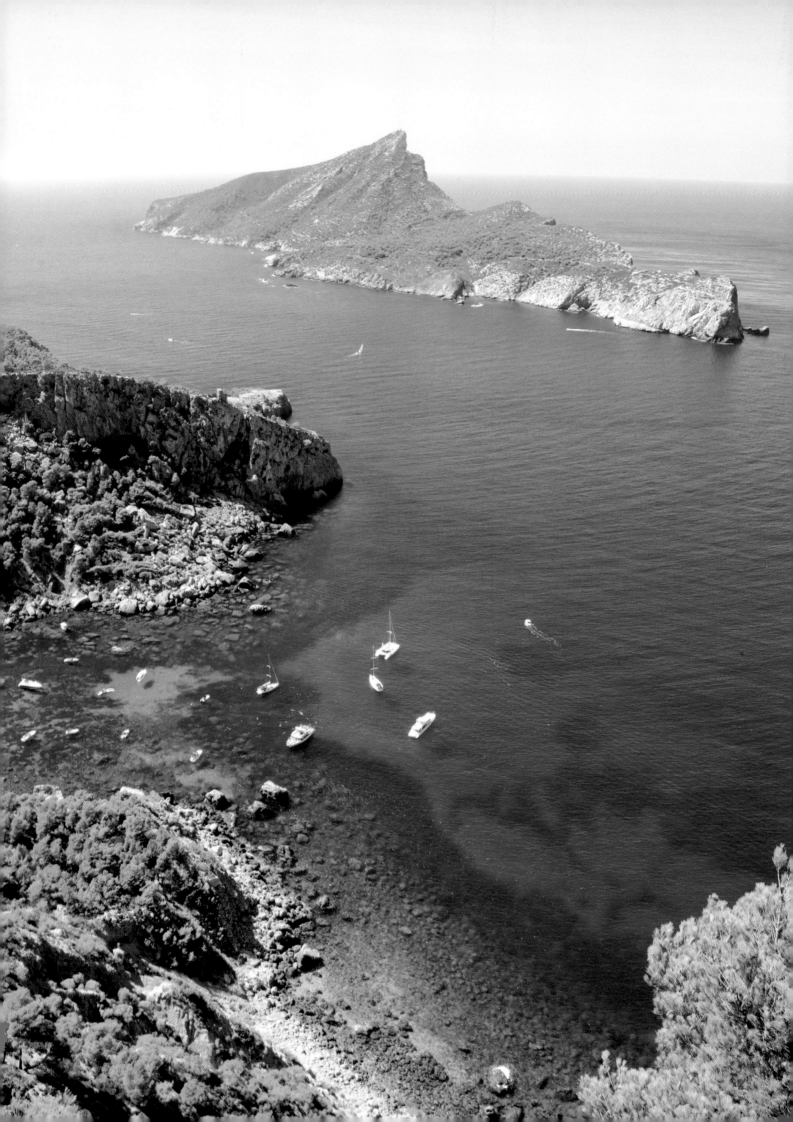

Europe

The early to mid-20th century saw the depopulation and abandonment of small islands across Europe. From Scotland's St Kilda to Malta's Comino, a combination of pushes and pulls proved too much for these island communities. For an island settlement to endure, it must have plentiful resources and people. Similar factors have led to the abandonment of islands since long before the day in the 8th century when the last farmers and fishermen set sail from the Greek island of Delos. The story of St Kilda is better known than most, due to Michael Powell's 1937 film about its final days, *The Edge of the World*. Despite violent storms, privations, epidemics brought by passing boats and a population never exceeding 180, the islands of St Kilda had been populated for around 2,000 years before the remaining 36 inhabitants asked to be relocated to the Scottish mainland in 1930. The St Kildans had built a strong community, with all taking part in a daily 'parliament'. They lived on a diet of gannet, fulmar, eggs, and a little barley and potato. Perhaps most importantly, the community knew little of life elsewhere. The early 20th century brought tourists and, during World War I, soldiers. Learning that life might be easier elsewhere, the island's youngsters began to leave. Then came a series of crop failures, a flu epidemic and – finally – the death of a young mother, daughter and friend, Mary Gillies, in 1930. The islanders made their final decision, like all their decisions, together.

OPPOSITE:
Dragonera, Balearic Islands, Spain
A few hundred metres from the coast of Majorca, Dragonera has been uninhabited since its two lighthouses were automated in 1975.

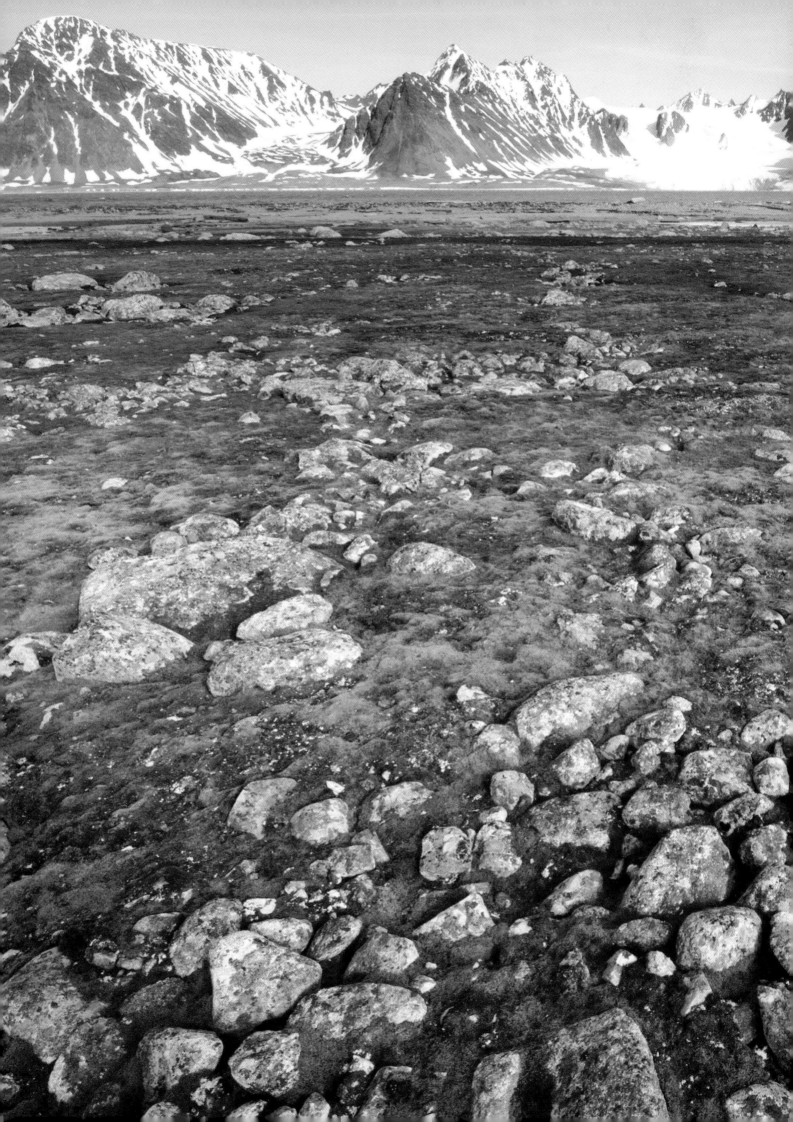

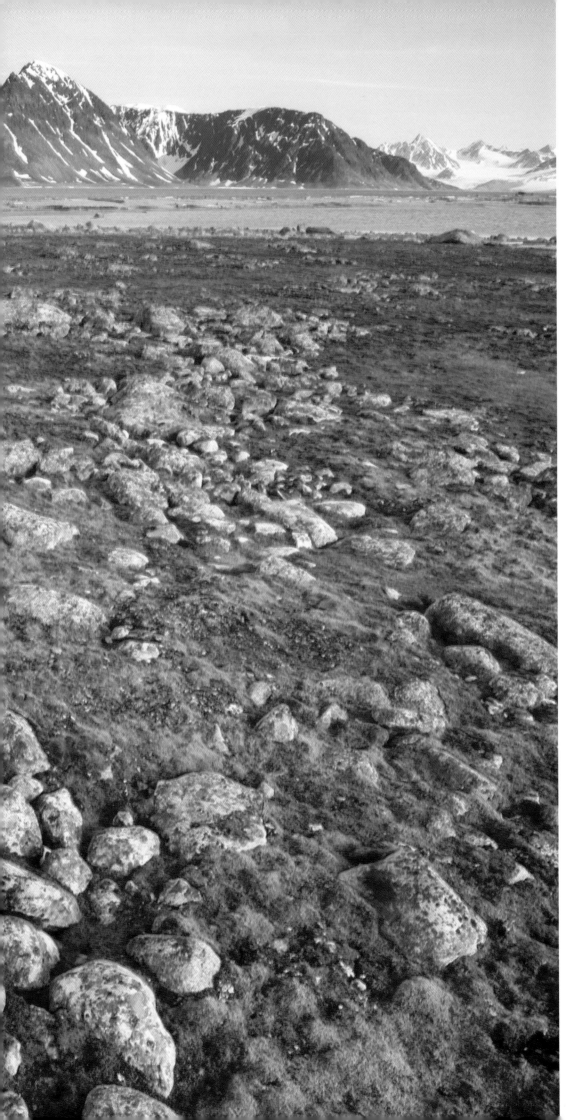

Danskøya, Svalbard, Norway
This small, tundra-covered island lies off the northwest coast of Spitsbergen. In the 1630s, there were two attempts at permanent settlements on Danskøya, both by the Danish. The station in Robbe Bay was abandoned in 1658, while the settlement in Houcker Bay was uninhabited long before its remains were spotted by naturalist Friderich Martens in 1671.

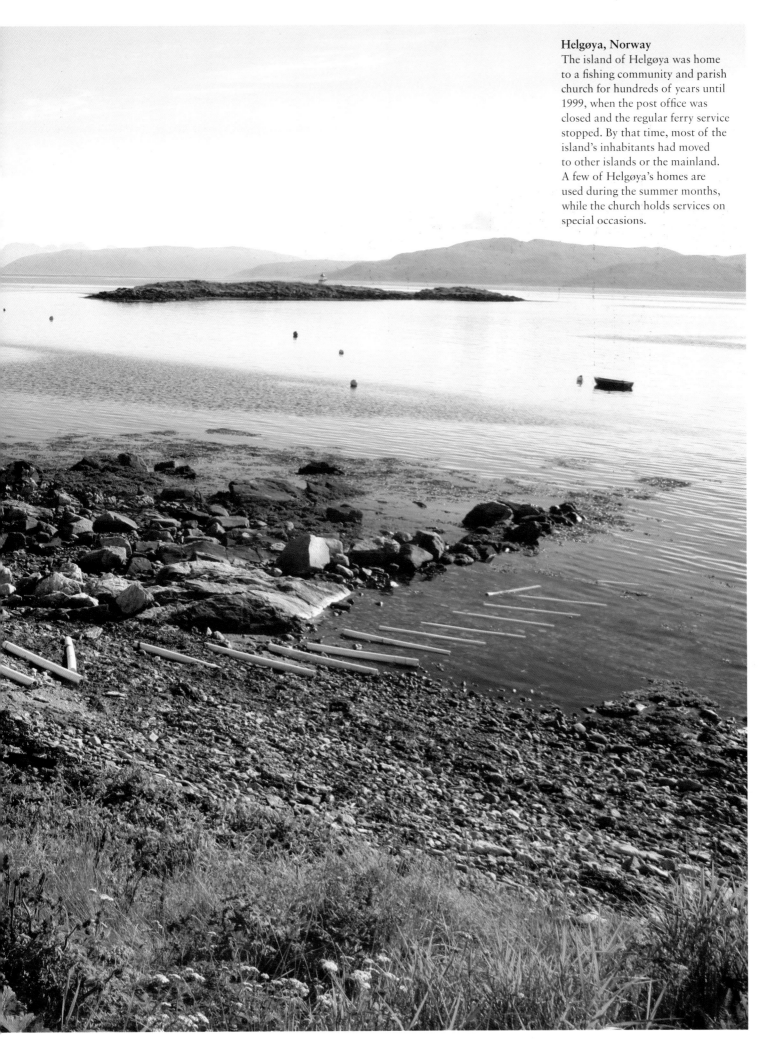

Helgøya, Norway
The island of Helgøya was home to a fishing community and parish church for hundreds of years until 1999, when the post office was closed and the regular ferry service stopped. By that time, most of the island's inhabitants had moved to other islands or the mainland. A few of Helgøya's homes are used during the summer months, while the church holds services on special occasions.

Elliðaey, Iceland
Today home only to puffins, this
island off Iceland's south coast
was inhabited until the 1930s.
Elliðaey's small community, never
larger than five families, lived by
fishing, hunting puffins and raising
cattle. As life became increasingly
impractical in comparison to
life on the mainland, Elliðaey's
inhabitants moved away. The
island's large white building
was built in 1953 by the Elliðaey
Hunting Association for use on
puffin-hunting trips.

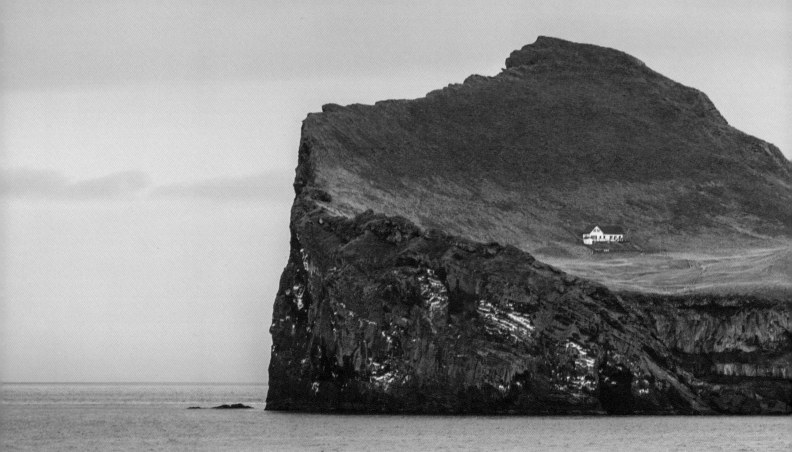

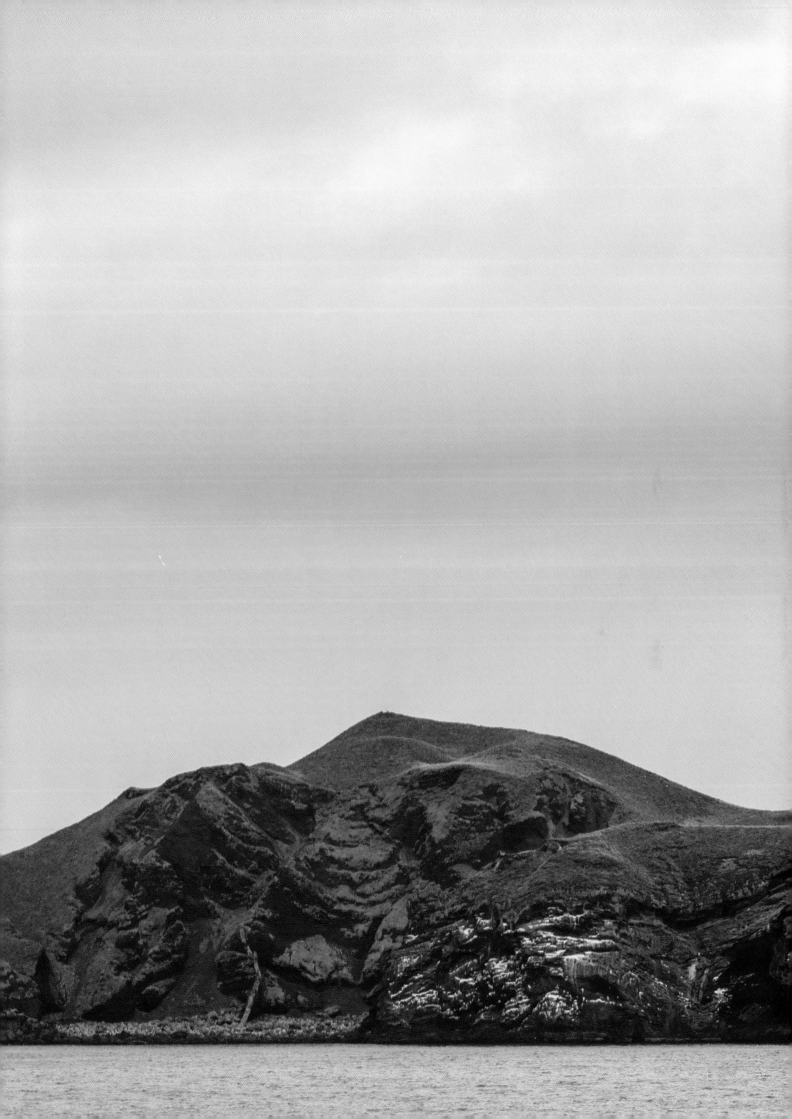

Gruinard, Scotland

In the 16th century, Scottish clergyman Dean Munro wrote that Gruinard's woods were 'guid for fostering of thieves and rebellis'. By 1881, there was a population of six, falling to zero by the 1920s. In 1942, British military scientists carried out biological warfare tests with anthrax here, rendering it unvisitable until 1990.

BELOW:
Cara, Scotland

Home to a herd of feral goats, Cara is owned by MacDonald Lockhart of Kintyre, a descendant of the medieval Norse-Gaelic Lords of the Isles. Cara has had no inhabitants since the 1940s.

OPPOSITE:
Castle Stalker, Scotland

One of the best-preserved medieval tower houses in Scotland, 15th-century Castle Stalker made an appearance in *Monty Python and the Holy Grail* (1975) as 'The Castle Aaaaarrrrrrggghhh'. The tower stands on a tidal islet in Loch Laich and is walkable from the mainland at low tide.

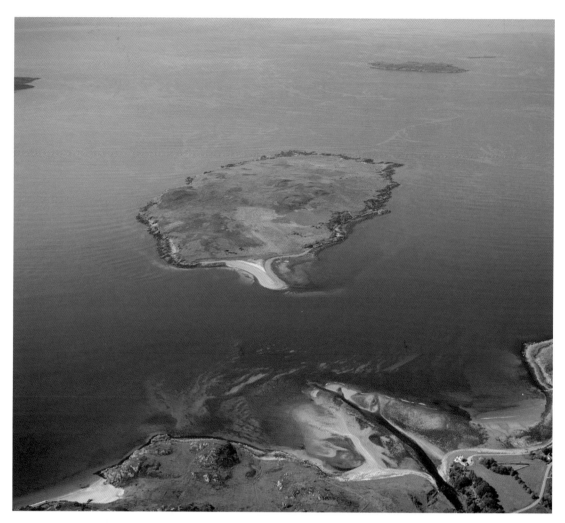

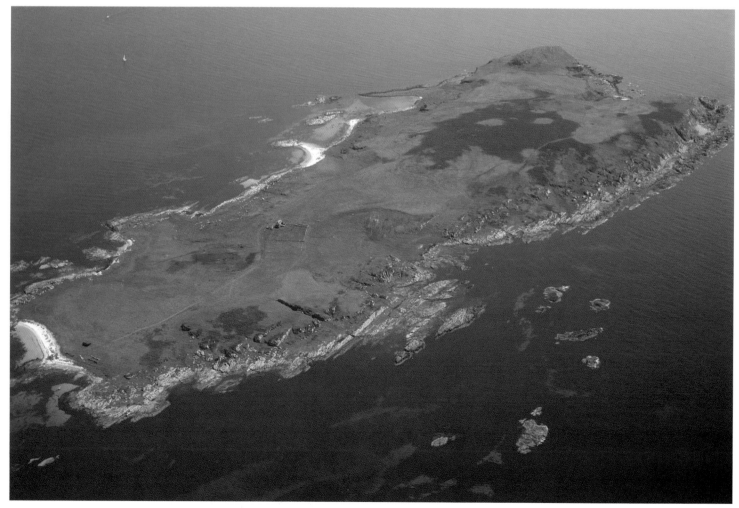

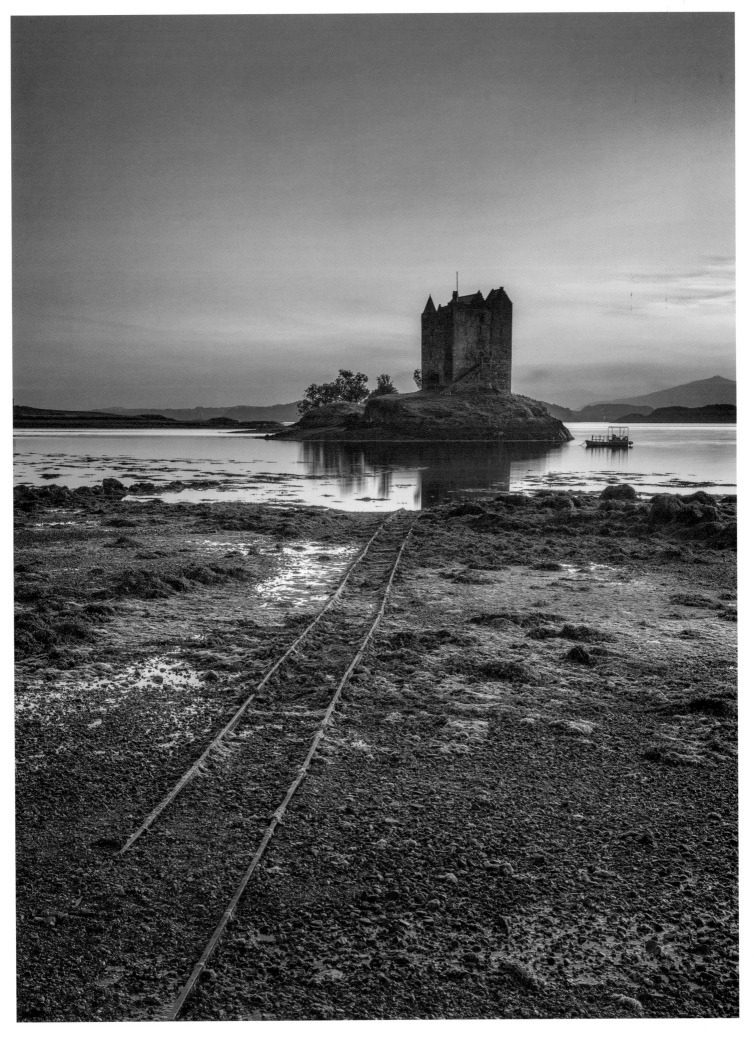

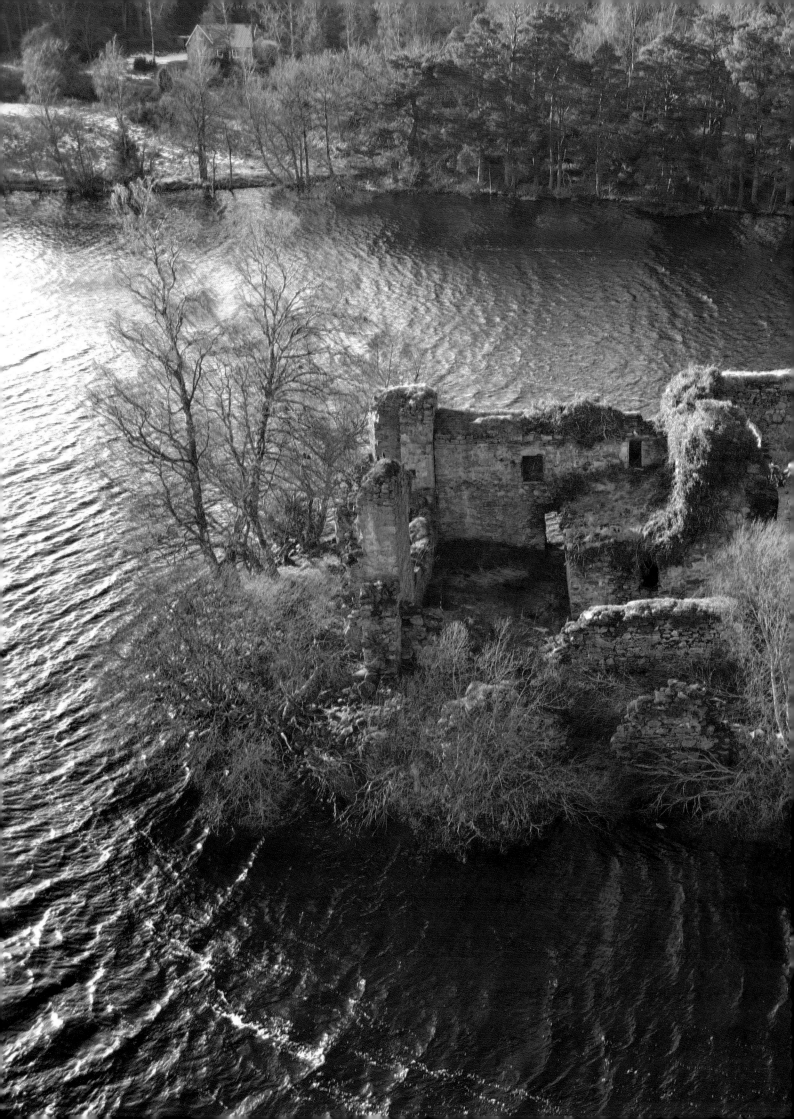

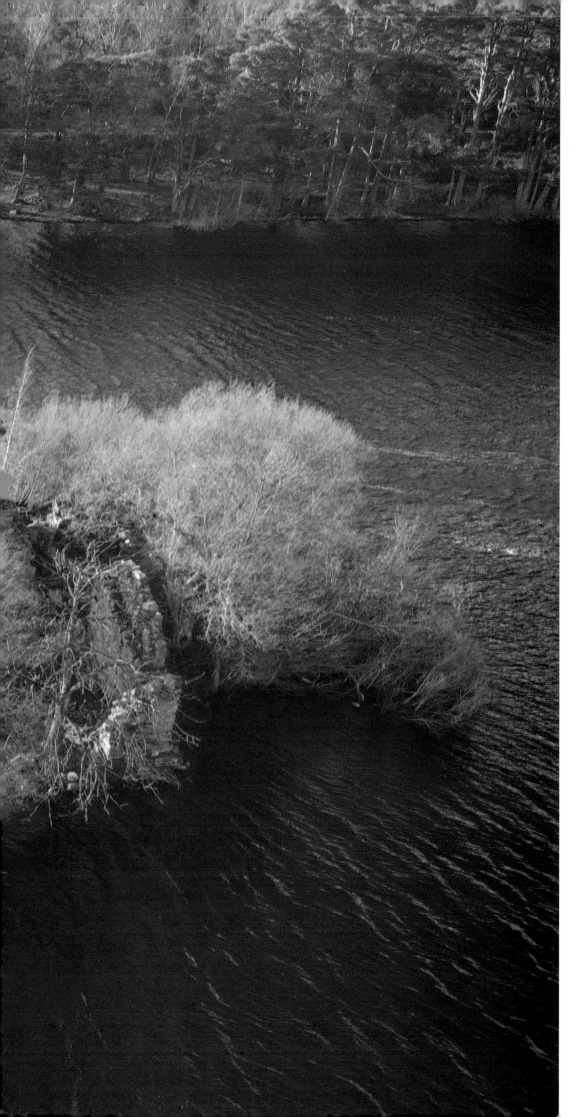

Loch an Eilein, Scotland
The ruins of a 14th-century castle stand on an unnamed island in Loch an Eilein, in Cairngorms National Park. The castle may have been owned by a son of King Robert II of Scotland, Alexander Stewart (1343–1405), known as the 'Wolf of Badenoch' for his violence and cruelty.

Mingulay, Scotland
Just 19km (12 miles) south of
Barra in the Outer Hebrides,
Mingulay was probably inhabited
continuously from the Iron Age
until 1912, when the last six
families left. The island school
had closed in 1910, making life
too hard for the remaining few.

Shillay, Scotland
Shillay lies in the Monach Islands
of the Outer Hebrides. In 1864, a
lighthouse was built on the island
by David and Thomas Stevenson,
designers of over 30 lighthouses
in and around Scotland. The
lighthouse was decommissioned in
1942, but reinstated in 2008.

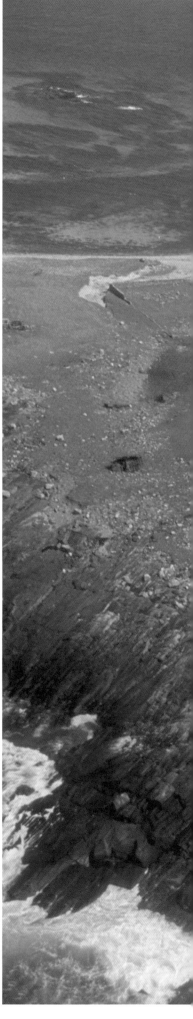

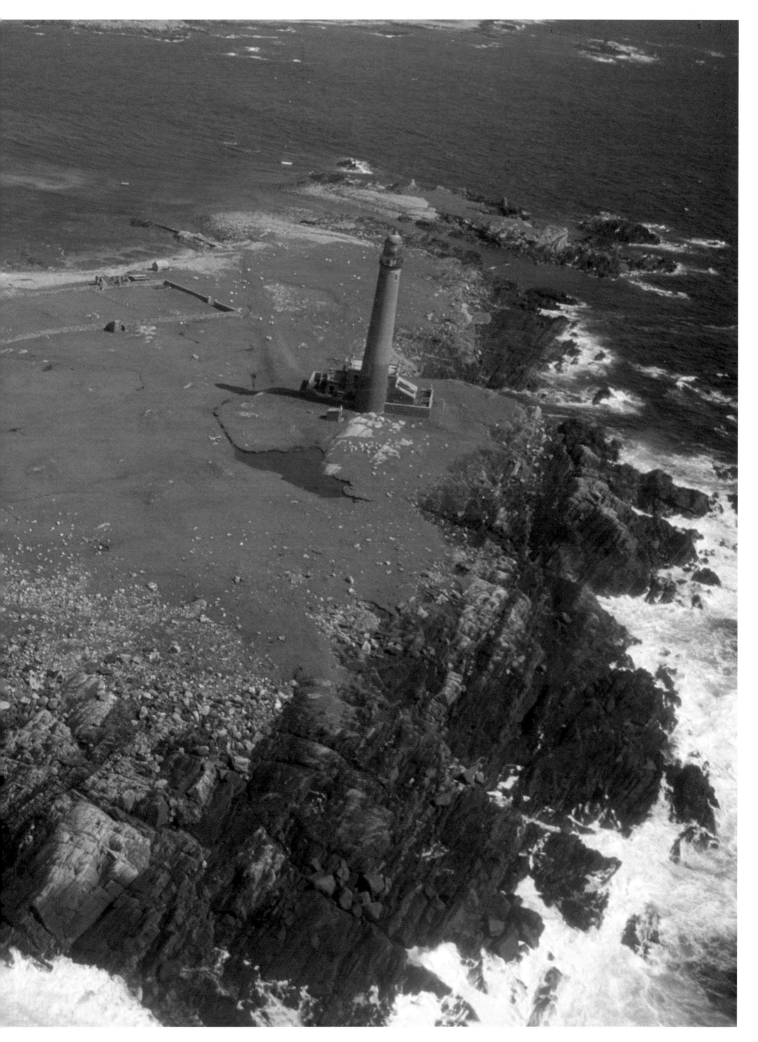

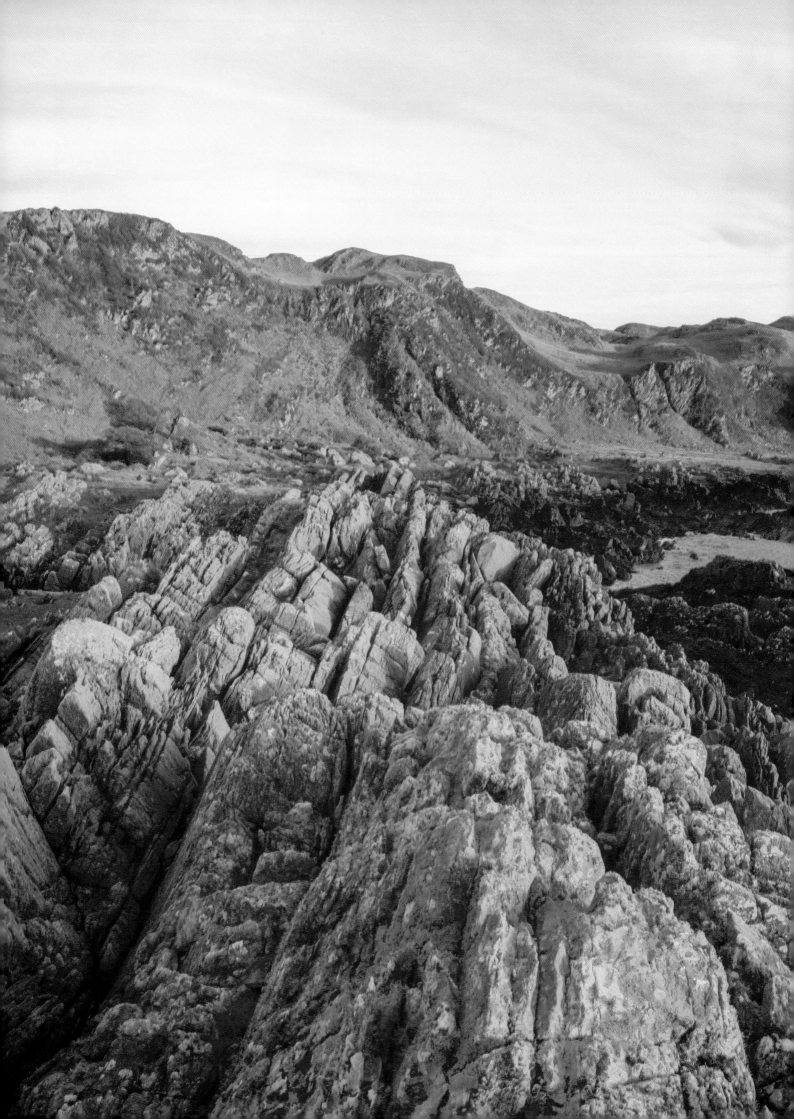

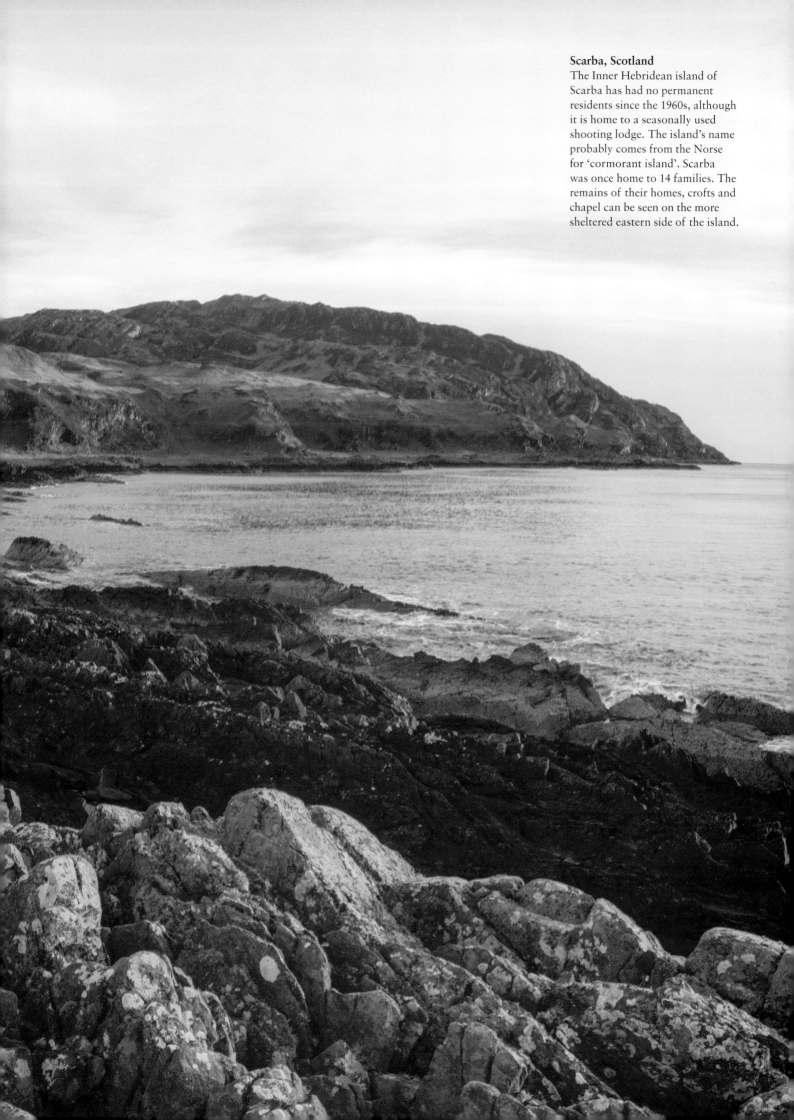

Scarba, Scotland
The Inner Hebridean island of Scarba has had no permanent residents since the 1960s, although it is home to a seasonally used shooting lodge. The island's name probably comes from the Norse for 'cormorant island'. Scarba was once home to 14 families. The remains of their homes, crofts and chapel can be seen on the more sheltered eastern side of the island.

Hirta, St Kilda, Scotland
The islands of St Kilda were inhabited for around 2,000 years until 1930, when the remaining 36 islanders requested relocation to the mainland. St Kilda's peak population was in the late 17th century, when Hirta, the largest island, was home to 180 people. Only the remains of the St Kildans' homes, dry-stone sheepfolds and storage huts, known as *cleitean*, remain. The last St Kildan, Rachel Johnson, died in 2016 at the age of 93.

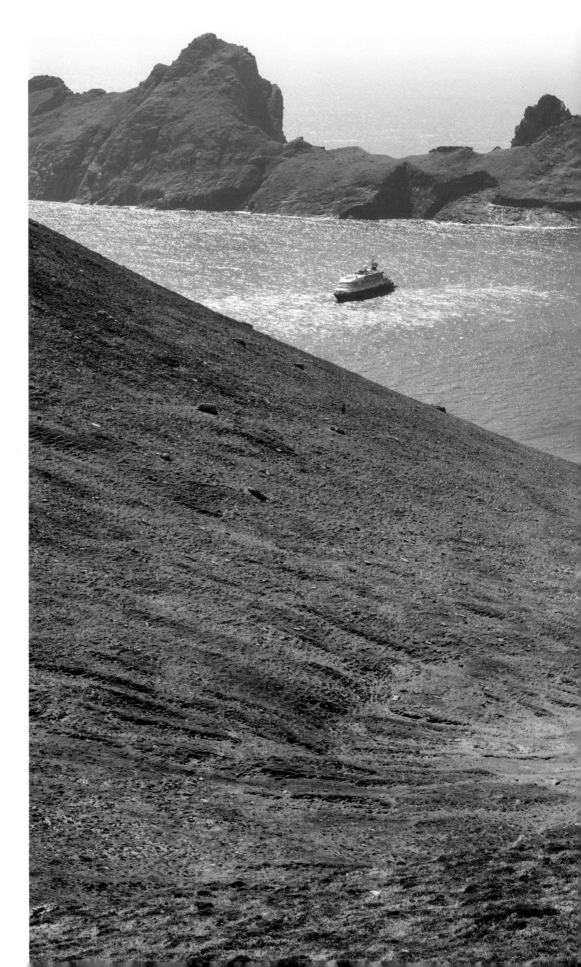

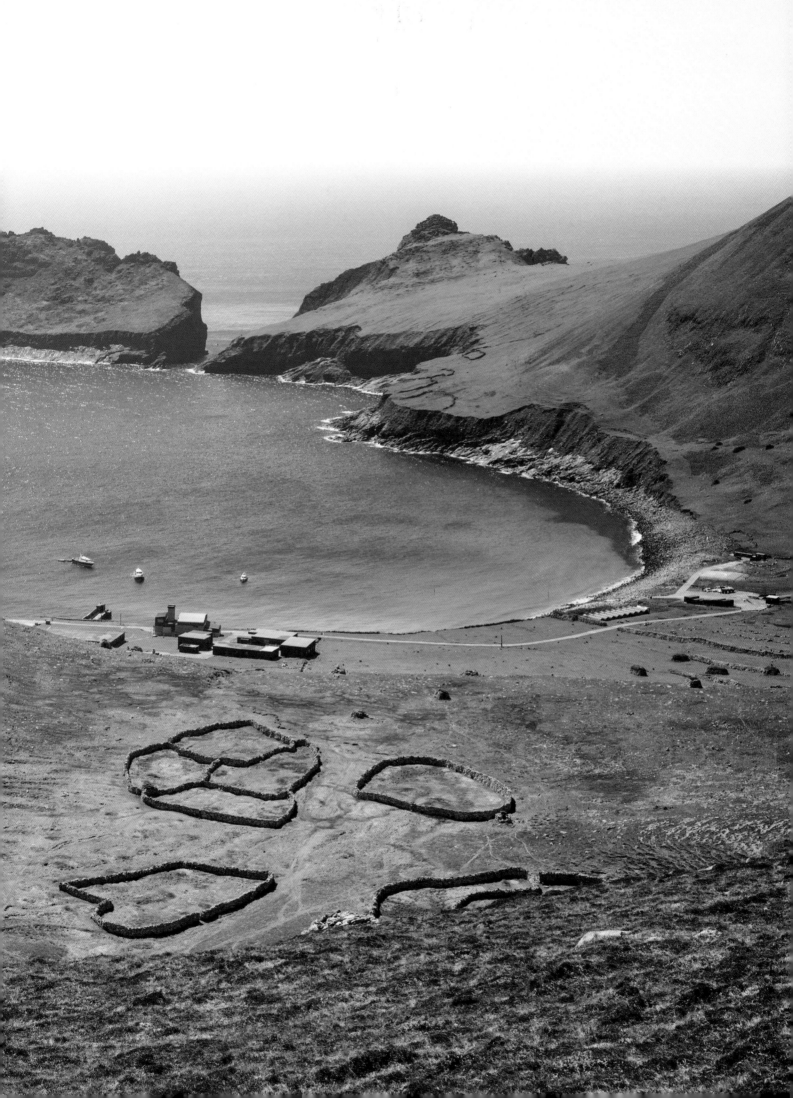

ALL PHOTOGRAPHS:
Devenish, Northern Ireland
St Molaise founded a monastery on Devenish, in Lower Lough Erne, in the 6th century. The oldest ruins on the island date from that period, while the latest are from the early 16th century, when St Mary's Augustinian Priory was completed. The 12th-century Romanesque round tower (pictured right) served as a belfry.

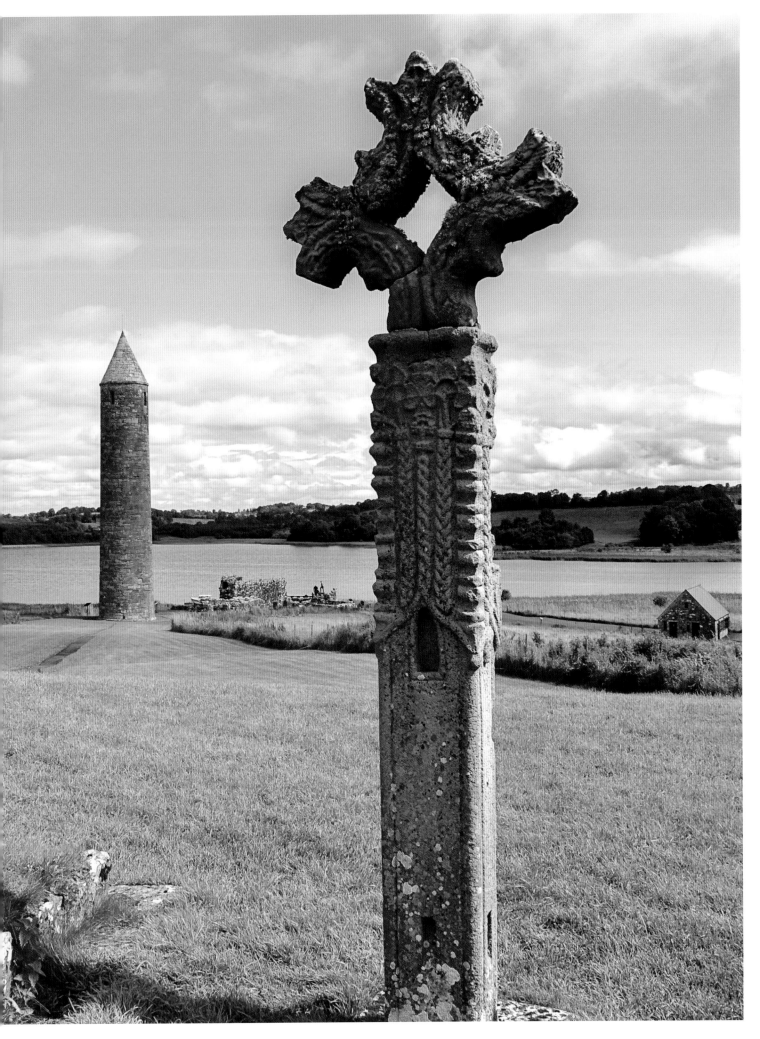

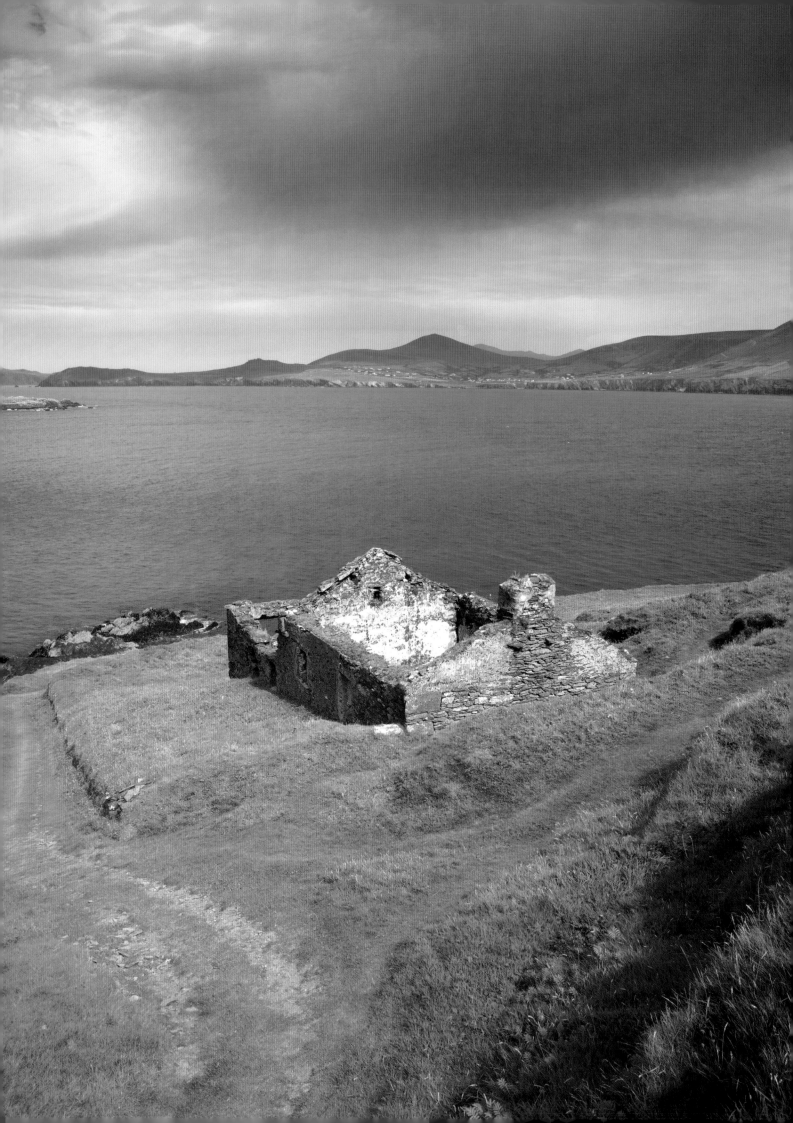

OPPOSITE:
Great Blasket, Ireland

By 1953, the population of the Blasket Islands had fallen from a peak of 175 to just 22. The islands were increasingly cut off from the mainland and emergency services by worsening weather, leading the remaining residents to request evacuation to the mainland. The author Muiris Ó Súilleabháin wrote about his early life on Great Blasket in *Fiche Blian ag Fás* ('Twenty Years A-Growing') in 1933.

BELOW TOP AND BOTTOM:
Innisfallen, Ireland

On County Kerry's Lough Leane, Innisfallen is the site of the ruined Innisfallen Abbey, which was occupied for around 950 years after its founding in 640. The oldest buildings on the island, carved in places with the faces of humans and animals, date from the 10th century. In the 11th century, a monk of Innisfallen started to compile the *Annals of Innisfallen*, which chronicles the history of Ireland.

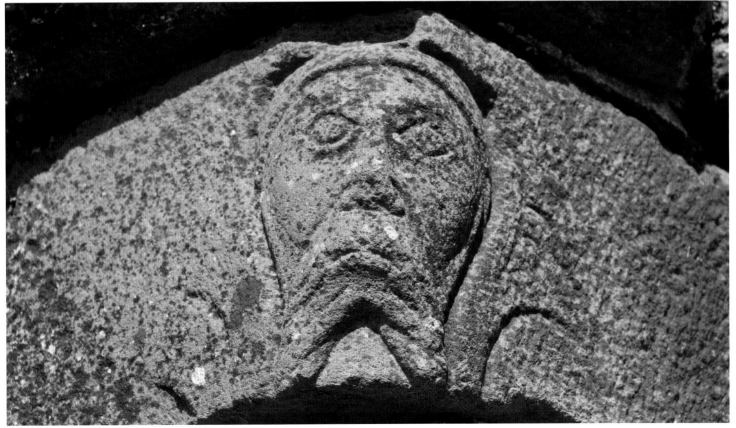

Inishmurray, Ireland

Inishmurray was the site of a monastic settlement (pictured), founded in the 6th century and abandoned in the early 9th century after an onslaught of Viking attacks. The monastery's wall, 3m (9.8ft) thick and 4.5m (14.8ft) high, surrounded an oratory, churches and a *clochán*, a round beehive-shaped hut used as a dwelling. Later secular dwellings on the island were all abandoned by 1948.

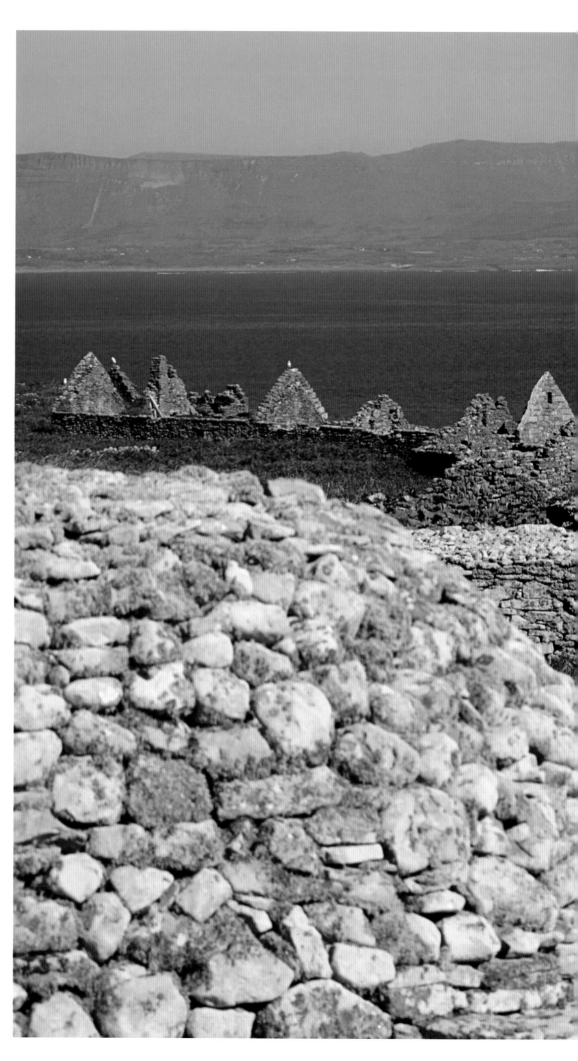

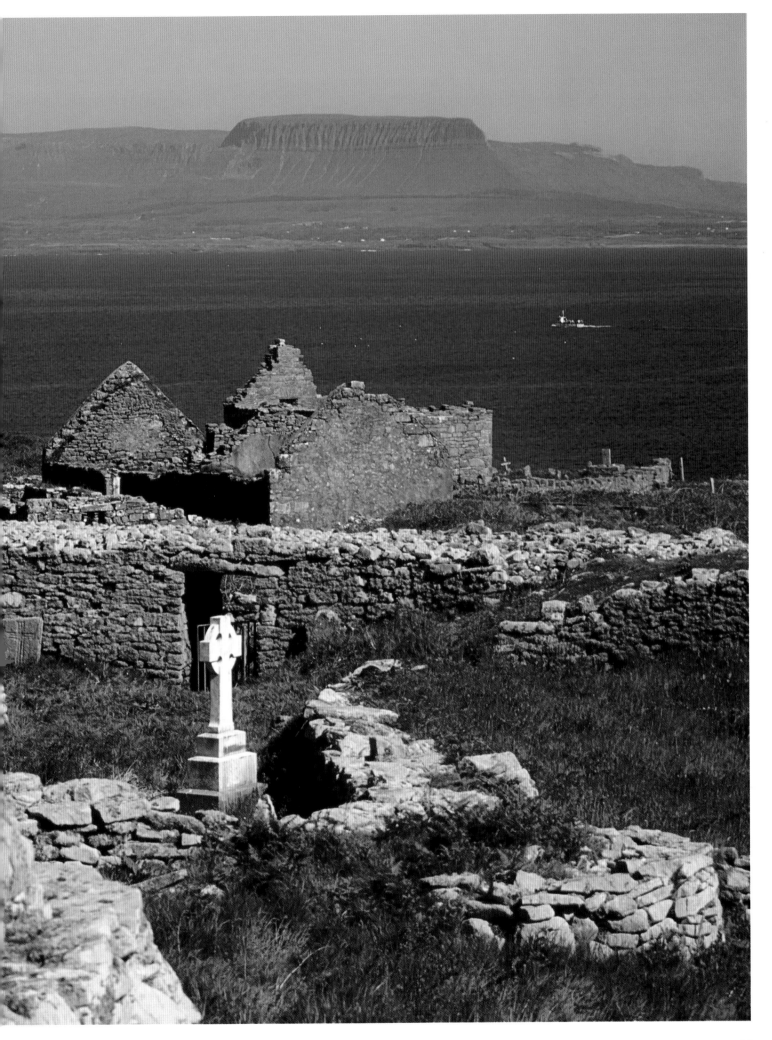

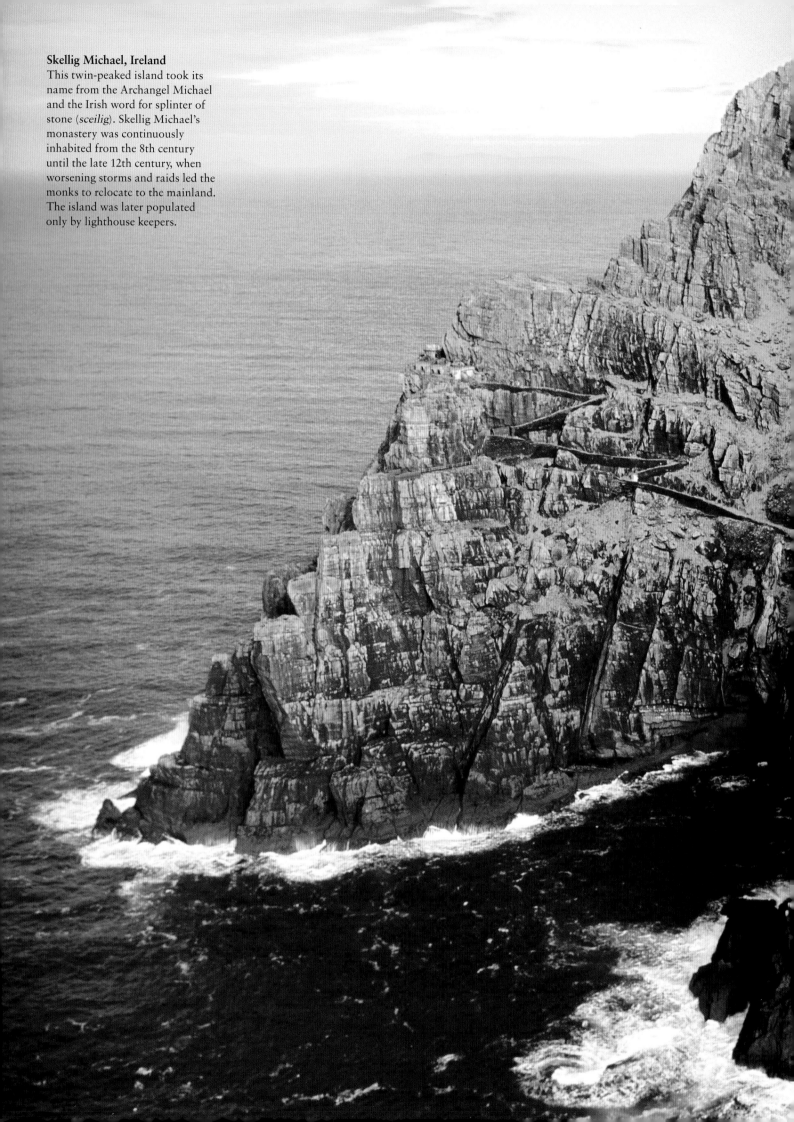

Skellig Michael, Ireland
This twin-peaked island took its name from the Archangel Michael and the Irish word for splinter of stone (*sceilig*). Skellig Michael's monastery was continuously inhabited from the 8th century until the late 12th century, when worsening storms and raids led the monks to relocate to the mainland. The island was later populated only by lighthouse keepers.

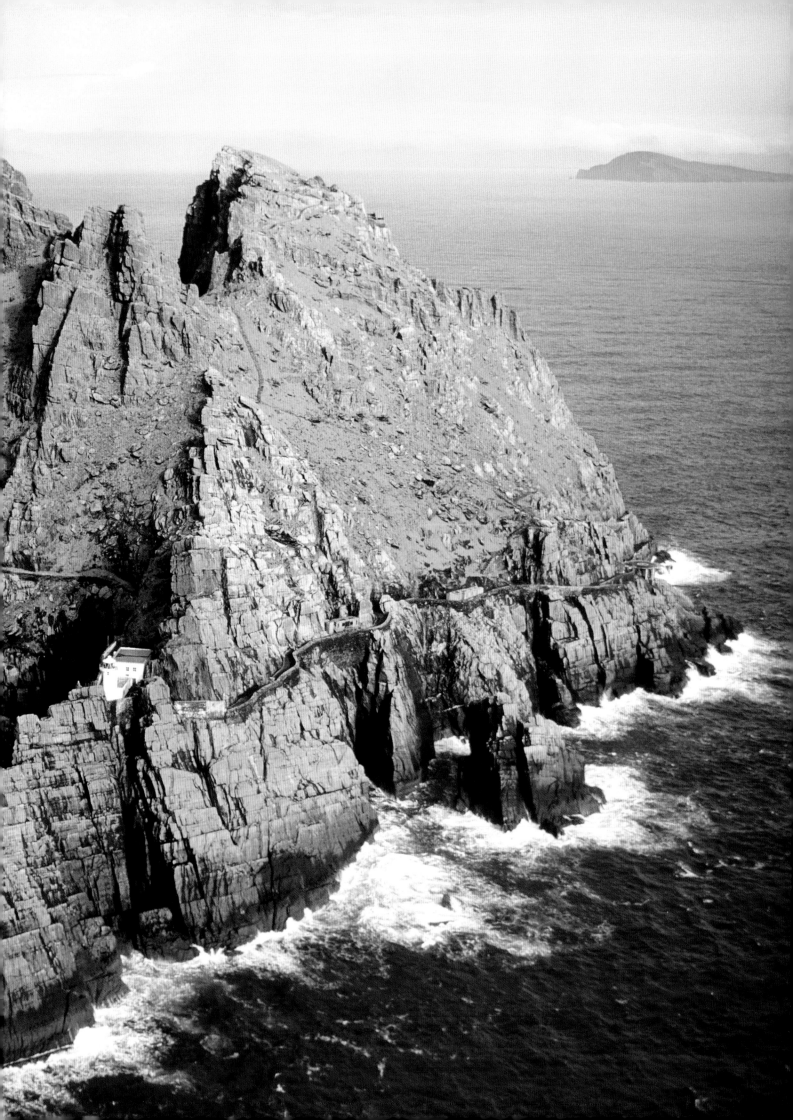

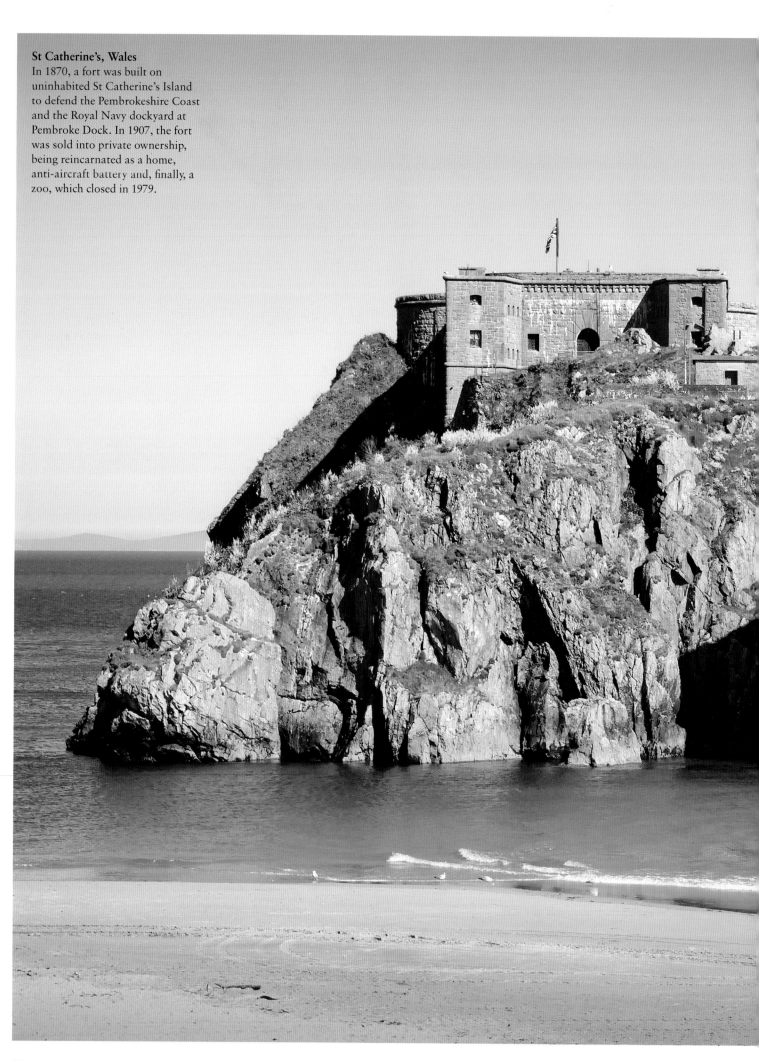

St Catherine's, Wales
In 1870, a fort was built on
uninhabited St Catherine's Island
to defend the Pembrokeshire Coast
and the Royal Navy dockyard at
Pembroke Dock. In 1907, the fort
was sold into private ownership,
being reincarnated as a home,
anti-aircraft battery and, finally, a
zoo, which closed in 1979.

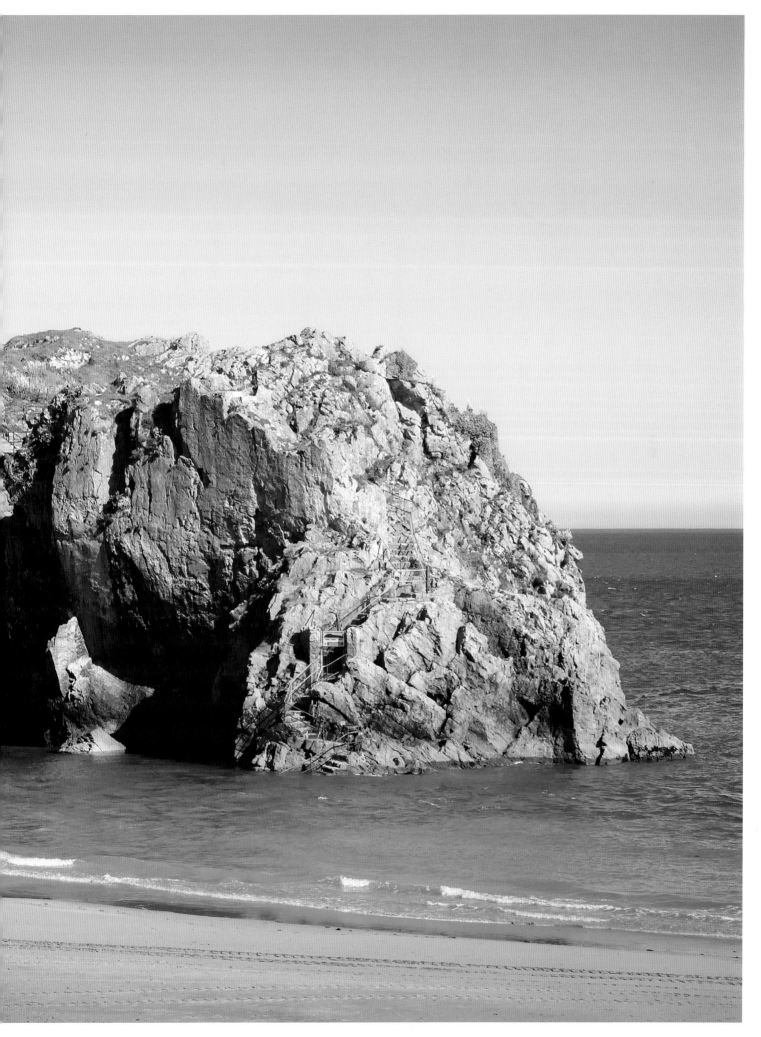

Stack Rock Fort, Wales
Completed in 1852, Stack Rock
Fort (pictured right) in the Milford
Haven Waterway was designed
to protect Pembroke Dock. Since
being disarmed in 1929, the fort
has been privately owned. Nearby
Thorne Island (pictured left and
over the page) hosts a sister fort
dating from the same period.

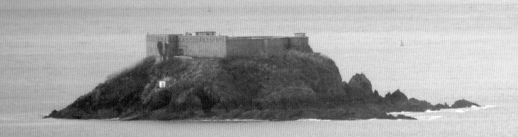

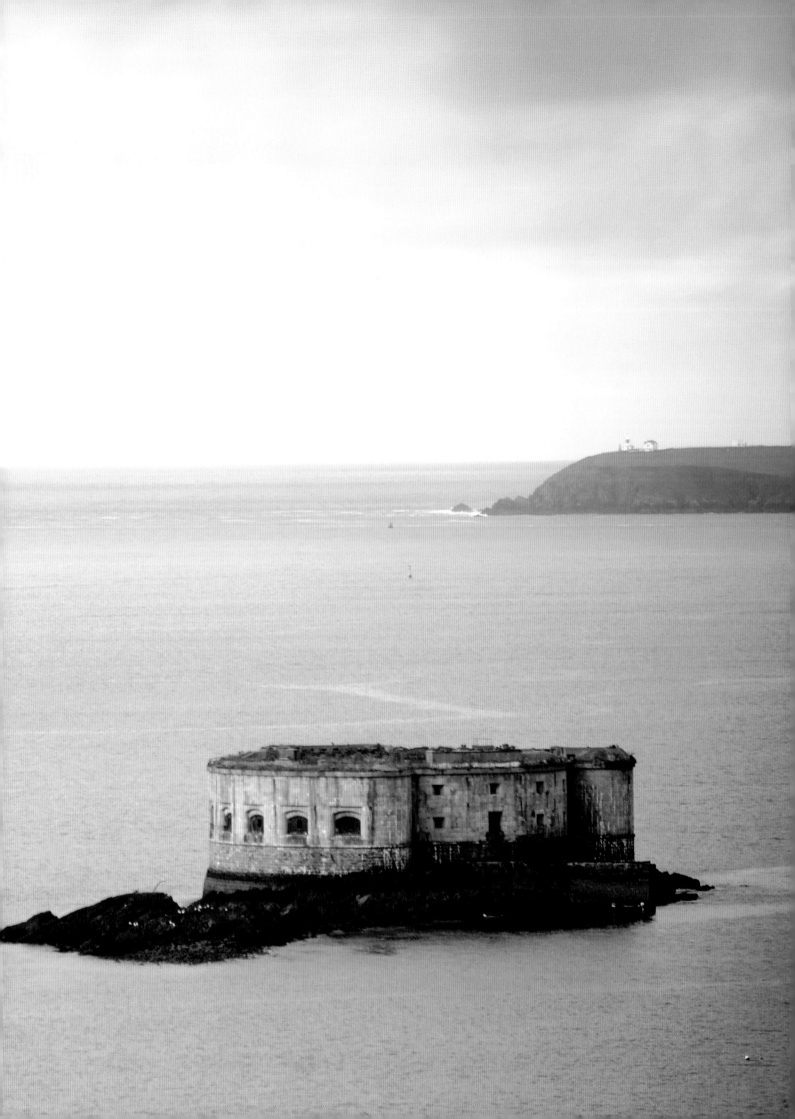

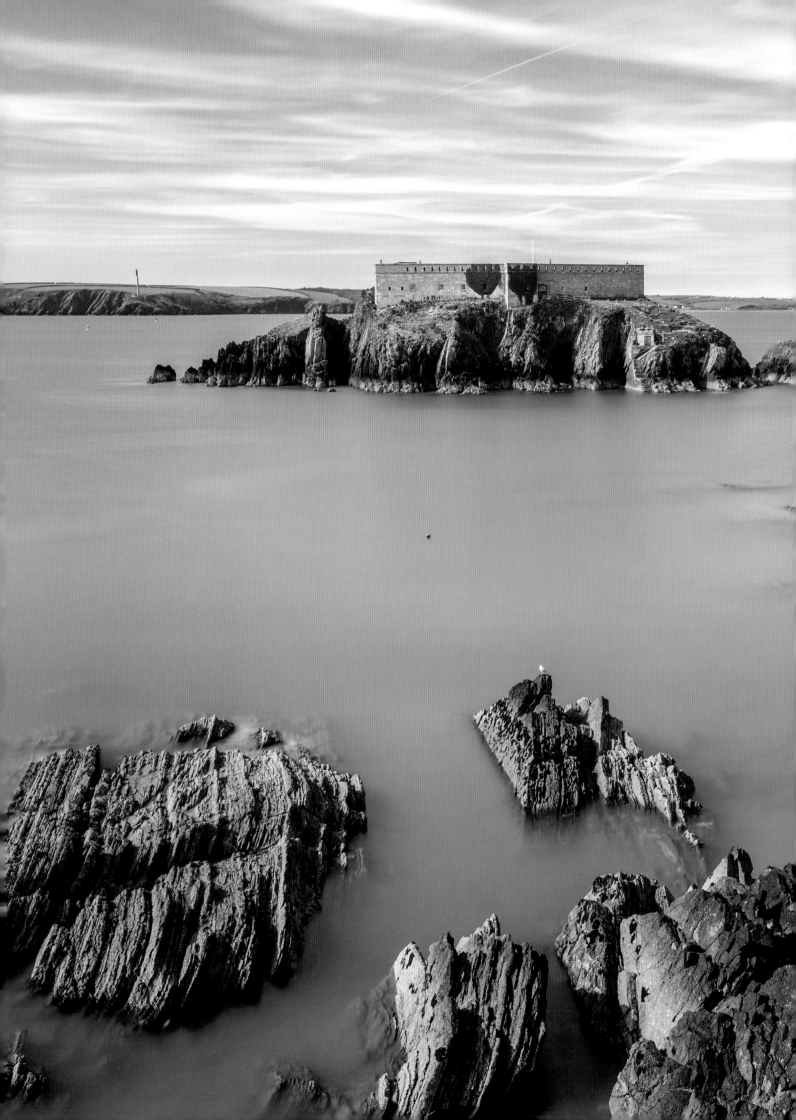

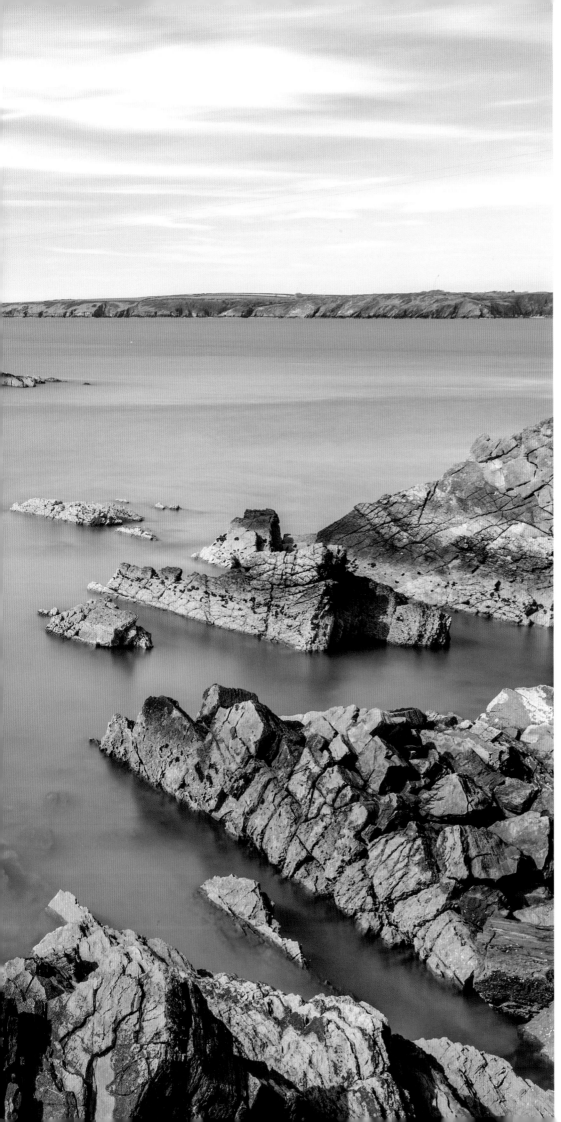

Thorne Island Fort, Wales
Thorne Island is dominated by a polygonal Napoleonic fort dating from 1854. The fort was converted into a hotel in 1947. Since 1999, the island has changed hands several times, due to the cost and difficulty of making the off-grid, hard-to-reach building suitable for 21st-century guests. At the time of writing, there were plans to re-open the fort as a hotel again.

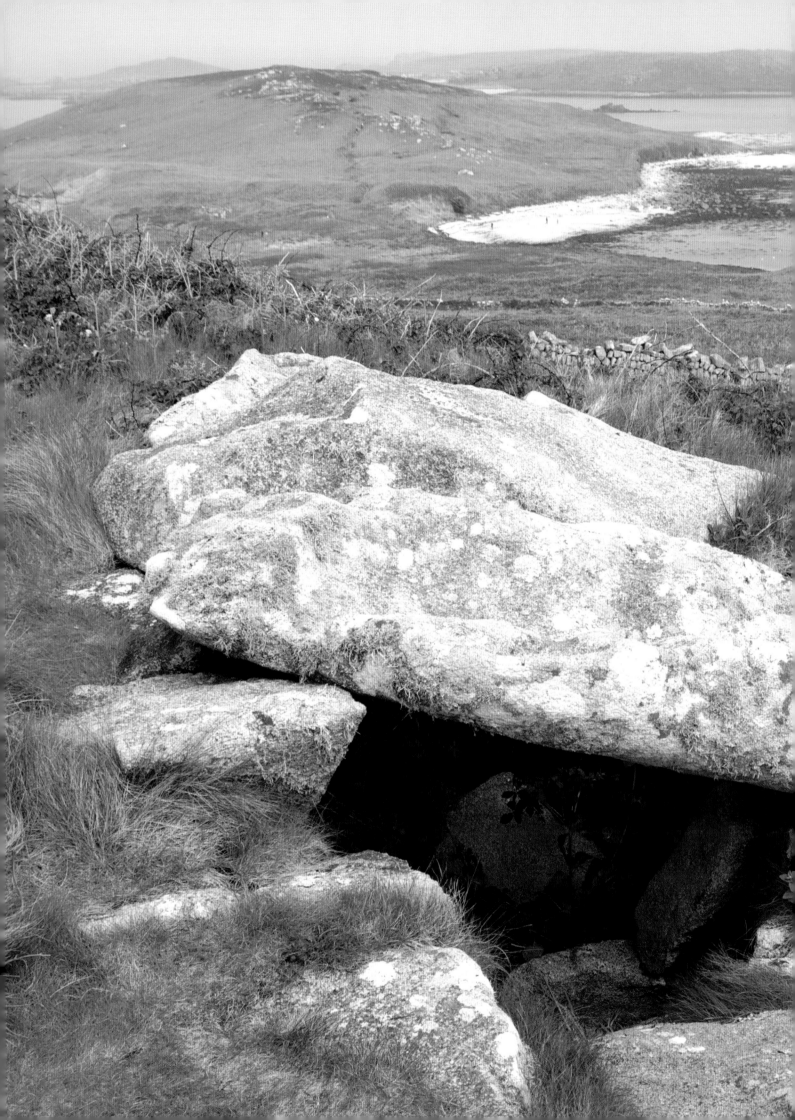

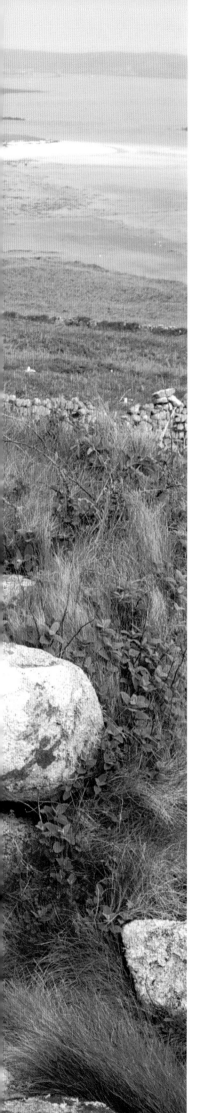

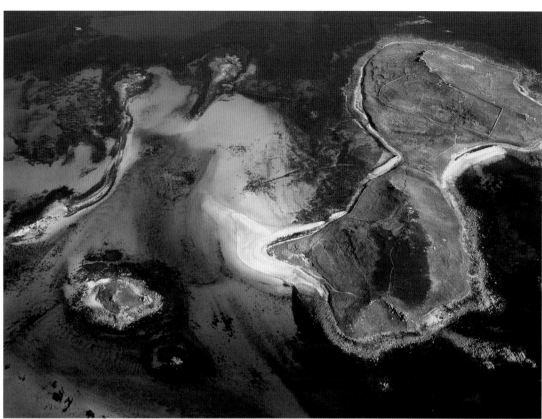

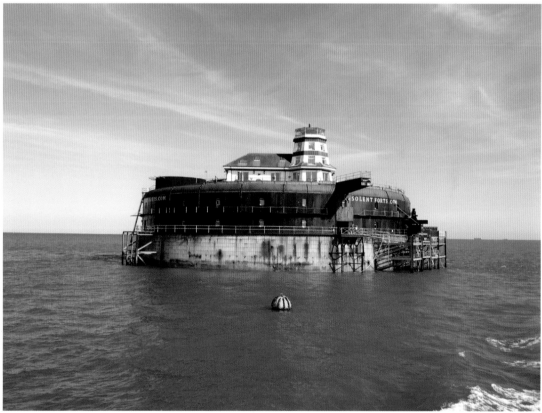

LEFT AND ABOVE TOP:

Samson, Isles of Scilly, England
In 1855, Samson's two remaining
families – suffering from
malnutrition due to a diet of
potatoes and limpets – were
relocated to St Mary's Island.
Habitation of Samson dates to the
Bronze Age, when numerous burial
chambers were constructed.

ABOVE:

No Man's Land Fort, England
Begun in 1865 but not completed
until 1880, this fort in the Solent
was intended to defend the south
coast against French invasion.
Although the fort has endured
periods of disuse, since 2015 it
has been serving as a luxury hotel,
complete with helipad.

OVERLEAF:

Cézembre, France
Off the Brittany coast, Cézembre
has been the site of a monastery,
quarantine hospital and garrison.
Today, there is only a restaurant
for daytrippers. Until 2017, much
of the island was off-limits as it
had not been demined after the
Allied bombardment of 1944.

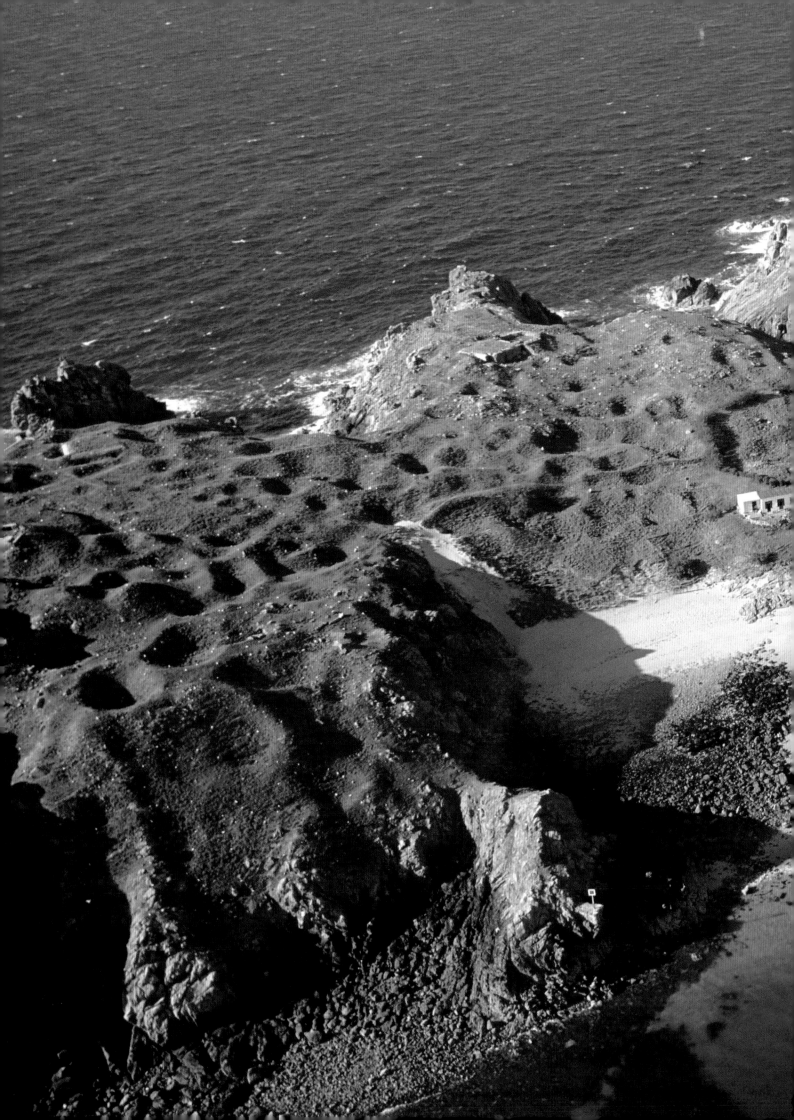

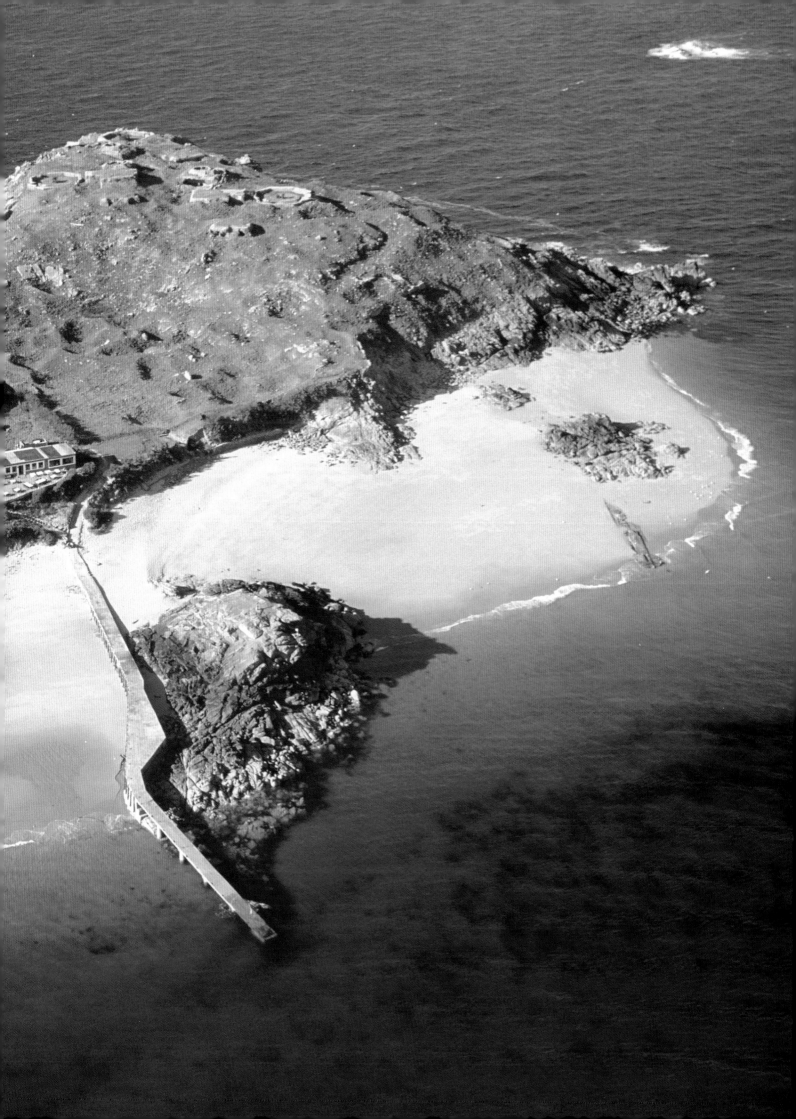

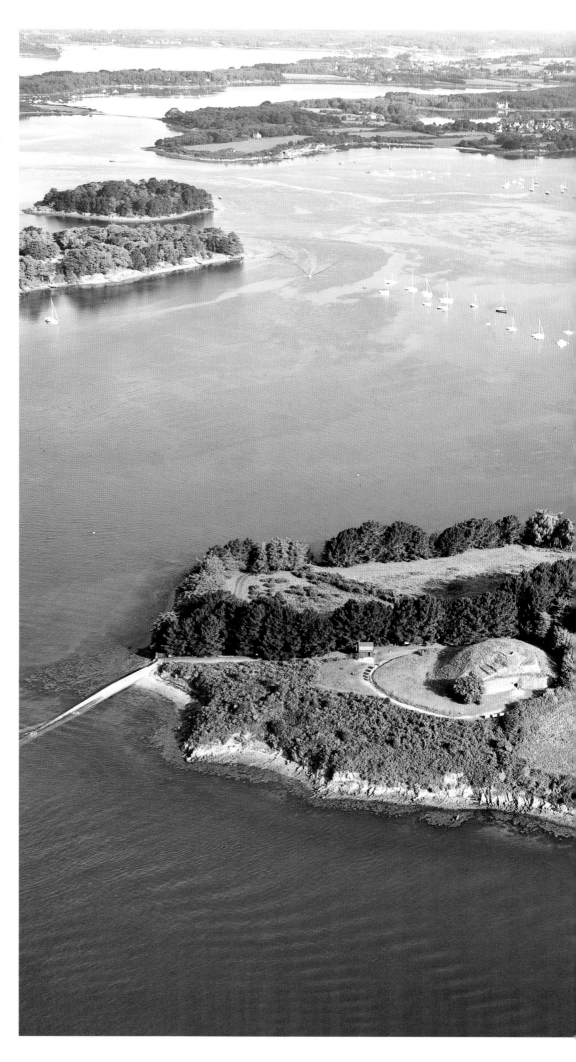

RIGHT AND OVERLEAF:
Gavrinis, France
The island of Gavrinis lies in
Britanny's Gulf of Morbihan.
It is home to a passage grave
constructed in around 3,500 BCE,
when the island was connected to
the mainland. The dry-stone cairn
contains a central burial chamber
reached by a passage carved with
designs including wiggling lines,
zigzags and symbols that may
represent axes and cattle.

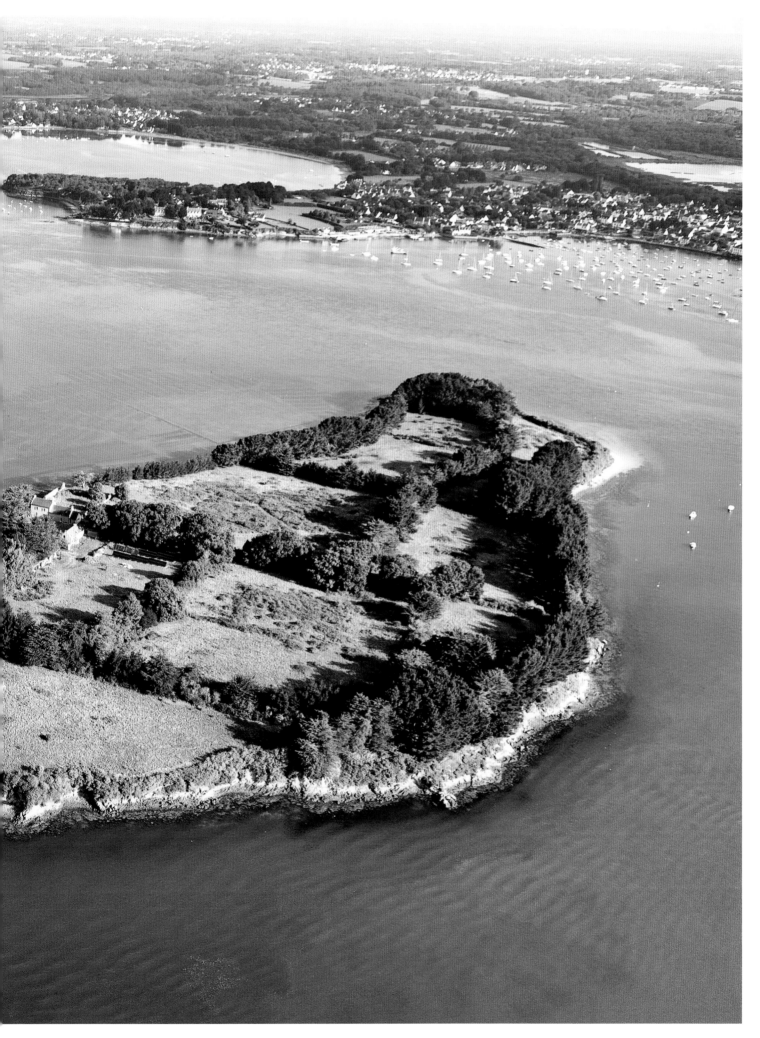

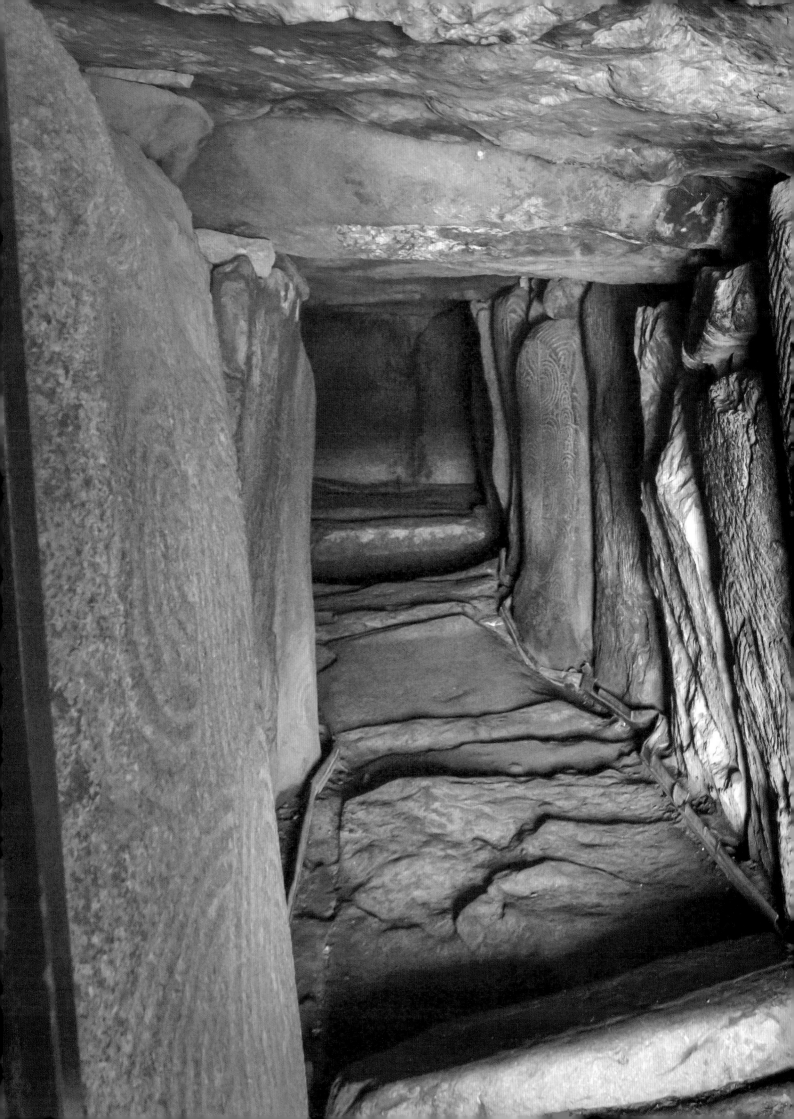

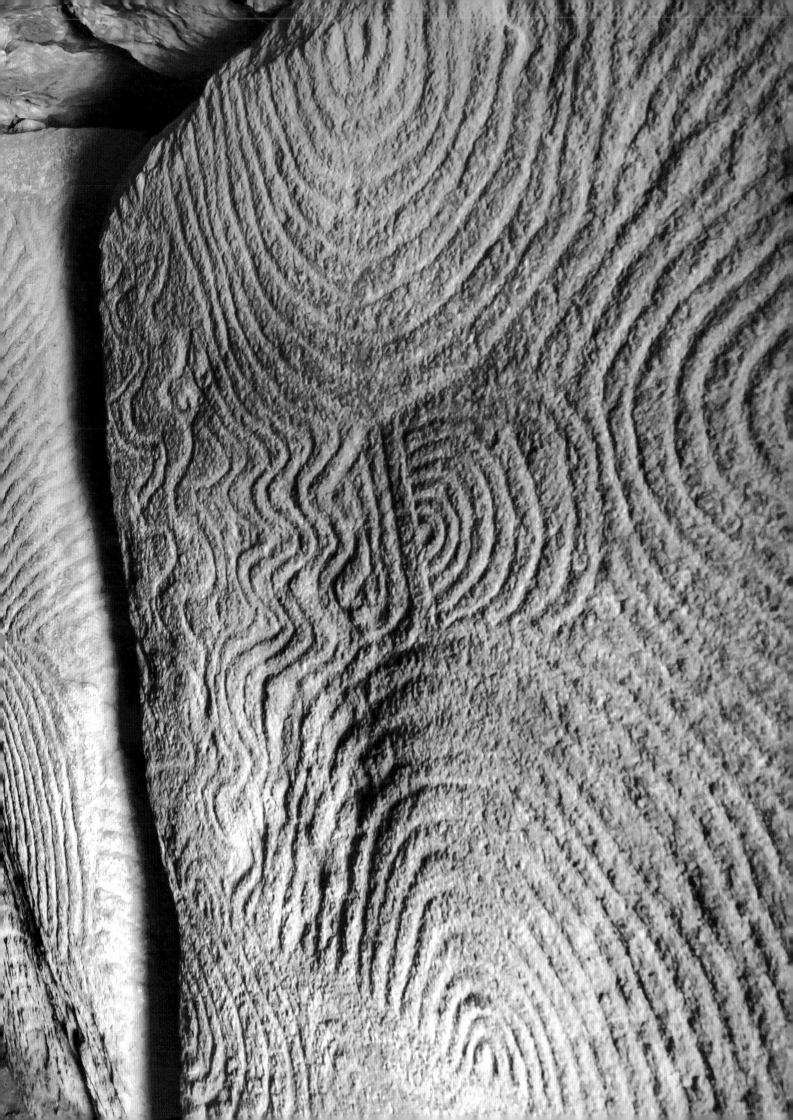

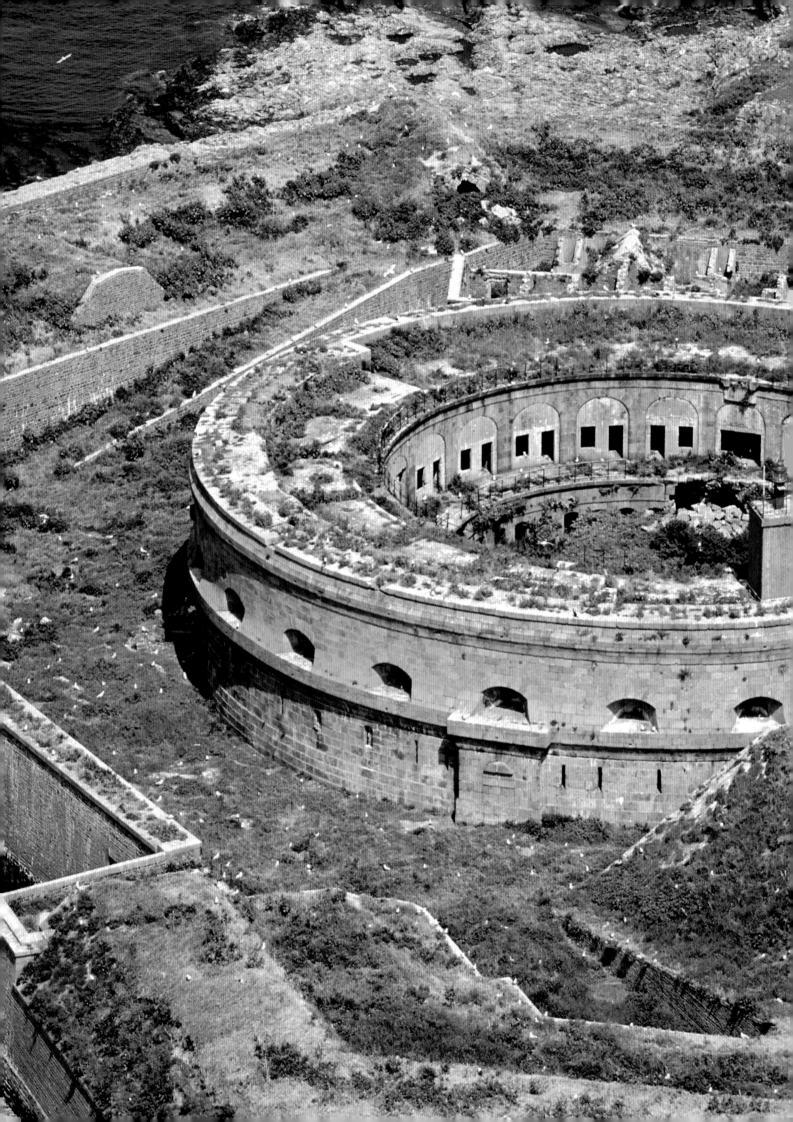

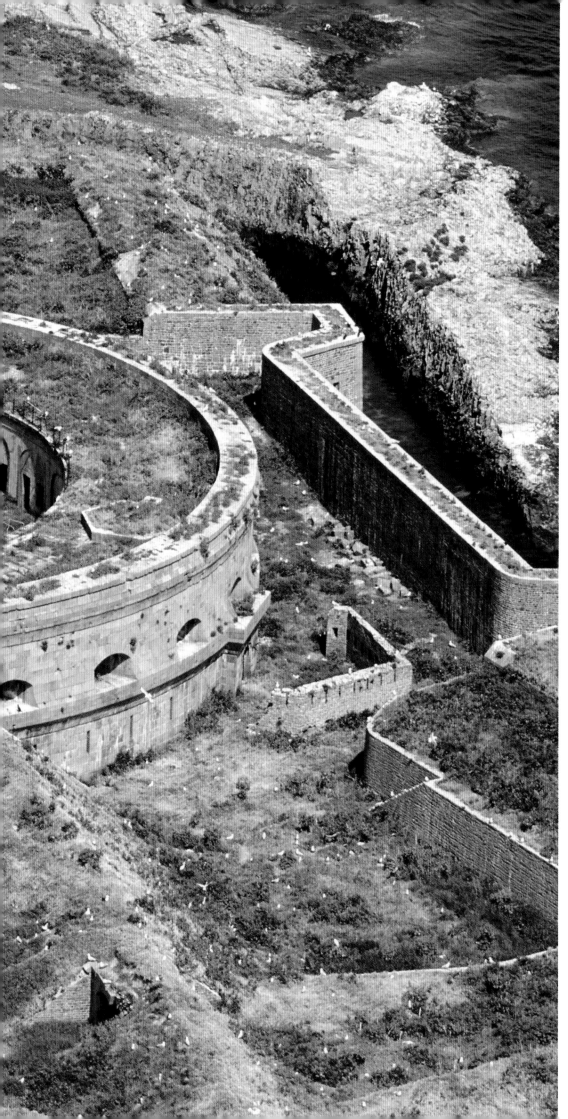

**Île du Large,
Îsles St-Marcouf, France**
After Britain returned the Norman Îsles St-Marcouf to France in 1802, Napoléon Bonaparte ordered that they be fortified. Île du Large's circular fort, with a diameter of 53m (174ft), was able to accommodate 500 soldiers. During World War II, these islands became the first French soil taken by the Allies on D-Day, at 4.30am on 6 June 1944.

RIGHT:
Dragonera, Balearic Islands, Spain

Its profile resembling a crouching dragon, Dragonera has been uninhabited since the 1970s. The Tramuntana lighthouse (pictured) is one of the island's two automated lights. Dragonera was formerly the site of a Roman necropolis, defensive watchtowers and, most recently, a farm. Today, it is a nature park.

ALL PHOTOGRAPHS OVERLEAF:
Gaiola, Italy

According to the citizens of Naples, the island of Gaiola – just a few metres from the city's coast – is cursed. This reputation was gained by the tragedies that befell the 20th-century owners of the island's villa. These included Jean Paul Getty, who endured the deaths of two sons and the kidnapping of a grandson; Hans Braun and Otto Grunback, who both died on the island; and Gianpasquale Grappone, who was sent to prison for debt. Not surprising, the island is today owned by the government of Campania.

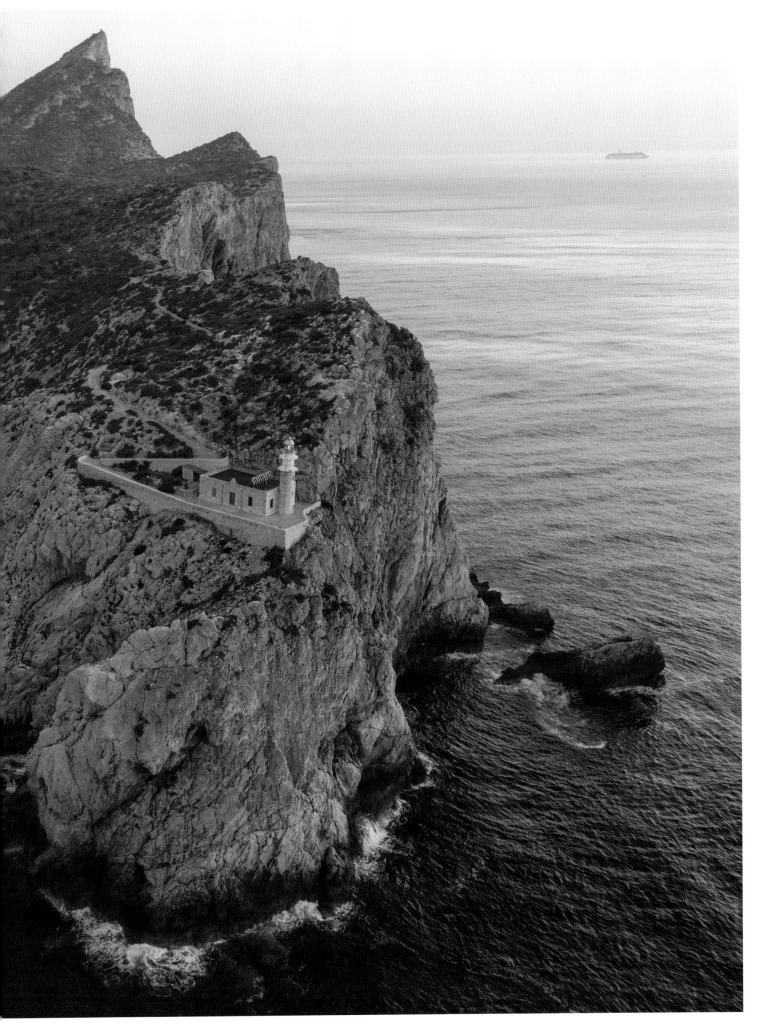

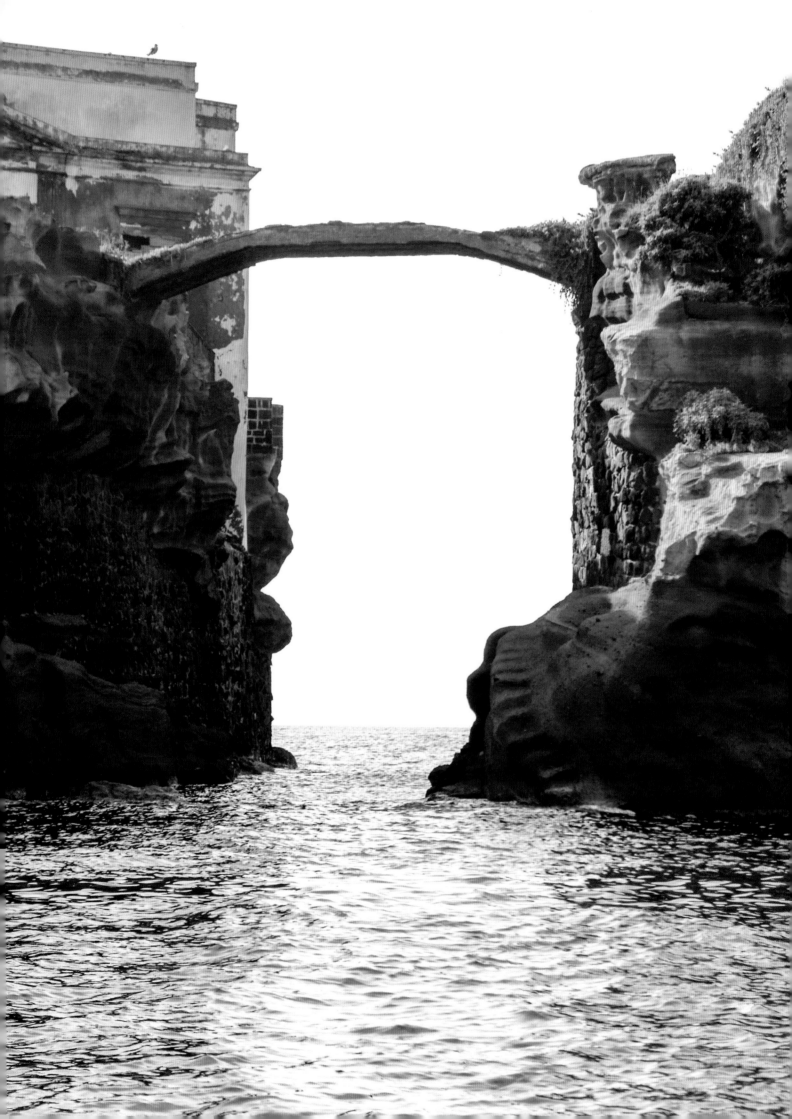

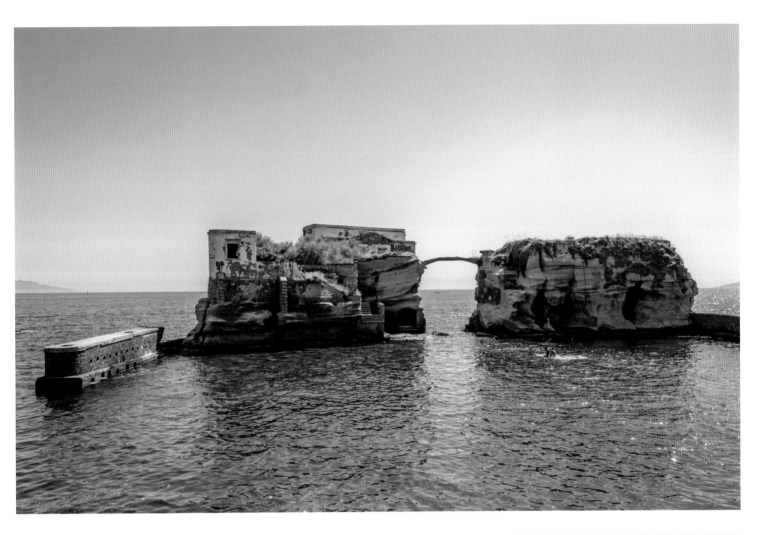

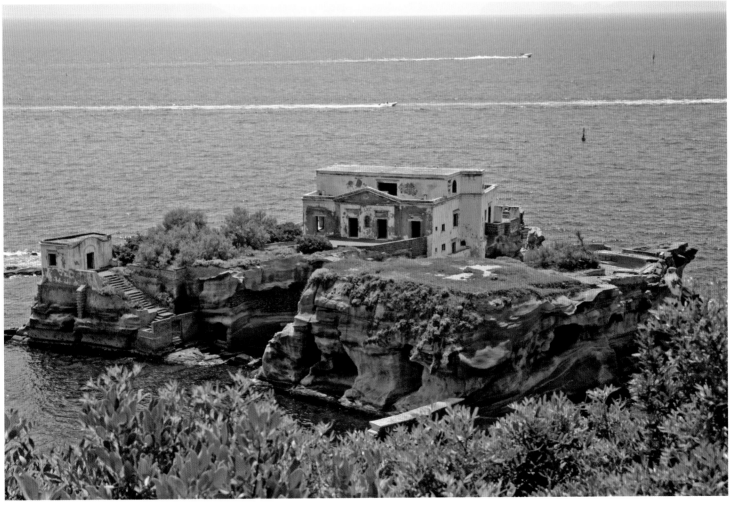

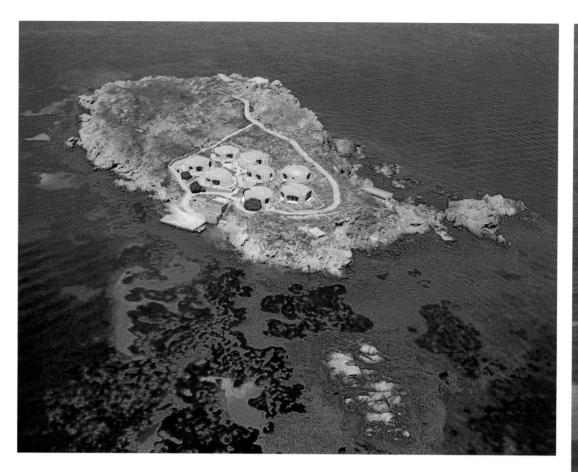

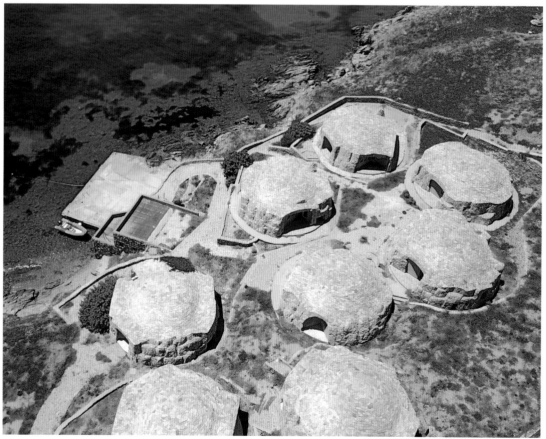

ALL PHOTOGRAPHS:
Isola dei Cappuccini, Sardinia, Italy
'Capuchin Island' takes its name from the abandoned monastery that
stands on the island's highest ground. Seeking to return to a simpler
way of life, of solitude and penance, Capuchin friars started to build
communities in Sardinia from 1591. Today, Isola dei Cappuccini boasts
eight circular bungalows used as holiday rentals.

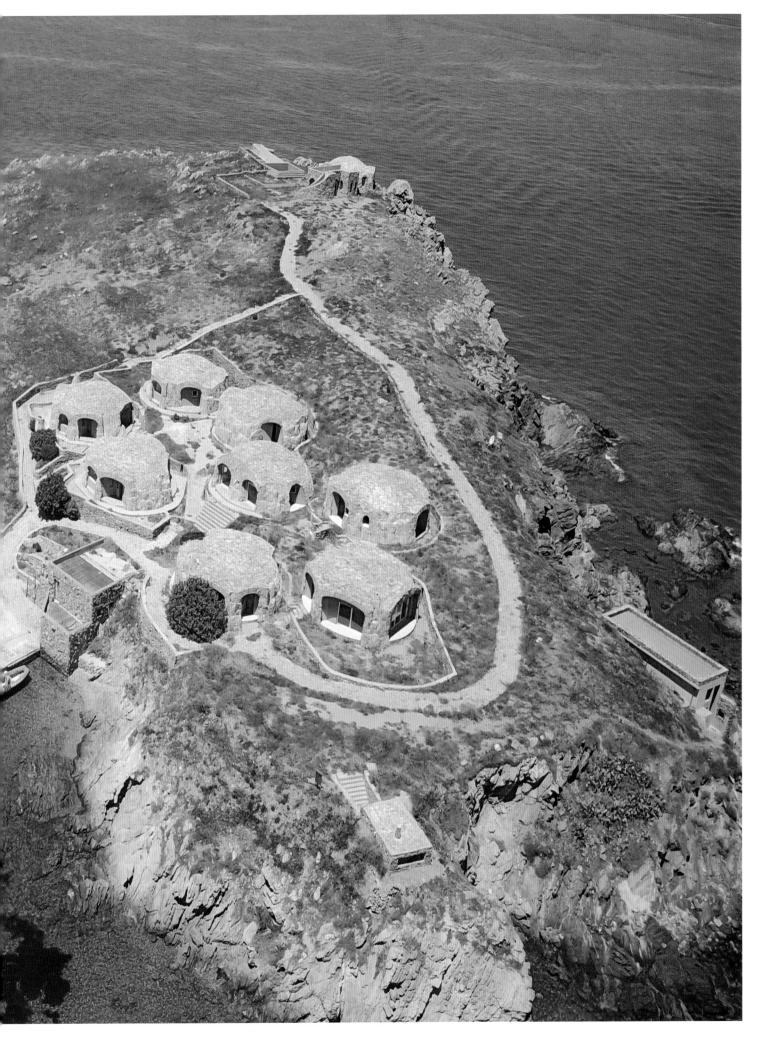

Isola delle Correnti, Sicily, Italy
At the southernmost tip of Sicily, the 'Island of Currents' has been uninhabited since its lighthouse, built in 1865, was automated. At low tide, the island can be reached by wading from the mainland, where international surfing competitions are held on the wind-whipped beach.

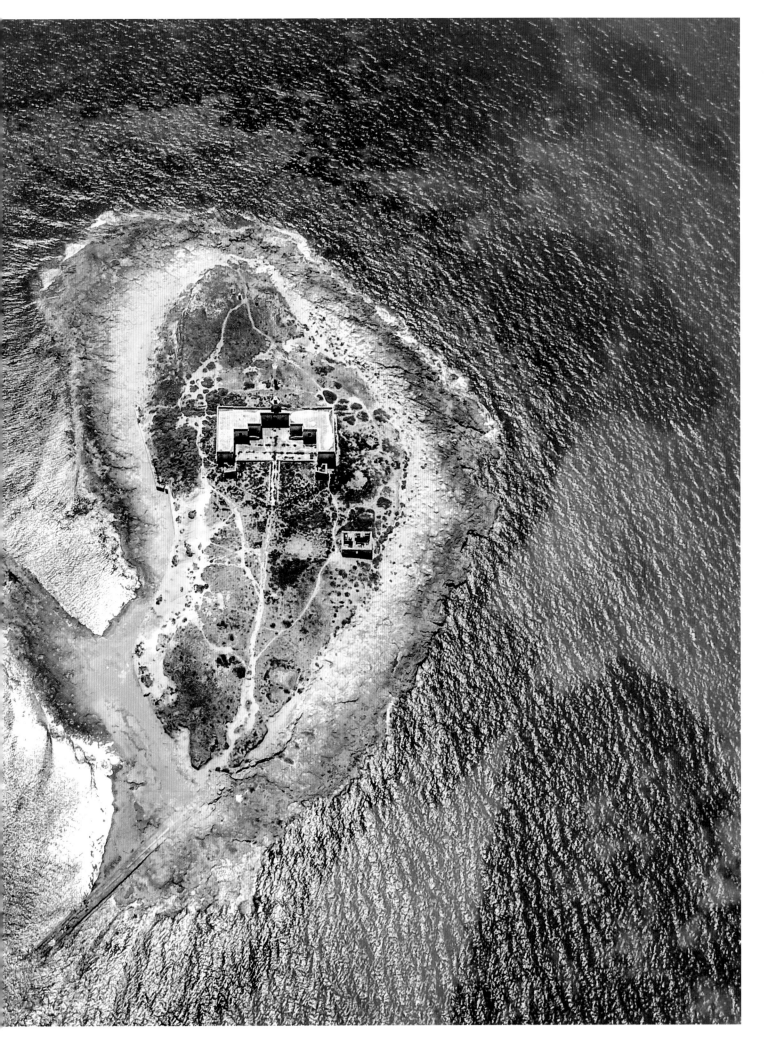

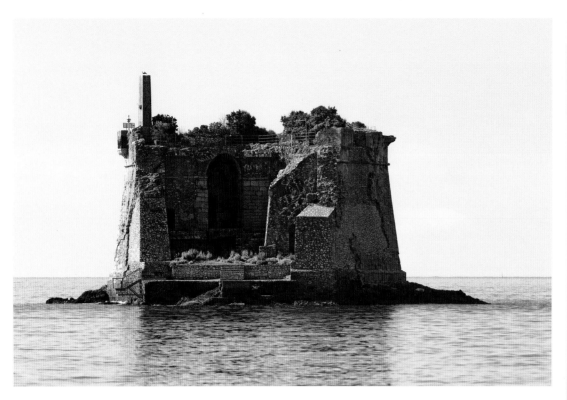

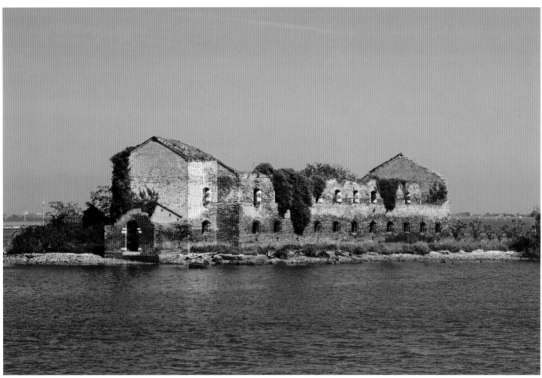

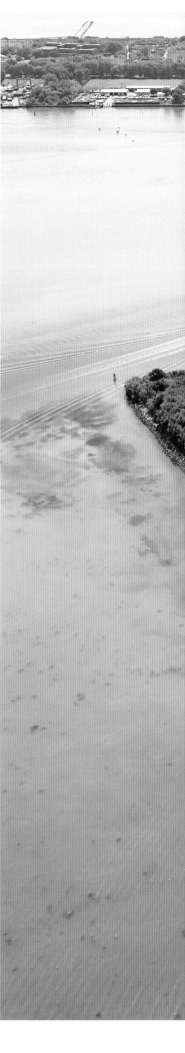

ABOVE TOP:
Torre Scola, Italy
During the 17th century, this pentagonal tower was built on a tiny islet to defend the Republic of Genoa. The tower was damaged by the British in 1800 and, later, by the Italian Navy's target practice. In the 1920s, the tower was converted for use as a lighthouse, today powered by a solar unit.

ABOVE:
Madonna del Monte, Italy
In the Venetian Lagoon, Madonna del Monte is actually two islets once joined by a dammed strip of land. On the larger islet stands the remains of a 19th-century gunpowder magazine, built on the site of a medieval monastery. Waves from traffic on the lagoon are eroding the islet year by year.

RIGHT:
Poveglia, Italy
The Venetian island of Poveglia was heavily populated until 1379, when its inhabitants moved to nearby Giudecca during attacks by Genoa. In the 19th century, the island was a quarantine station. In 1922, the hospital buildings were converted into an asylum, which closed in 1968.

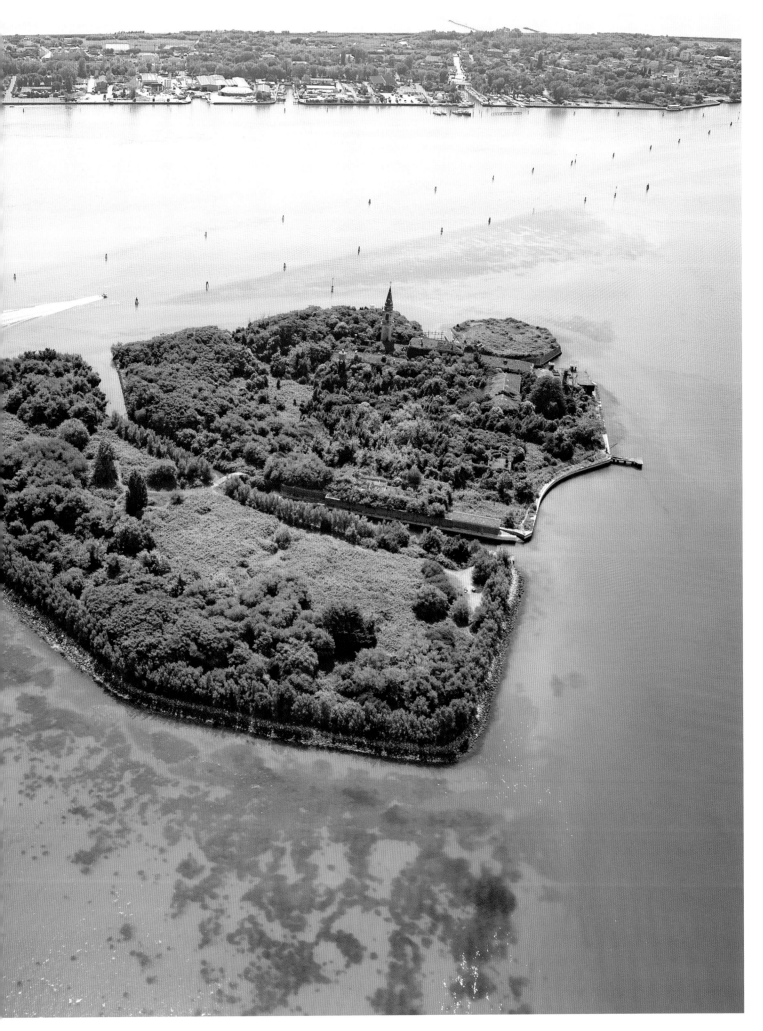

Comino, Malta
Named for the cumin once grown here, the 3.5 sq km (1.4 sq mile) island of Comino has two permanent residents, although the population is swelled in summer by visitors to the island's hotel. Disused buildings on the island were previously a barracks, an isolation hospital, a prison, a battery and place of exile for errant Knights of Malta.

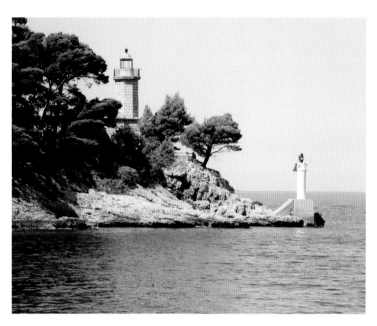

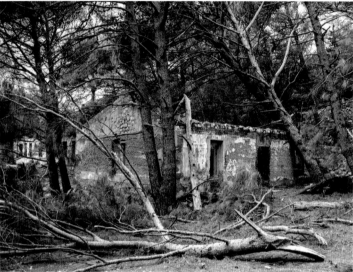

ABOVE TOP:
Daksa, Croatia
This small island was the site of the Daksa massacre of 1944, the execution of 53 Dubrovnik citizens accused of collaborating with the Nazis during World War II. Despite the island's proximity to the tourist haven of Dubrovnik, its lighthouse, 13th-century monastery and 19th-century villa are rarely visited.

ABOVE:
Sveti Grgur, Croatia
During the days of the Socialist Federal Republic of Yugoslavia, Sveti Grgur was the location of a women's prison, which closed in 1986. Before the prison was built, largely by the inmates themselves, the island was home to a small village, its community living by mining bauxite, hunting deer and grazing sheep.

RIGHT:
Sveti Andrija, Croatia
In the Elaphiti Islands, Sveti Andrija is crowned with a 19th-century lighthouse, its powerful light visible for 44km (28 miles). The island was formerly home to poet Mavro Vetranovic (1482–1576), who wrote about his time in the island's monastery in *Remeta*: 'For penance there is a cave, Where there are rocks and cliffs, Where there are stones and mounds, Where lizards lie.'

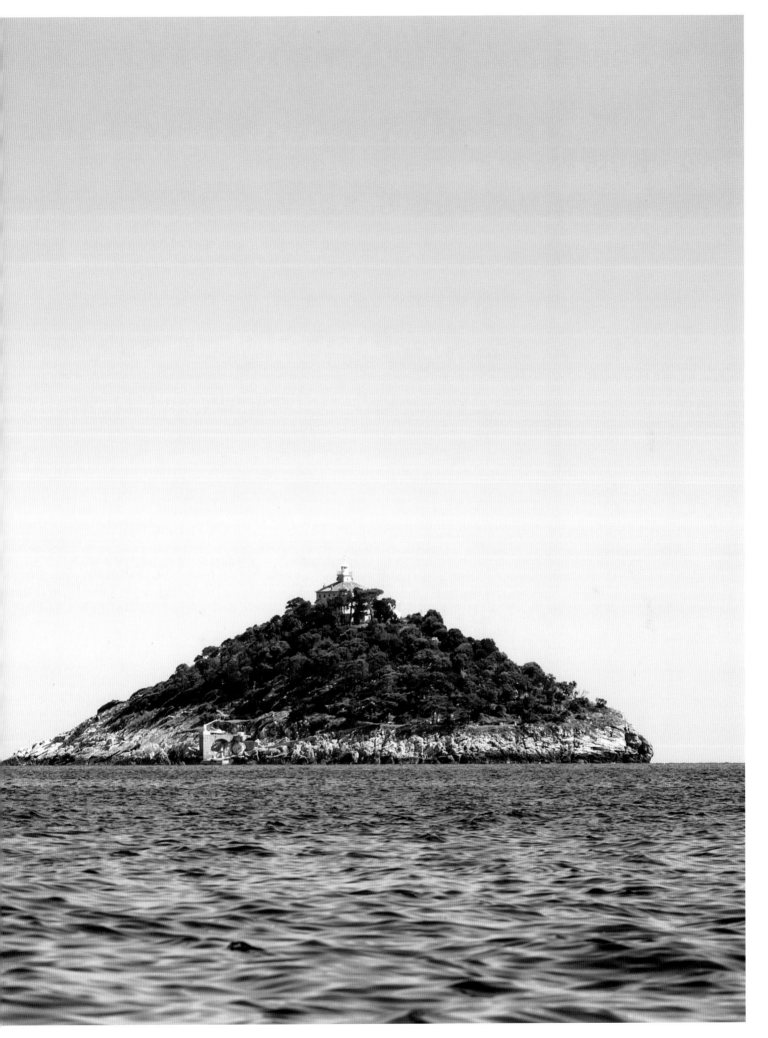

Baljenac, Croatia
Resembling a fingerprint when viewed from the air, Baljenac has 23km (14 miles) of dry stone walls, known as *suhozid*. For hundreds of years, the inhabitants of the nearby island of Kaprije used Baljenac for farming, constructing the walls to divide their vines, figs and olive trees, and to protect them from the wind.

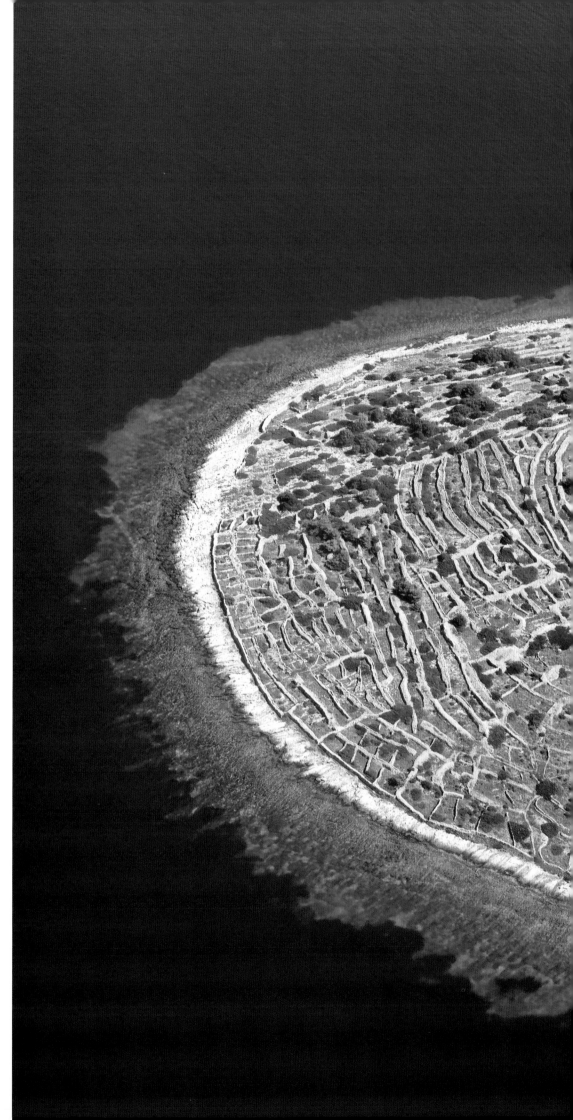

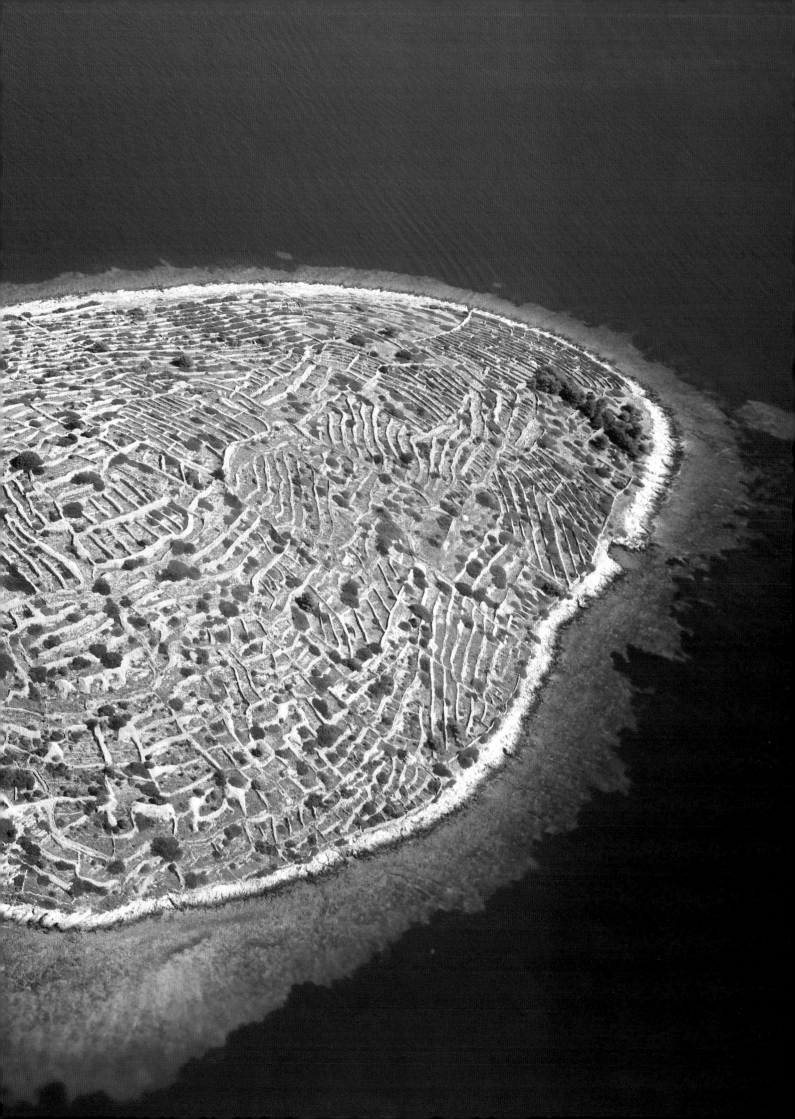

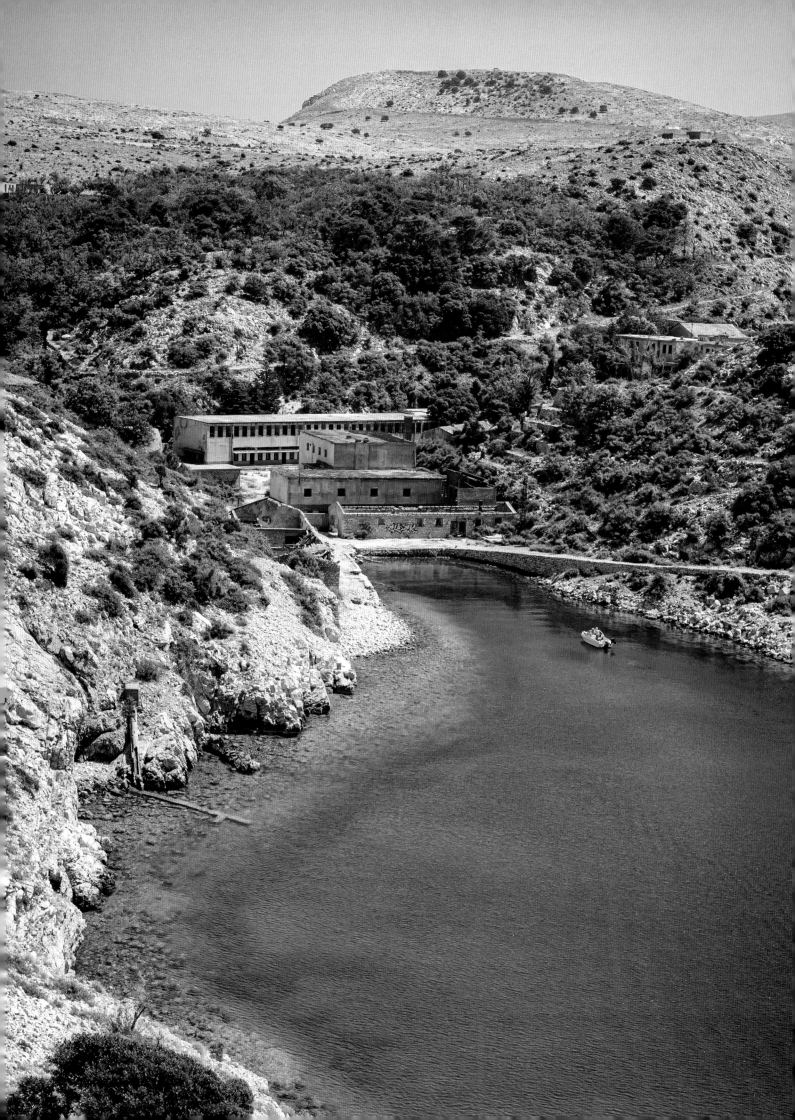

ALL PHOTOGRAPHS:
Goli Otok, Croatia
'Barren Island' was the location of a men's political prison from 1949 to 1988. The inmates endured forced labour and were pressured to beat, denounce and humiliate each other. Of the 16,000 political prisoners who were housed here over the years, it is believed around 600 died. Serbian author Antonije Isakovi wrote the bestseller *Tren 2* about his time in the prison.

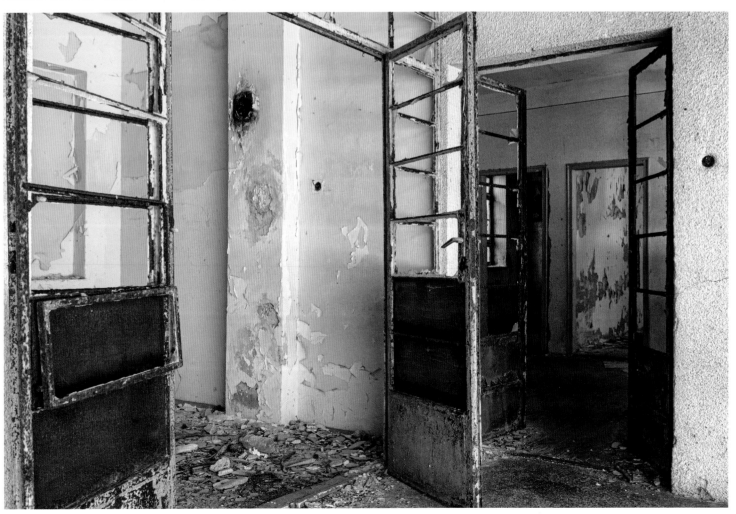

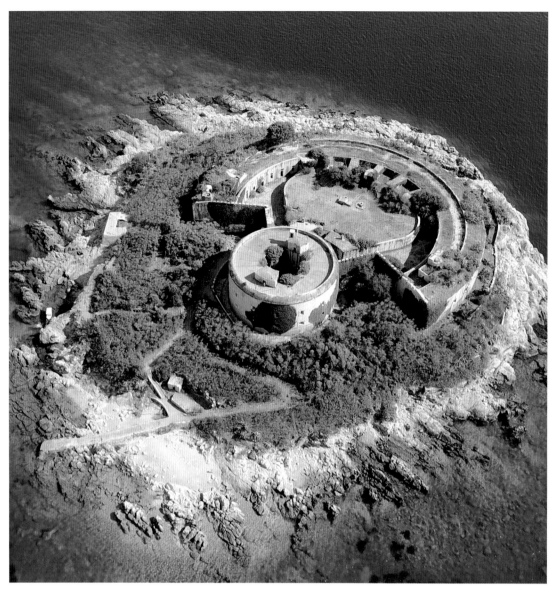

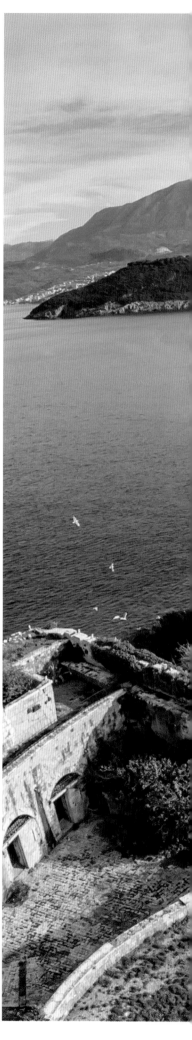

ABOVE AND RIGHT:

Mamula, Montenegro
This islet's fort was built in 1853 by Austro-Hungarian general Lazarus von Mamula to defend the Bay of Kotor. During World War II, the fort was used as an internment camp by Benito Mussolini's fascist forces. At the time of writing, there were plans to turn Mamula into a hotel.

OVERLEAF:

Delos, Greece
Inhabited since the 3rd millennium BCE, Delos became a major place of pilgrimage between 900 BCE and 100 CE. Its landmarks included temples, marketplaces, theatres, homes and a monumental avenue lined with statues of snarling lions. The island was abandoned in the 8th century.

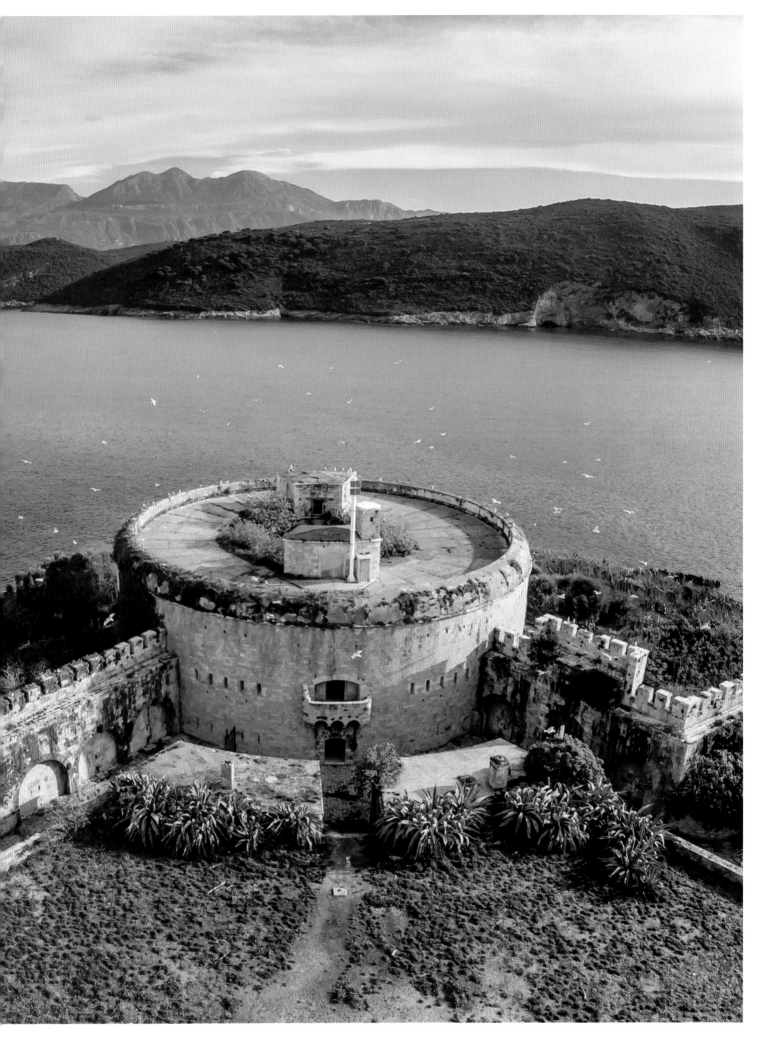

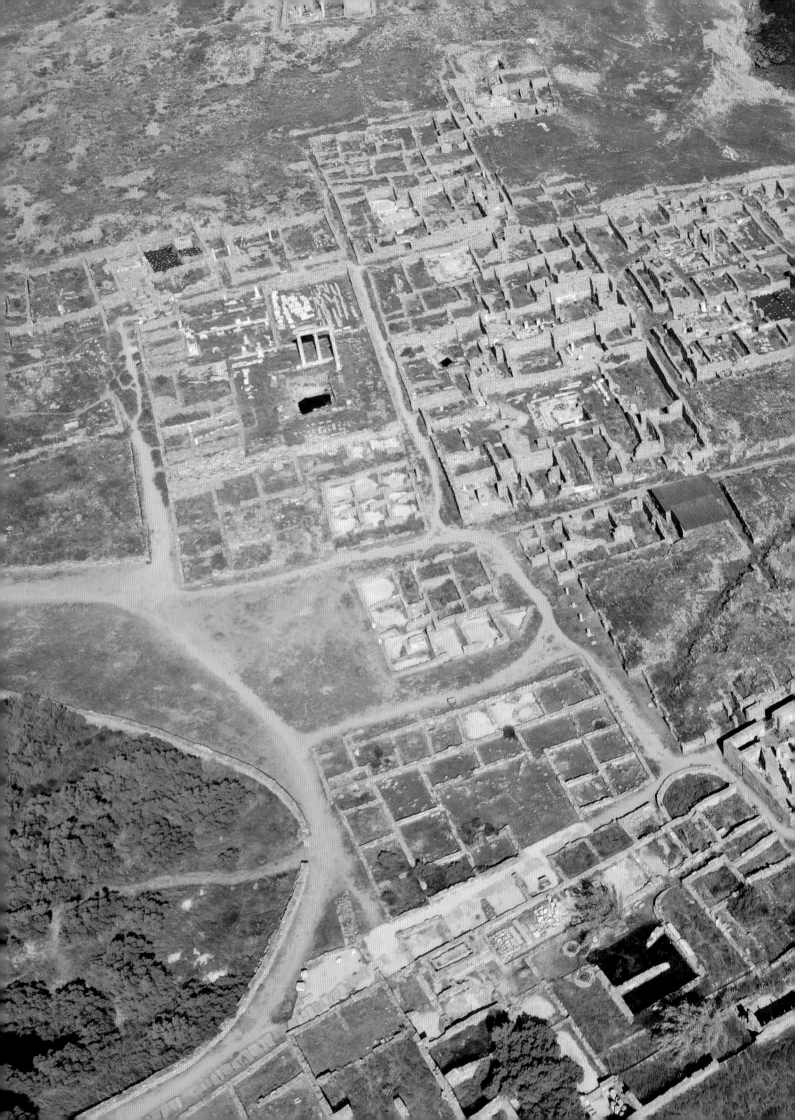

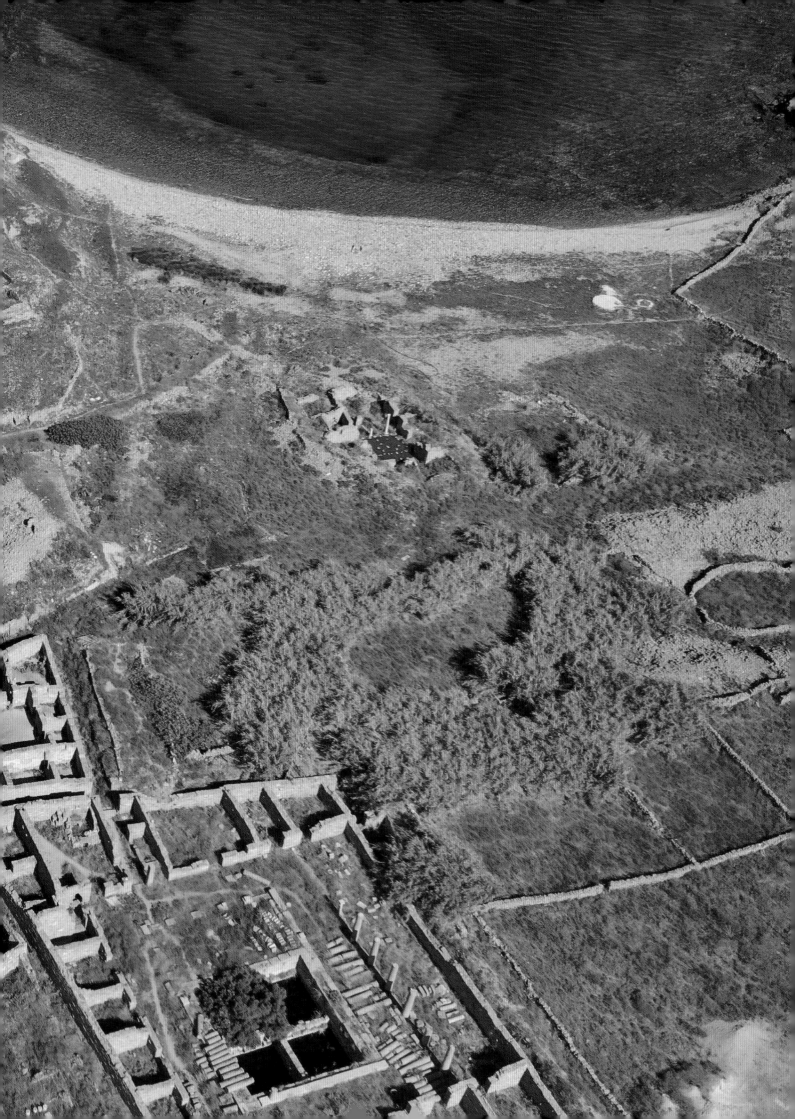

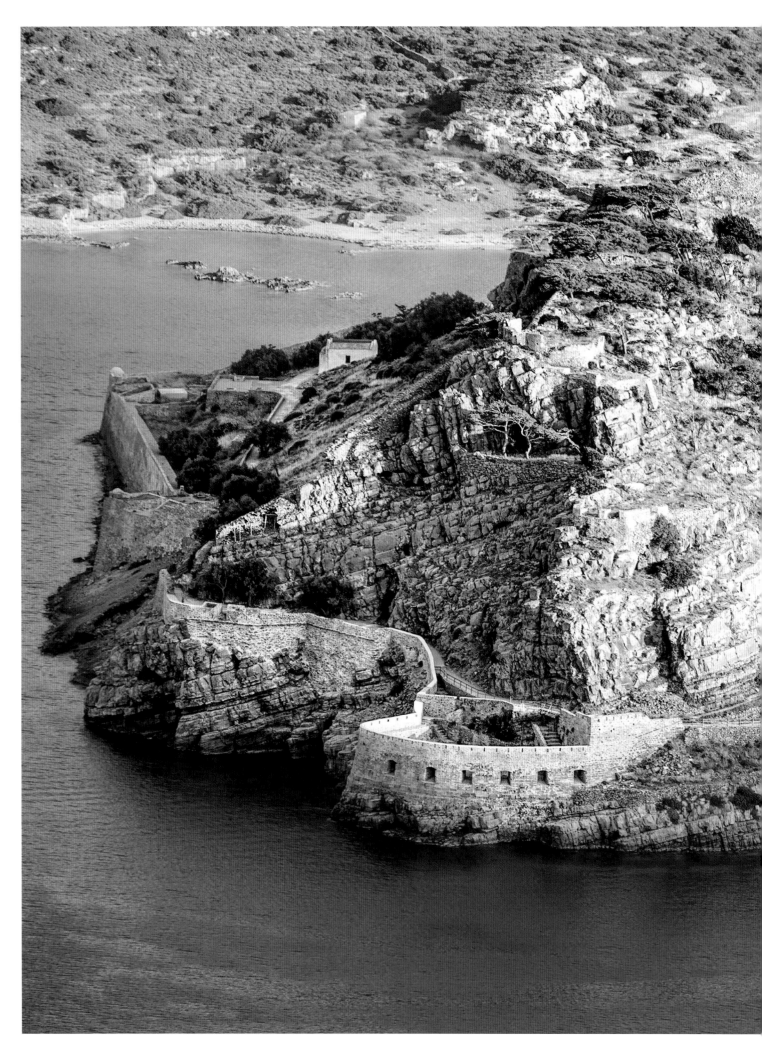

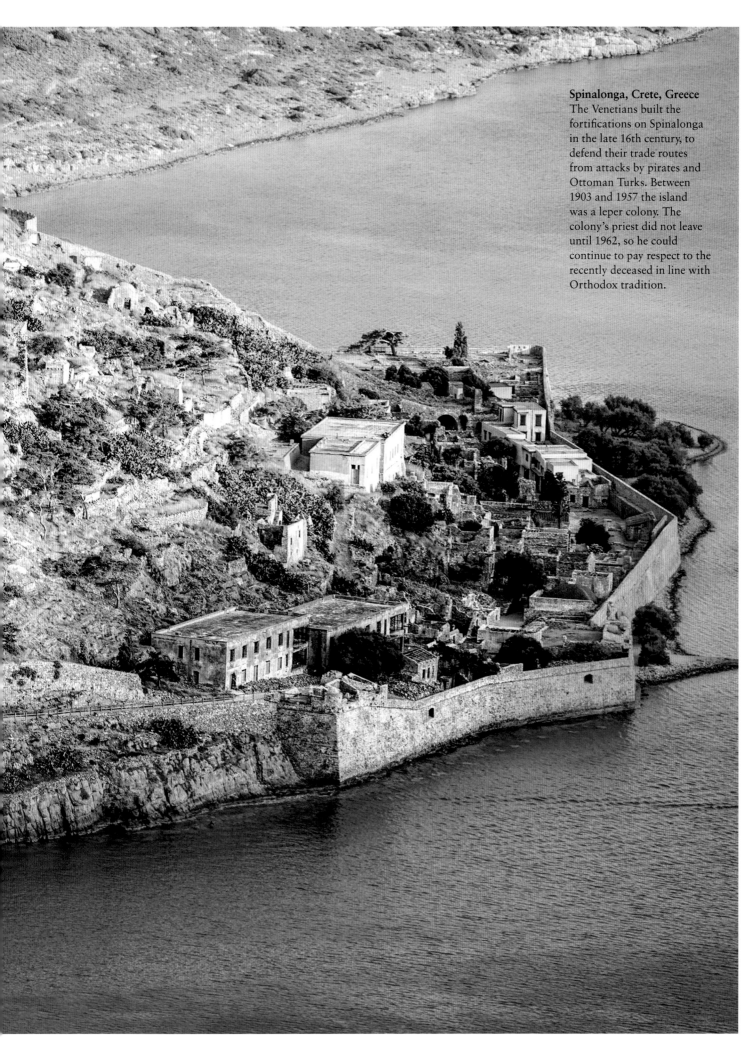

Spinalonga, Crete, Greece
The Venetians built the fortifications on Spinalonga in the late 16th century, to defend their trade routes from attacks by pirates and Ottoman Turks. Between 1903 and 1957 the island was a leper colony. The colony's priest did not leave until 1962, so he could continue to pay respect to the recently deceased in line with Orthodox tradition.

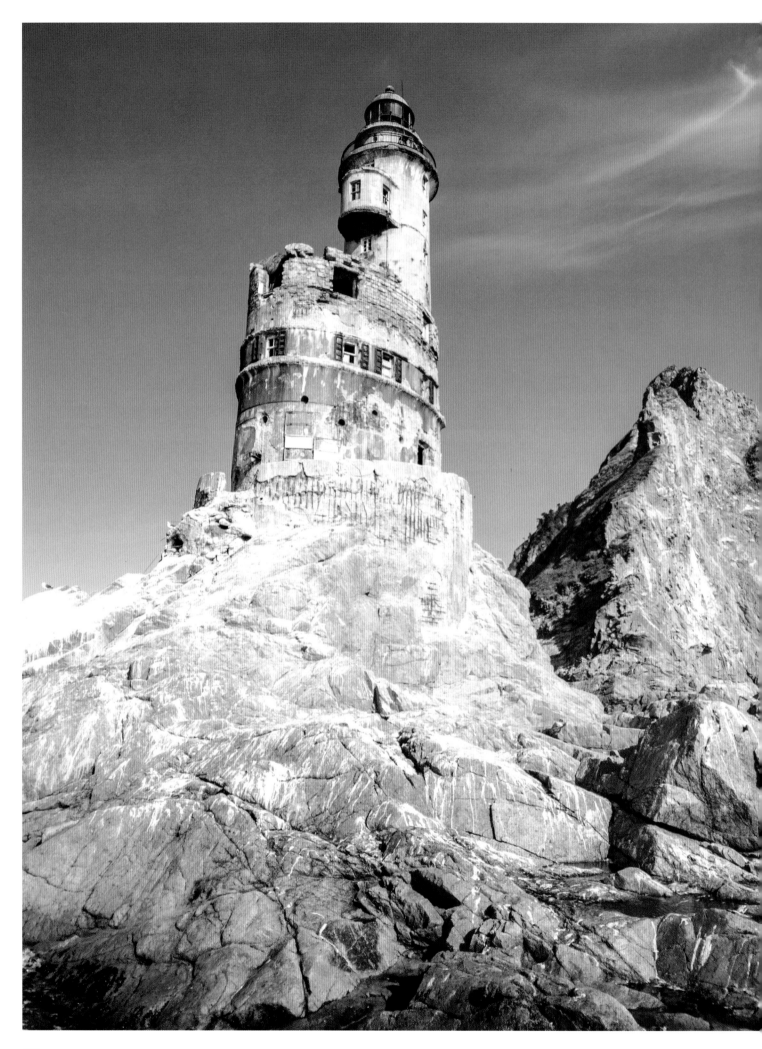

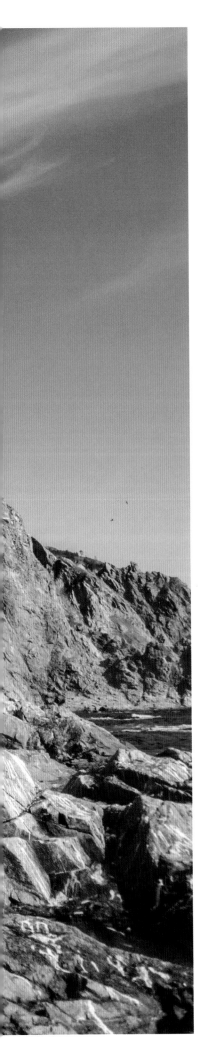

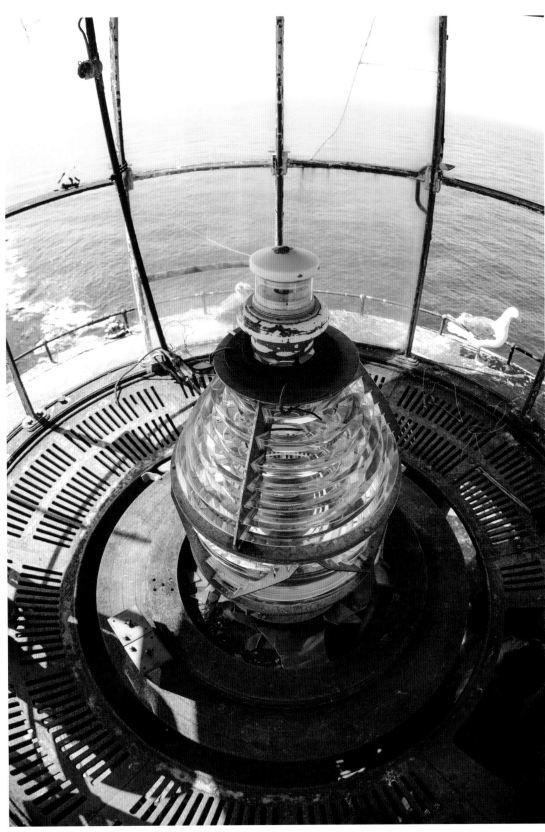

ALL PHOTOGRAPHS:
**Aniva Lighthouse,
Sakhalin, Russia**
In 1939, this concrete lighthouse
was built by the Japanese on an
islet off the coast of Sakhalin,
six years before the island was
annexed by Russia. The lighthouse
was automated and given
radioisotope generators in the
1990s. Decommissioned in 2006, it
is now used only by seabirds.

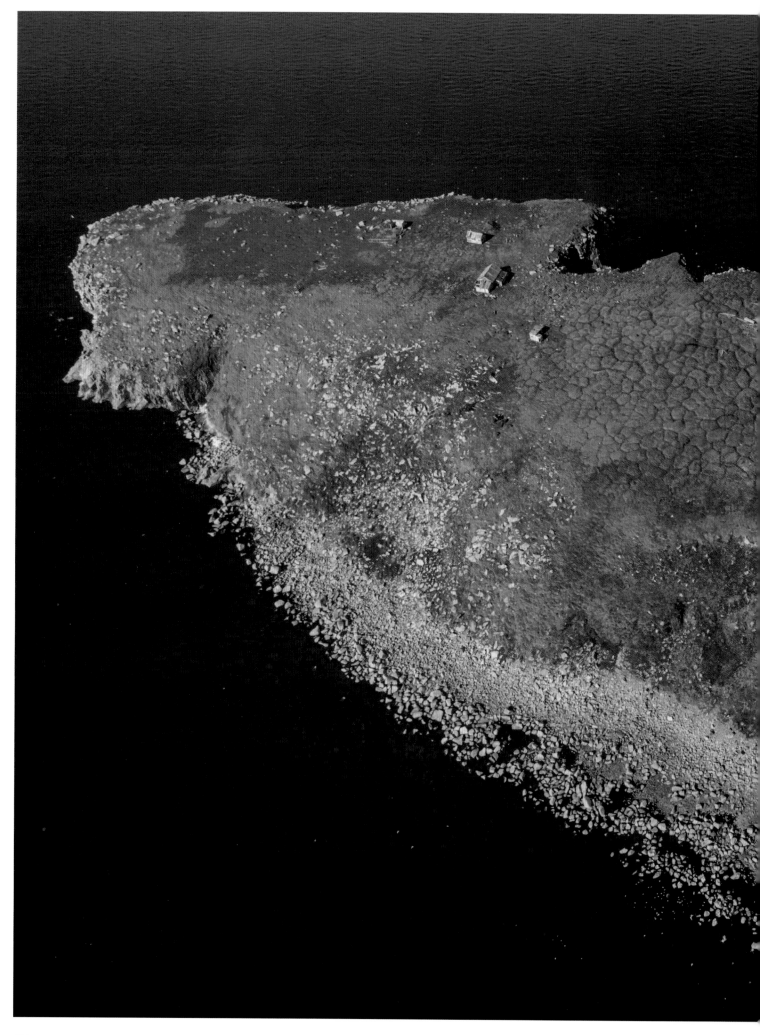

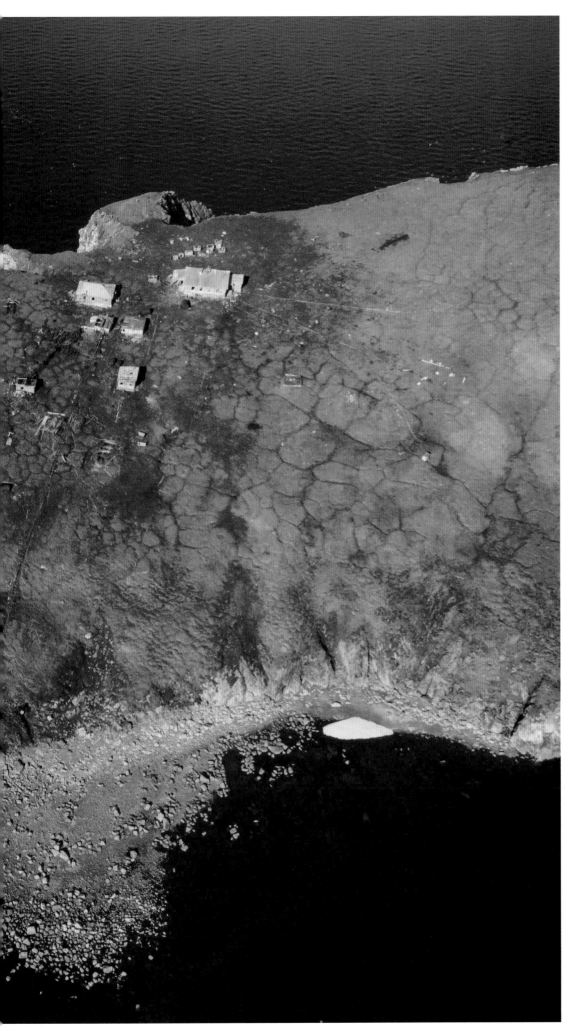

Kolyuchin, Russia
In the Chukchi Sea of the Arctic Ocean, the island of Kolyuchin was once inhabited by Chukchi people, who lived by hunting seals, walrus and whales. In 1934, scientists moved into a weather station (pictured) on the cliffs, where they endured an average temperature of -9.5°C (15°F). The station closed in 1992.

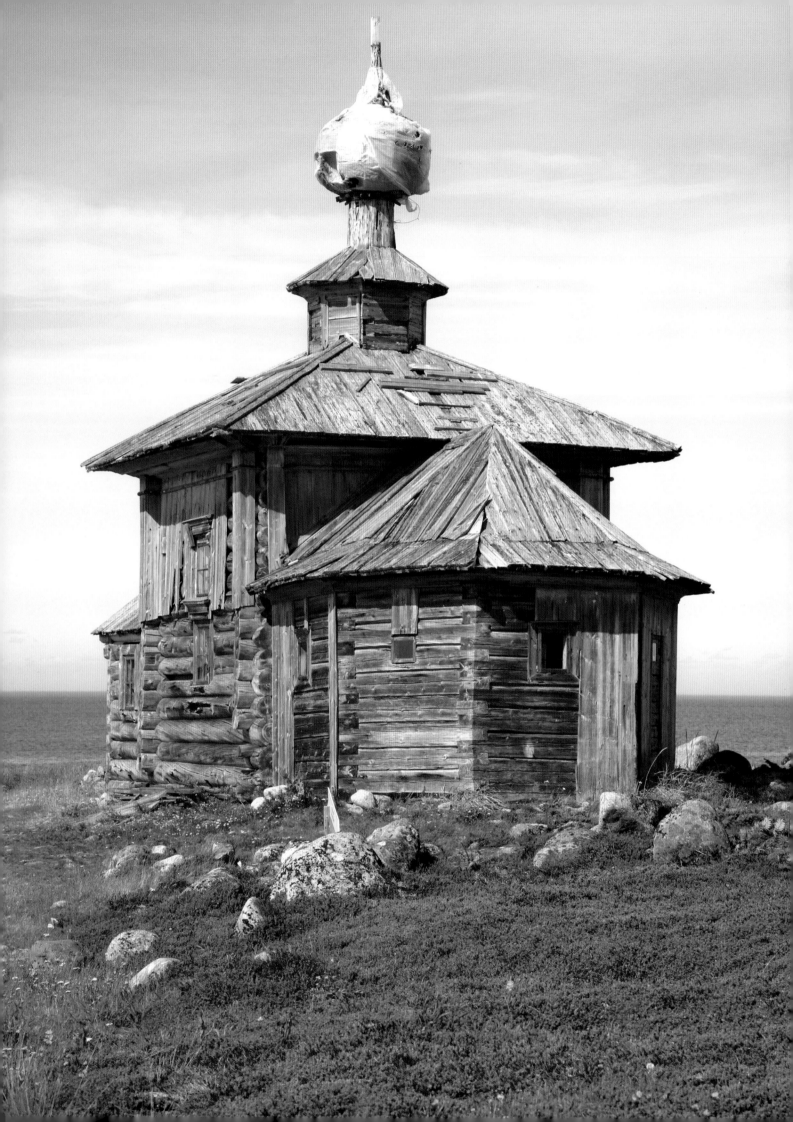

OPPOSITE:

Bolshoy Zayatsky, Russia
St Andrew's Church was built
as part of a hermitage in 1702,
making it one of the oldest
wooden structures in the region.
In addition, the uninhabited
island has nine stone maze-like
constructions erected from around
2,000 years ago, probably for
religious rituals.

ABOVE:

Bolshoy Tyuters, Russia
In 1939, this Baltic island had a
population of 436 Finns, who were
all evacuated the following year
when Bolshoy Tyuters was ceded
to the Soviet Union. The island
has never been repopulated as its
World War II minefields, along
with heaps of rusting German
weaponry, have never been cleared.

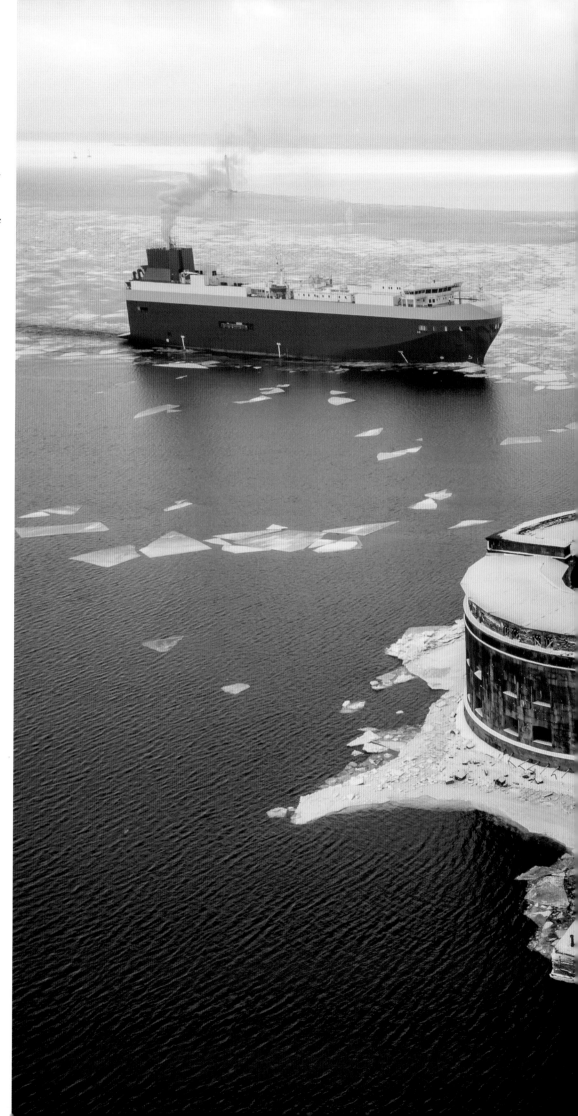

RIGHT AND OVERLEAF:

Fort Alexander, Russia
Built in 1838–45 on an artificial
island in the Gulf of Finland,
this fort was commissioned to
protect nearby St Petersburg and
the port of Kronstadt. In 1899, the
fort was repurposed as a research
laboratory for the study of a newly
discovered plague pathogen, and
other bacteria. Two workers died
from the plague before the institute
was closed in 1917.

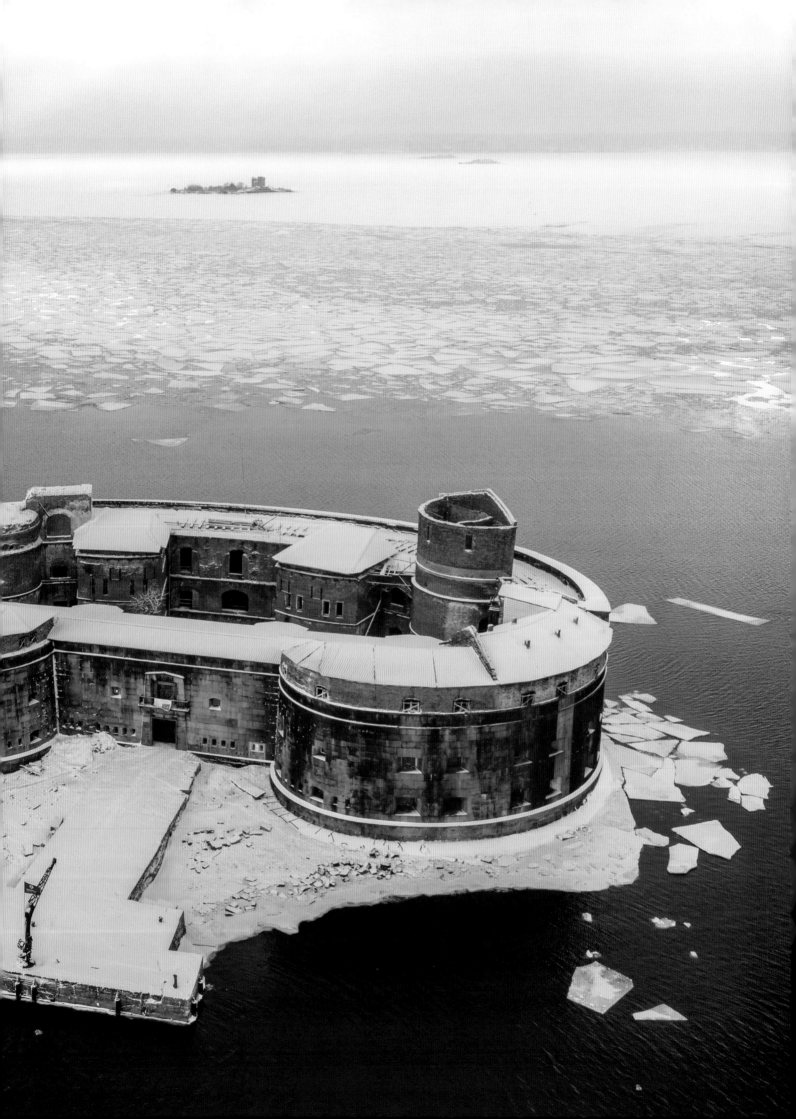

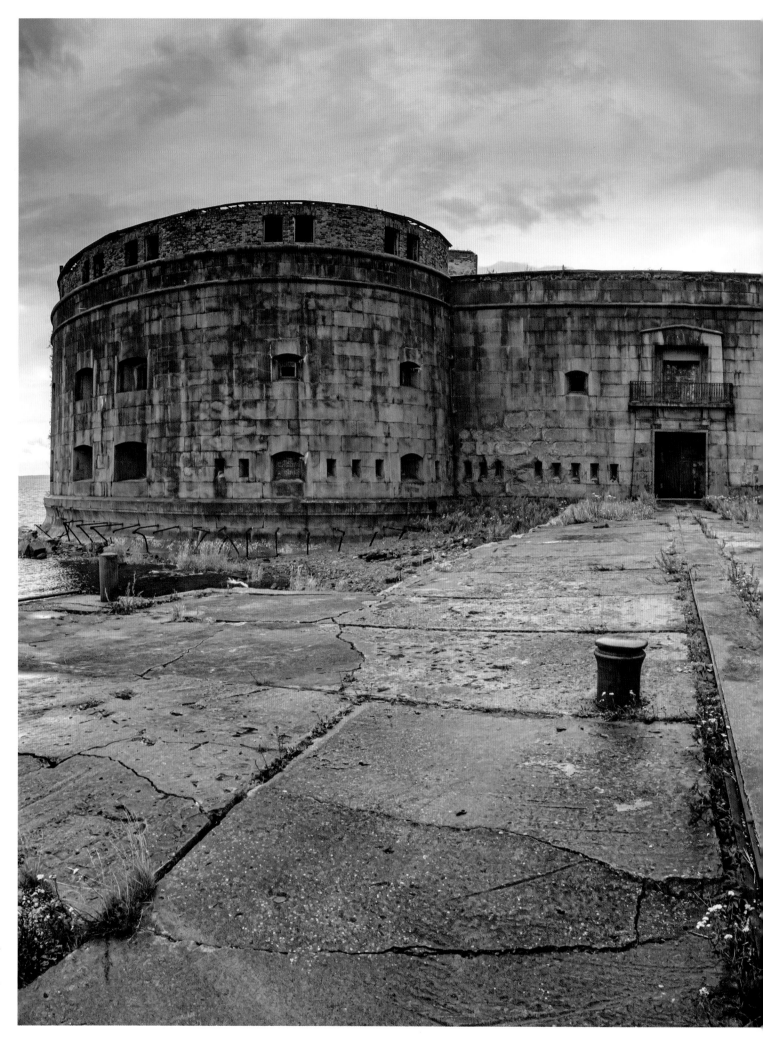

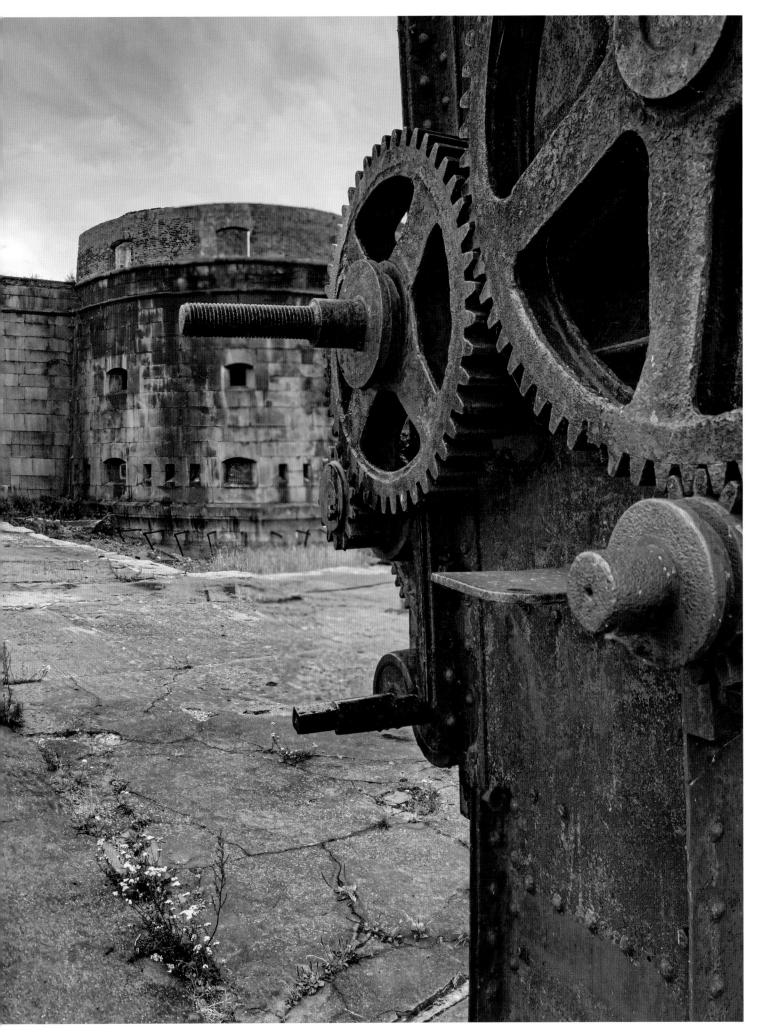

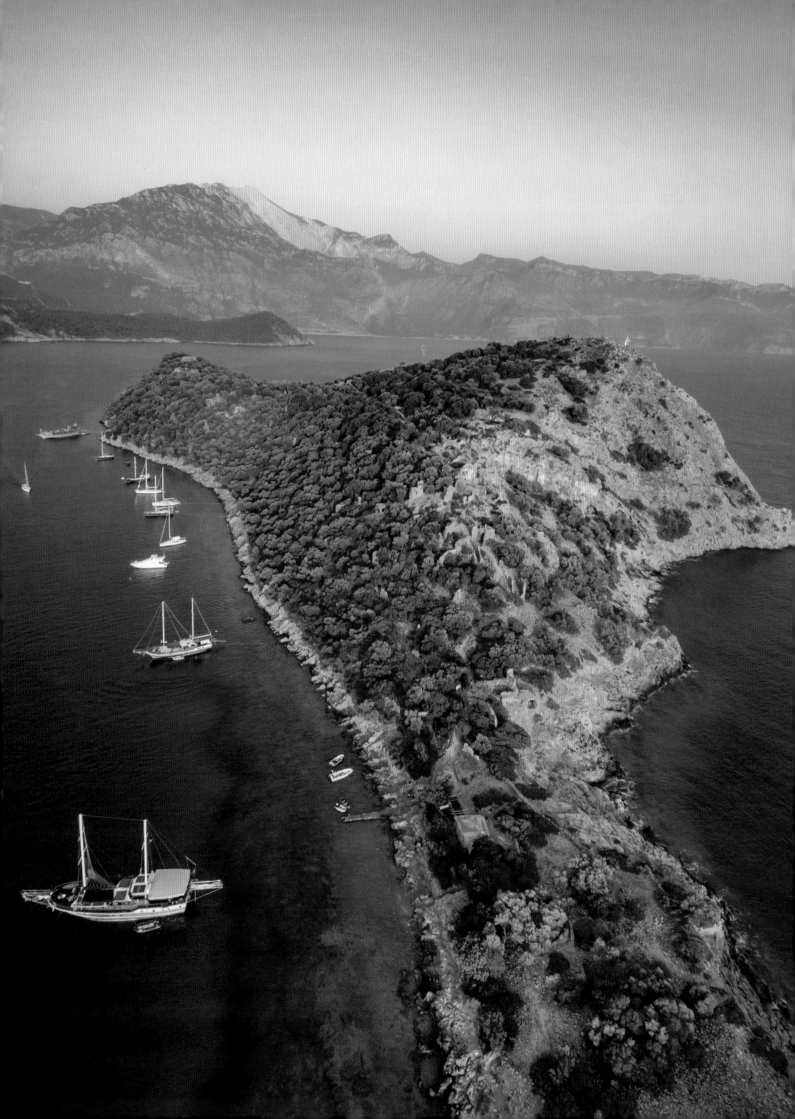

The Middle East and Africa

Once abandoned by the fishermen or traders who made the isle their home, countless islands in Africa and the Middle East have become important – and, in some cases, the only – habitats for fragile animal species. Some of these species, such as the Nosy Hara leaf chameleon and Chagos clownfish, are found only on or around these islands. Abandoned islands also offer undisturbed nesting sites for reptiles, from endangered green turtles to Lake Turkana's teeming population of Nile crocodiles. Ground-nesting seabirds, at risk elsewhere from coastal development and tourism, may throng abandoned islands in the tens of thousands. South Africa's St Croix hosts a breeding colony of 22,000 African penguins, out of a total population of only around 55,000. The Red Sea's Tiran Island – protected, like many other abandoned islands, as a national park – is an important migration stopover as well as a breeding site for seabirds such as white-eyed gulls and white-cheeked terns. Inaccessible islands may also be designated as sanctuaries for species under threat from habitat loss or hunting. Nine aye-ayes were introduced to Madagascar's Nosy Mangabe island in 1966. On the mainland, this lemur had been hunted close to extinction due to the belief that it was a harbinger of death. Today, the 'abandoned' island's aye-aye population is thriving.

OPPOSITE:
Gemiler, Turkey
Home only to the ruins of five Byzantine churches and other ecclesiastical buildings, Gemiler is a popular destination for *gulets* (traditional sailing boats).

Gemiler, Turkey
Archaeologists believe the
remains of the early Christian
bishop St Nicholas were laid to
rest on Gemiler in 326 CE. The
island soon became a pilgrimage
destination. Under threat from
attacks by Arab ships, the saint's
remains were removed to the
mainland in 650 CE, leading to
the ecclesiastical settlement's
abandonment.

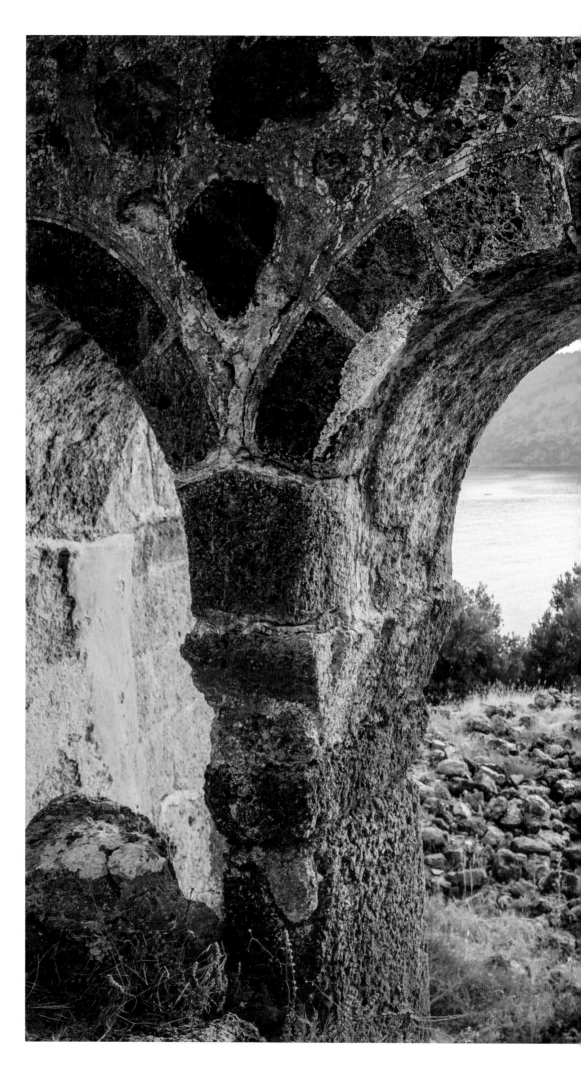

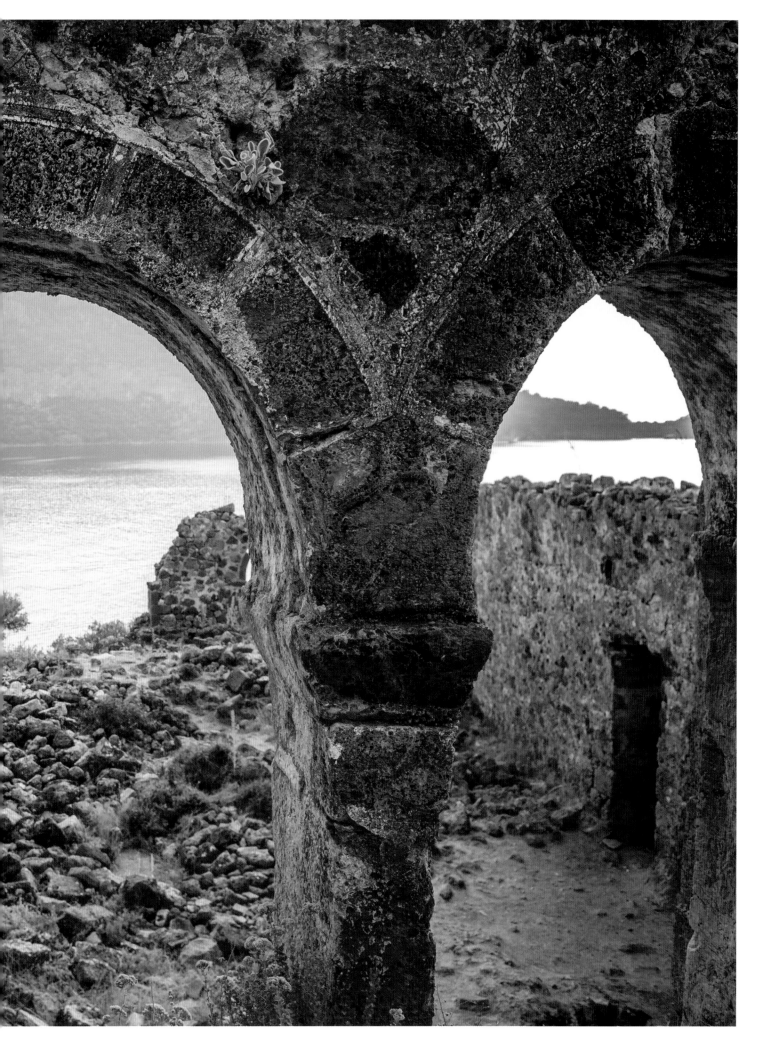

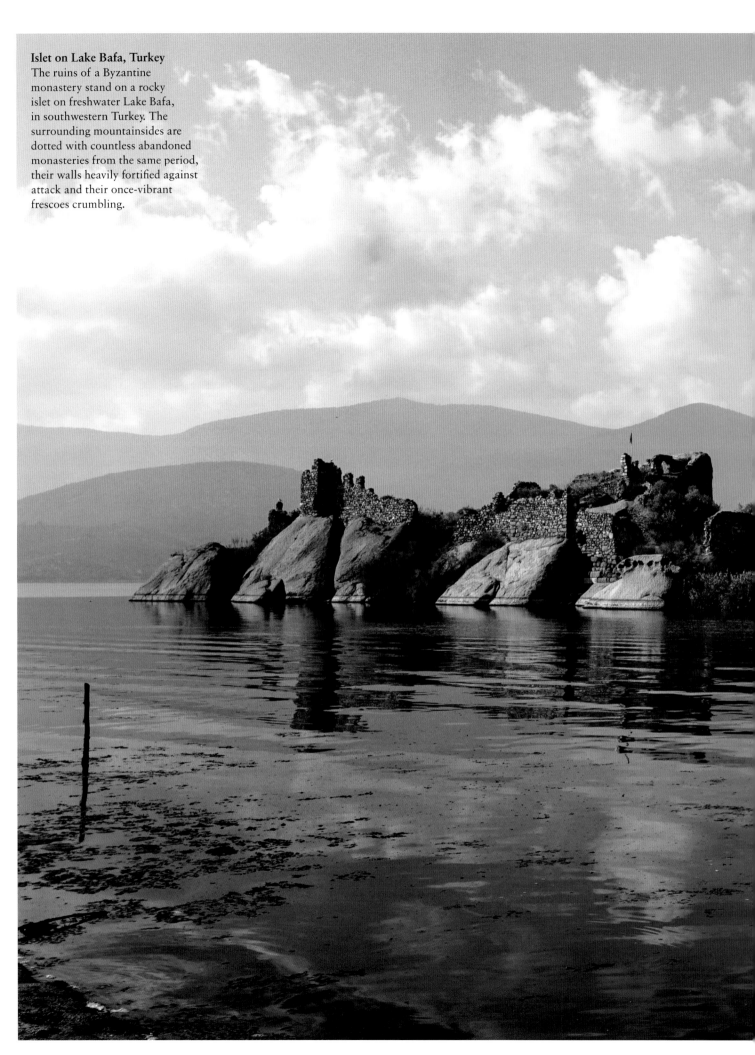

Islet on Lake Bafa, Turkey
The ruins of a Byzantine monastery stand on a rocky islet on freshwater Lake Bafa, in southwestern Turkey. The surrounding mountainsides are dotted with countless abandoned monasteries from the same period, their walls heavily fortified against attack and their once-vibrant frescoes crumbling.

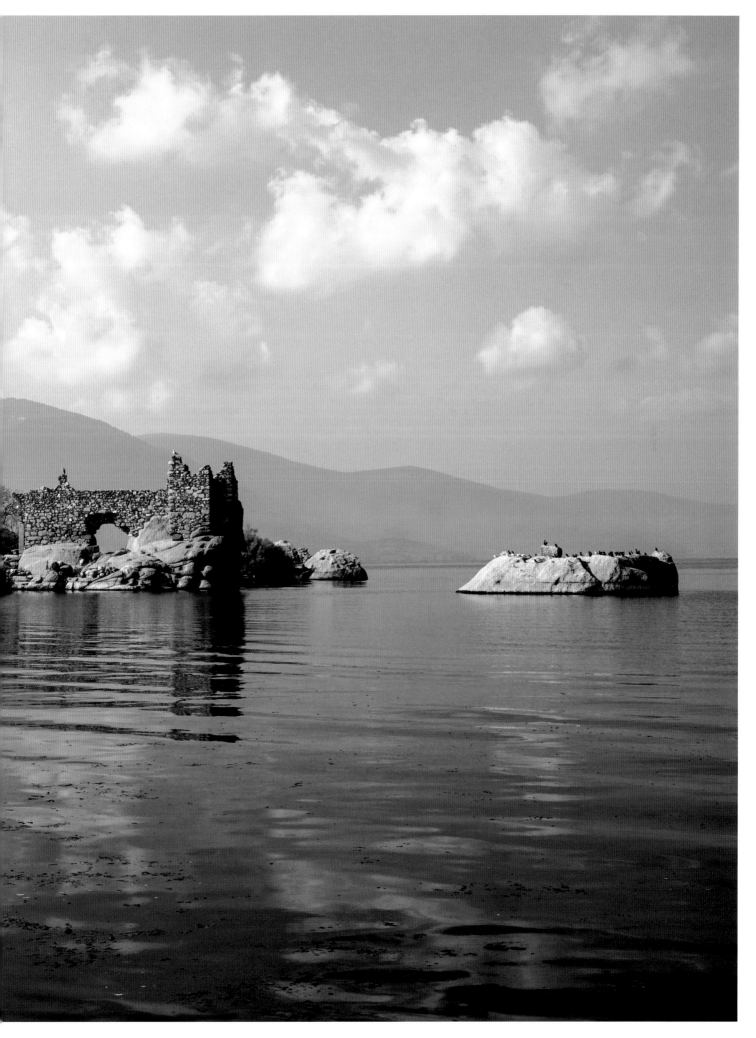

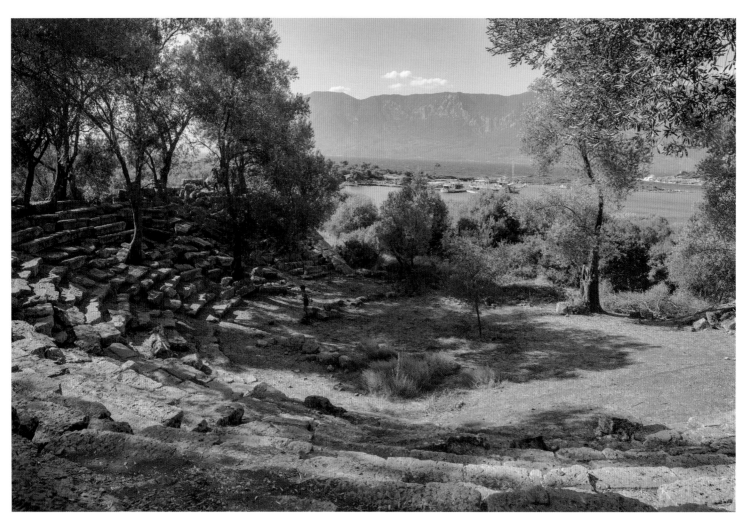

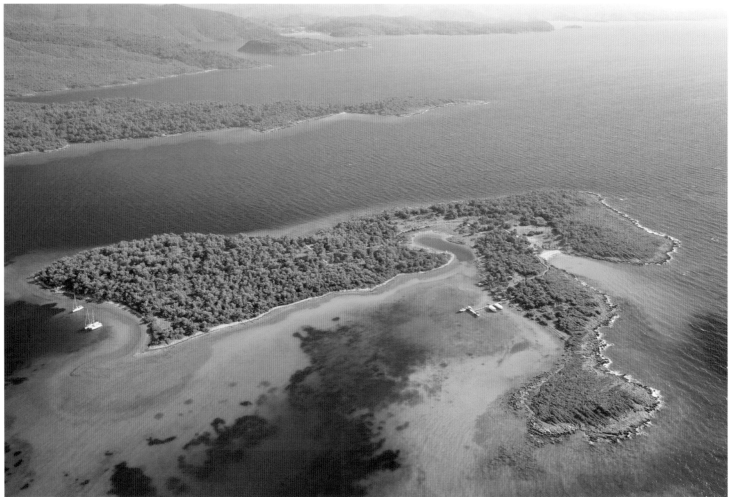

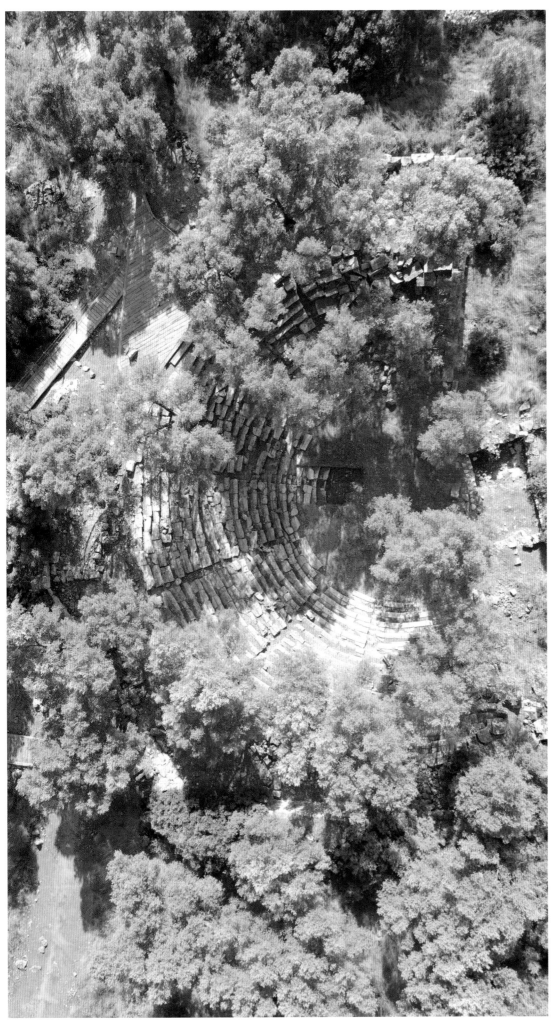

ALL PHOTOGRAPHS:
Sedir, Turkey
The island of Sedir is known for its beach, composed of perfectly spherical calcium carbonate particles (known as ooids), and the remains of the Greek port of Kedrai. Buildings of note within the towered city walls include a theatre and temple to Apollo, which was converted into a church during the Byzantine period.

RIGHT AND OVERLEAF:
Bunce, Sierra Leone
Lying in the estuary of the Rokel River, Bunce was the limit of navigation for ocean-going ships, making it a base for European slave traders, including England's Royal Africa Company, which built a castle here in around 1670. Tens of thousands of enslaved Africans were carried from Bunce to the New World colonies.

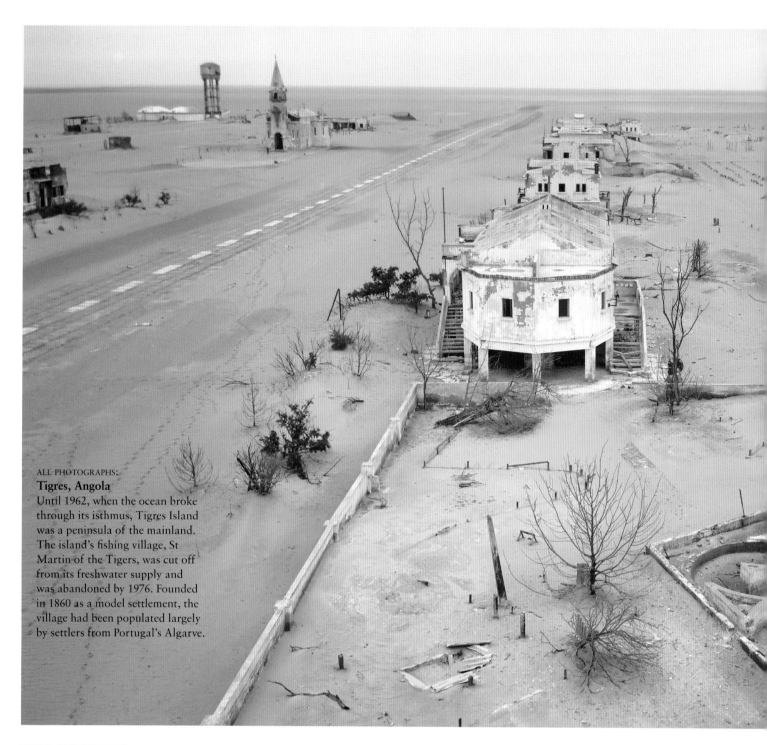

ALL PHOTOGRAPHS:
Tigres, Angola
Until 1962, when the ocean broke through its isthmus, Tigres Island was a peninsula of the mainland. The island's fishing village, St Martin of the Tigers, was cut off from its freshwater supply and was abandoned by 1976. Founded in 1860 as a model settlement, the village had been populated largely by settlers from Portugal's Algarve.

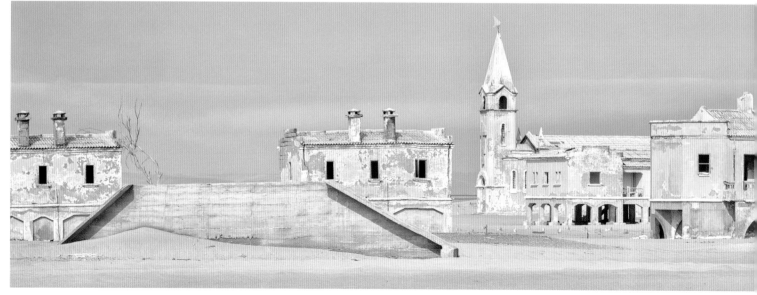

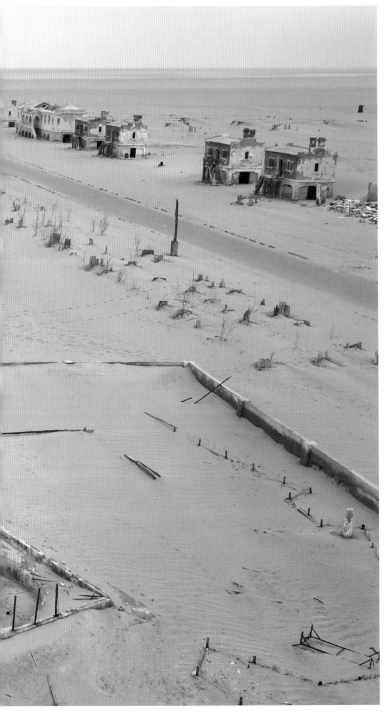

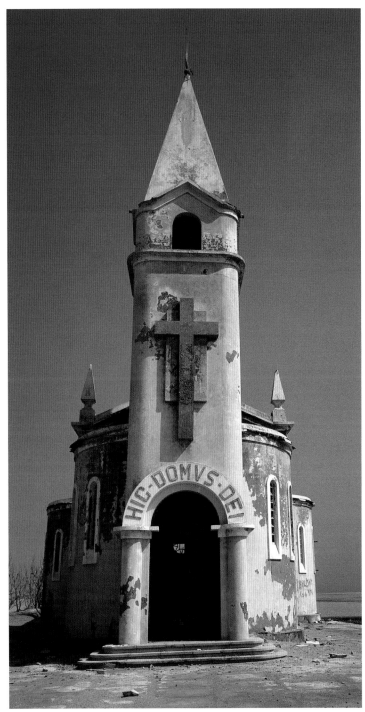

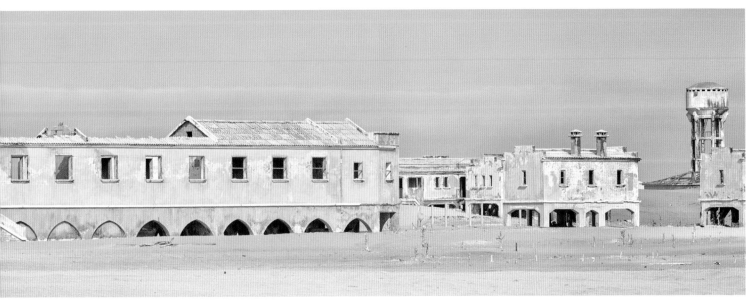

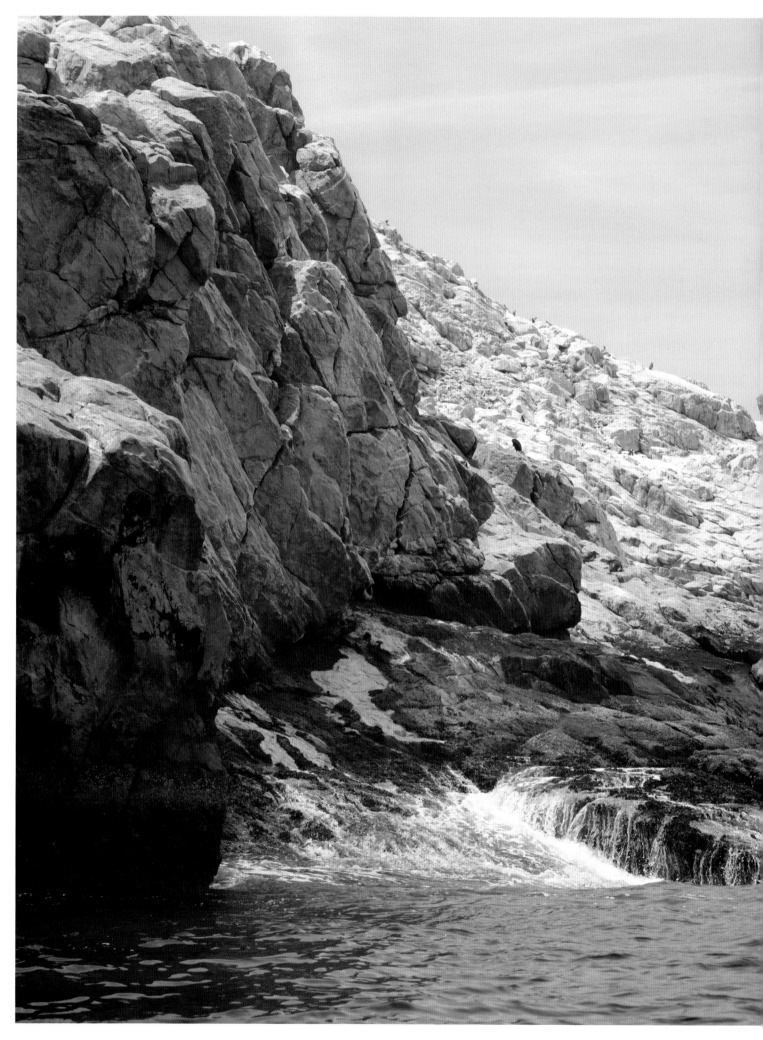

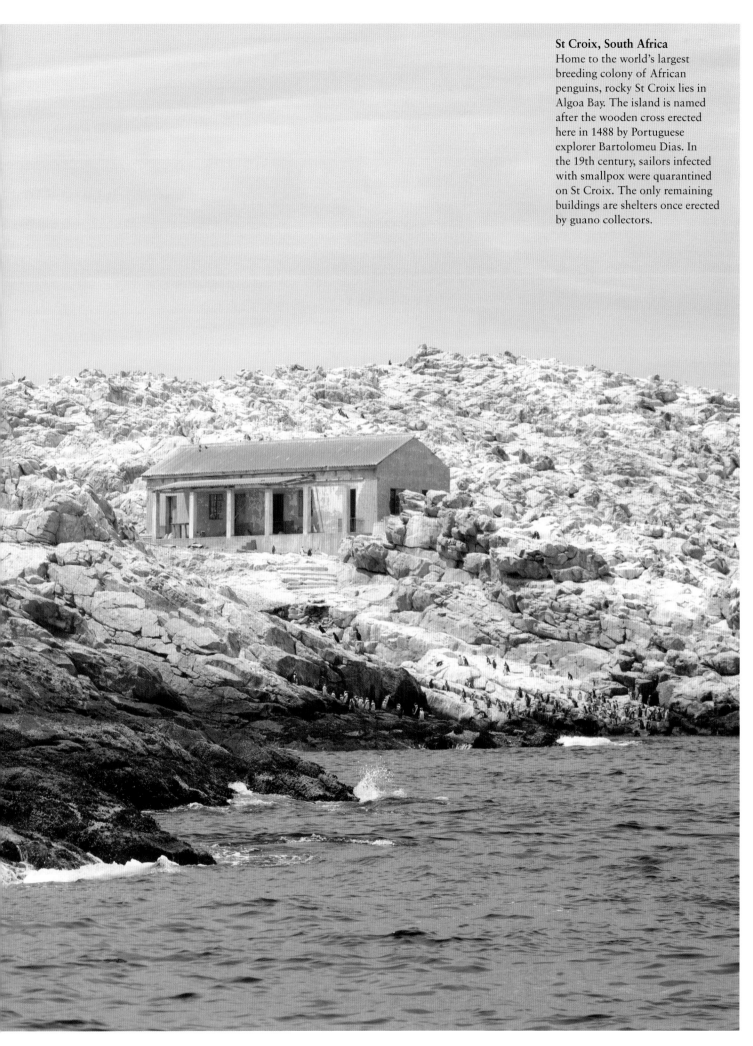

St Croix, South Africa
Home to the world's largest breeding colony of African penguins, rocky St Croix lies in Algoa Bay. The island is named after the wooden cross erected here in 1488 by Portuguese explorer Bartolomeu Dias. In the 19th century, sailors infected with smallpox were quarantined on St Croix. The only remaining buildings are shelters once erected by guano collectors.

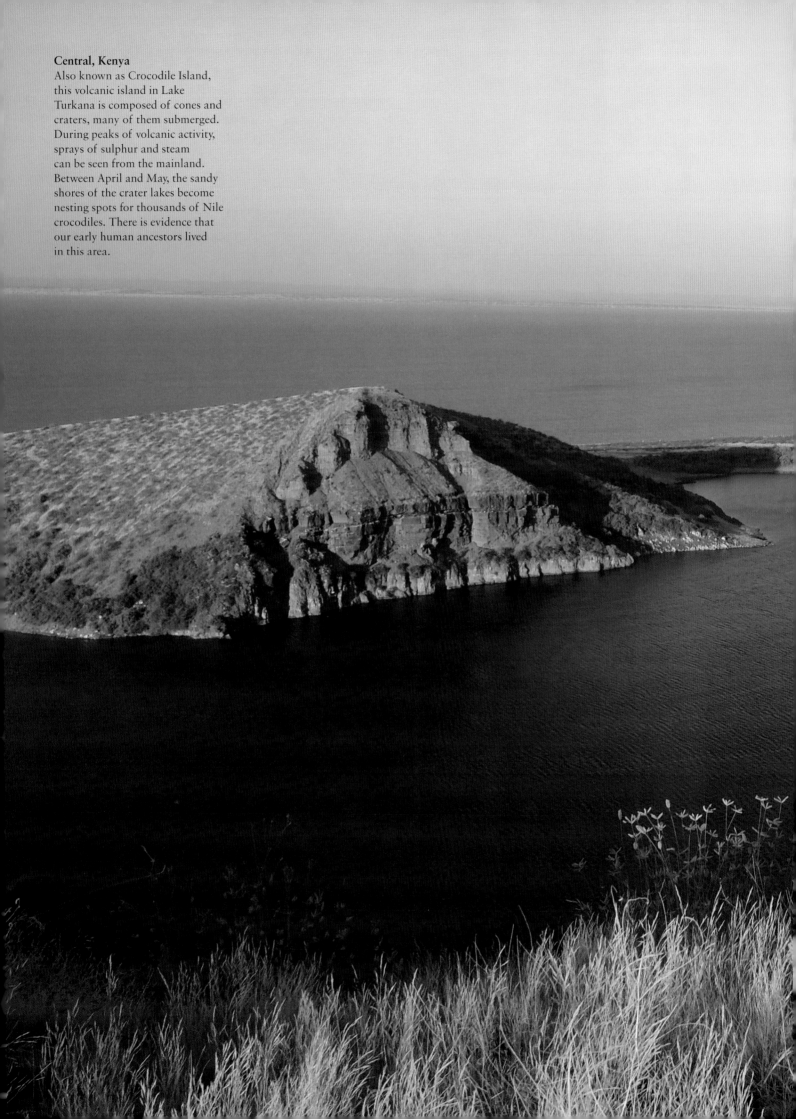

Central, Kenya
Also known as Crocodile Island,
this volcanic island in Lake
Turkana is composed of cones and
craters, many of them submerged.
During peaks of volcanic activity,
sprays of sulphur and steam
can be seen from the mainland.
Between April and May, the sandy
shores of the crater lakes become
nesting spots for thousands of Nile
crocodiles. There is evidence that
our early human ancestors lived
in this area.

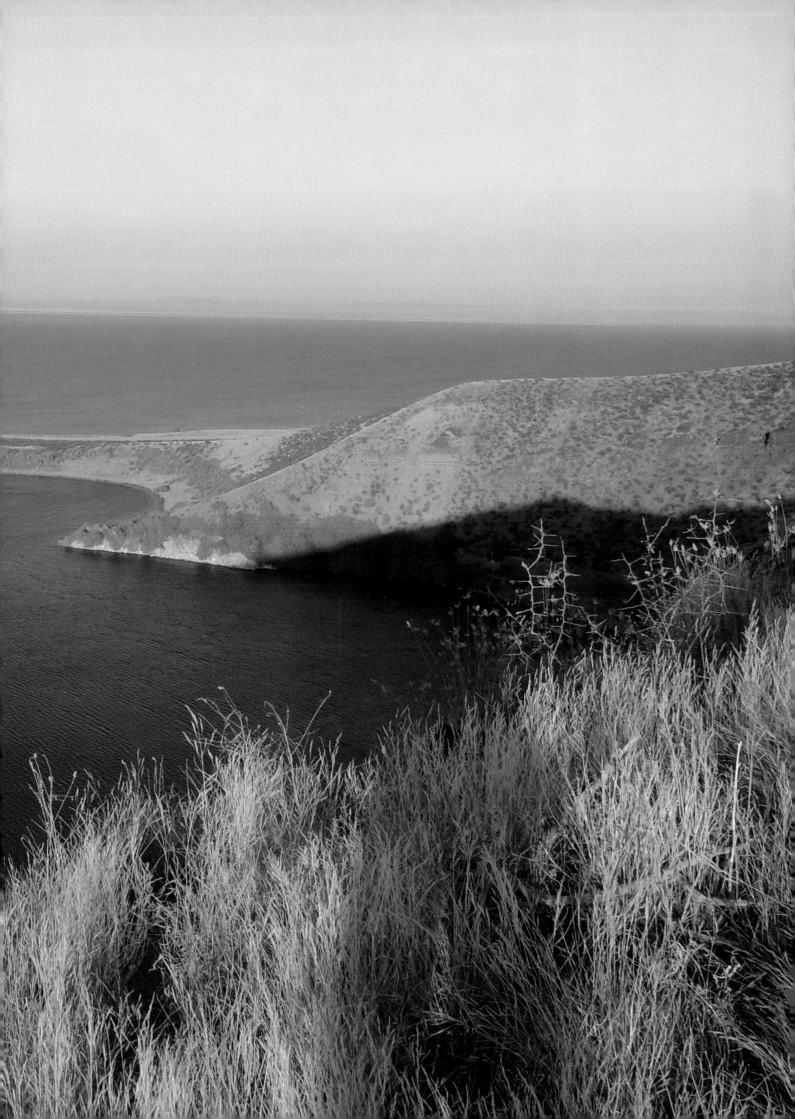

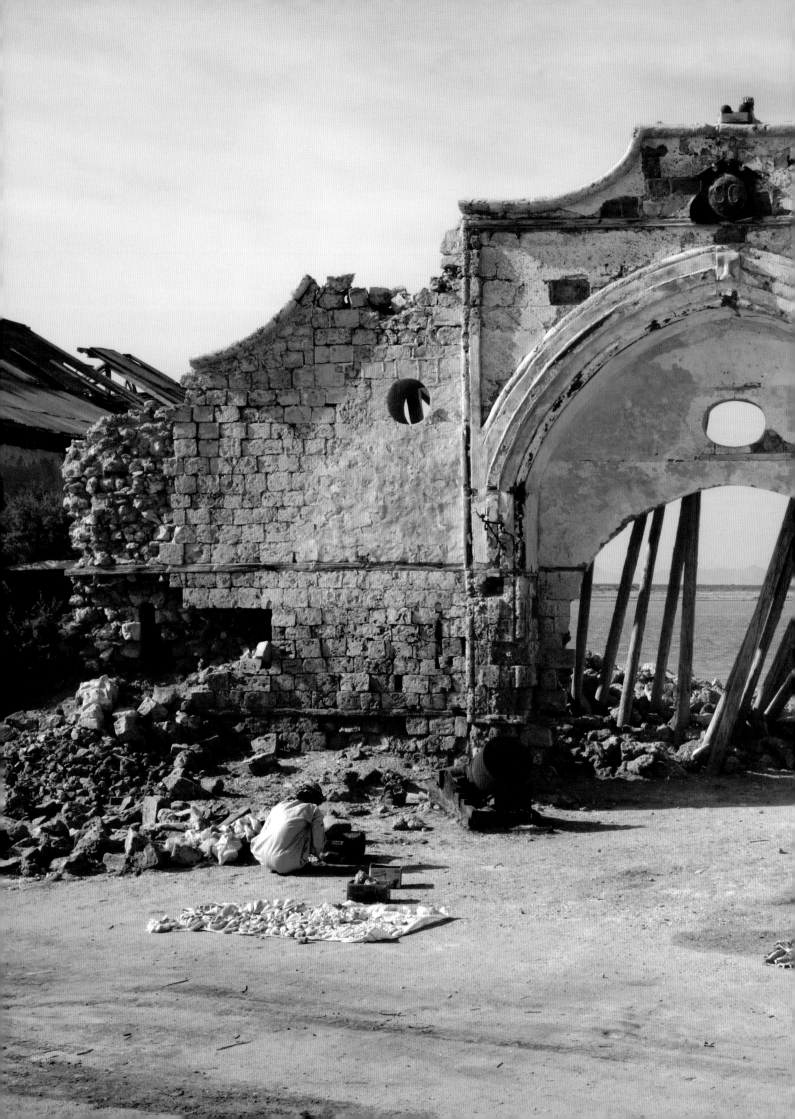

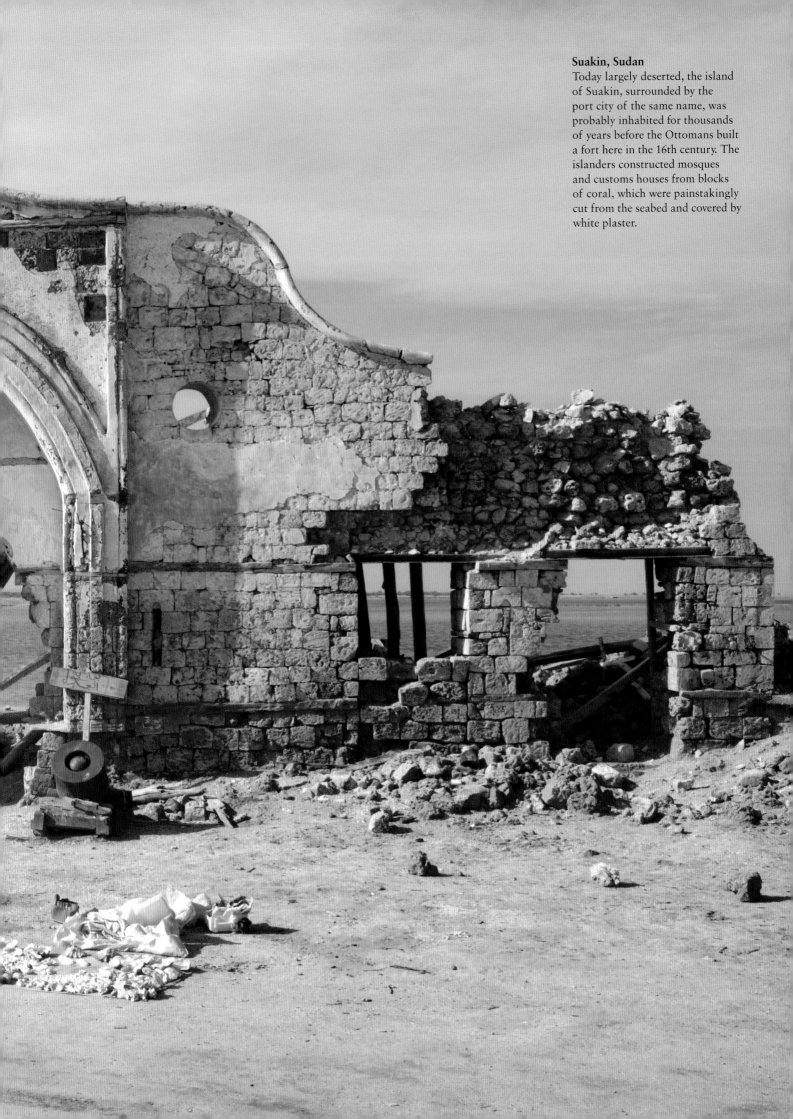

Suakin, Sudan
Today largely deserted, the island of Suakin, surrounded by the port city of the same name, was probably inhabited for thousands of years before the Ottomans built a fort here in the 16th century. The islanders constructed mosques and customs houses from blocks of coral, which were painstakingly cut from the seabed and covered by white plaster.

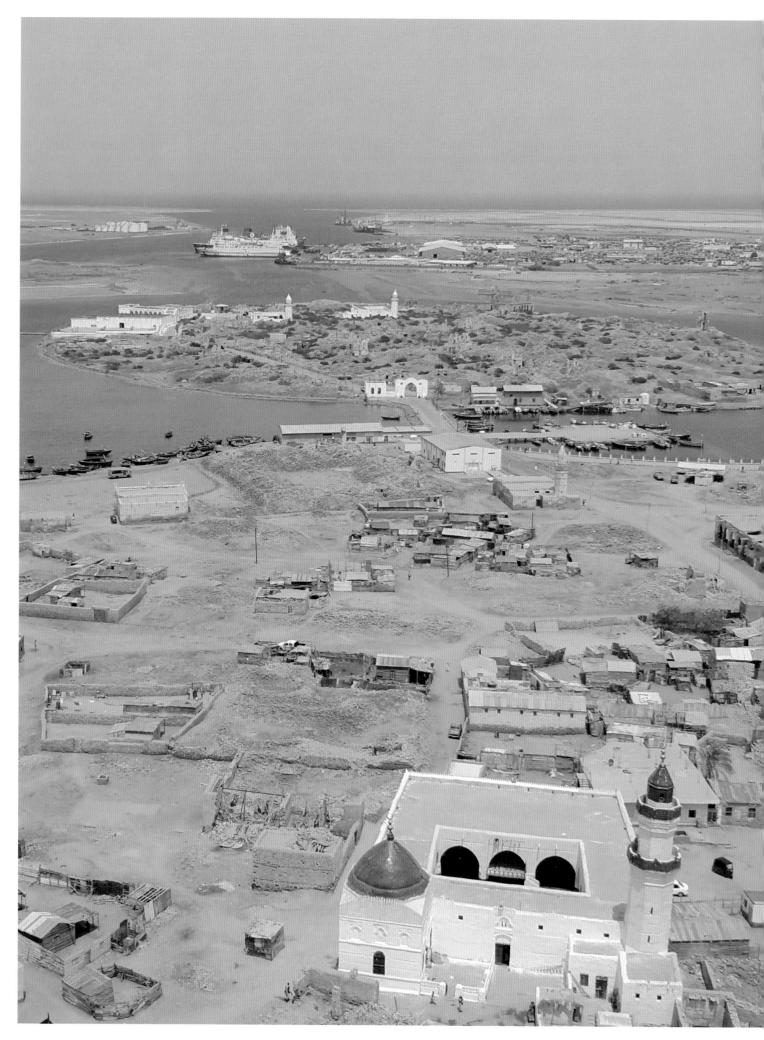

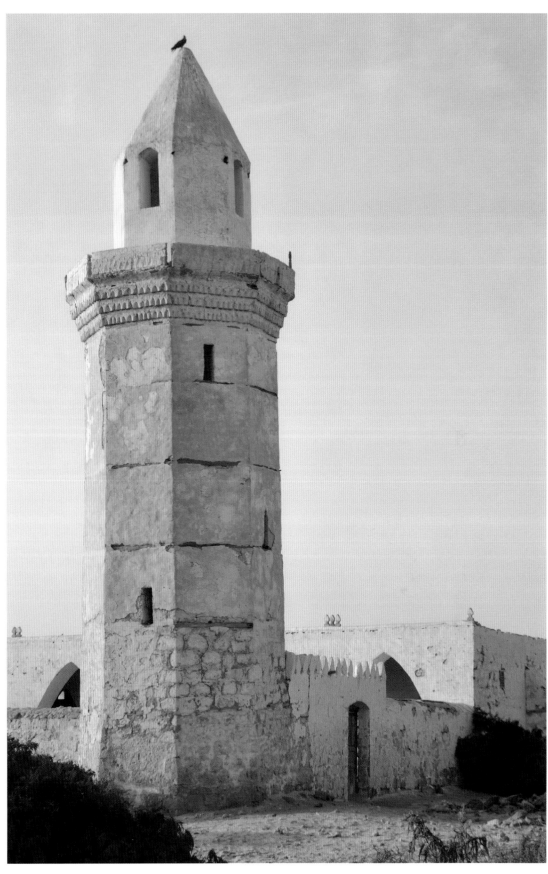

ALL PHOTOGRAPHS:
Suakin, Sudan
Connected to the mainland by a causeway, the island of Suakin is wedged between the modern ferry port, largely used by pilgrims heading for Saudi Arabia, and the neglected town, which has been overlooked in favour of the newly built Port Sudan since 1905.

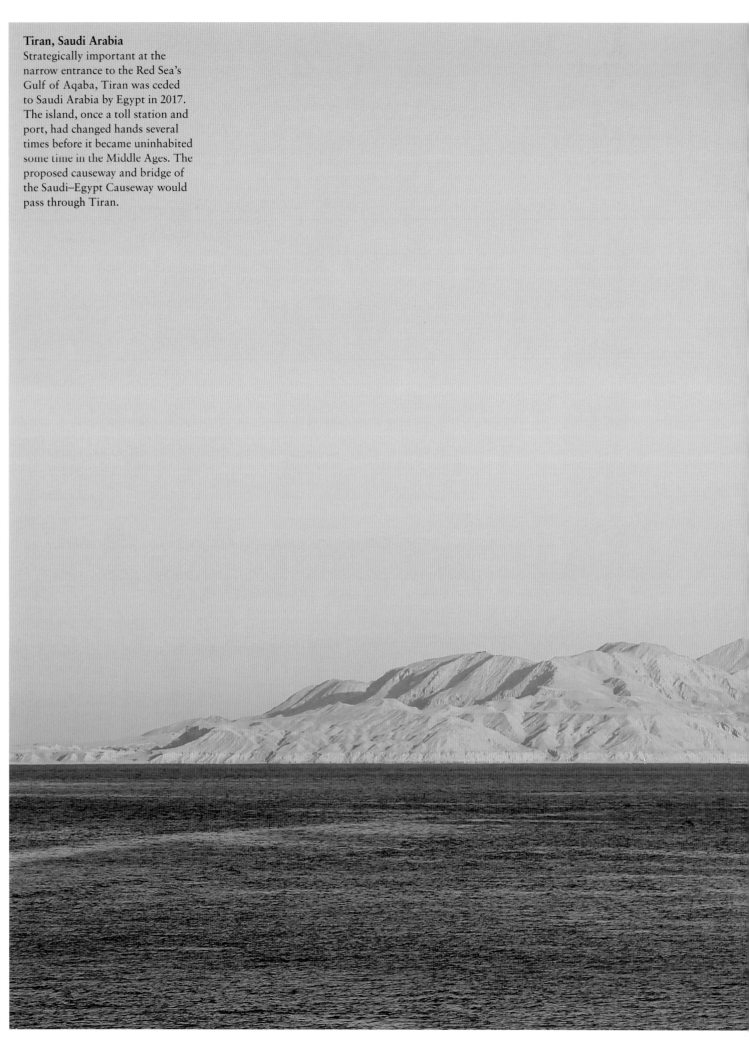

Tiran, Saudi Arabia
Strategically important at the
narrow entrance to the Red Sea's
Gulf of Aqaba, Tiran was ceded
to Saudi Arabia by Egypt in 2017.
The island, once a toll station and
port, had changed hands several
times before it became uninhabited
some time in the Middle Ages. The
proposed causeway and bridge of
the Saudi–Egypt Causeway would
pass through Tiran.

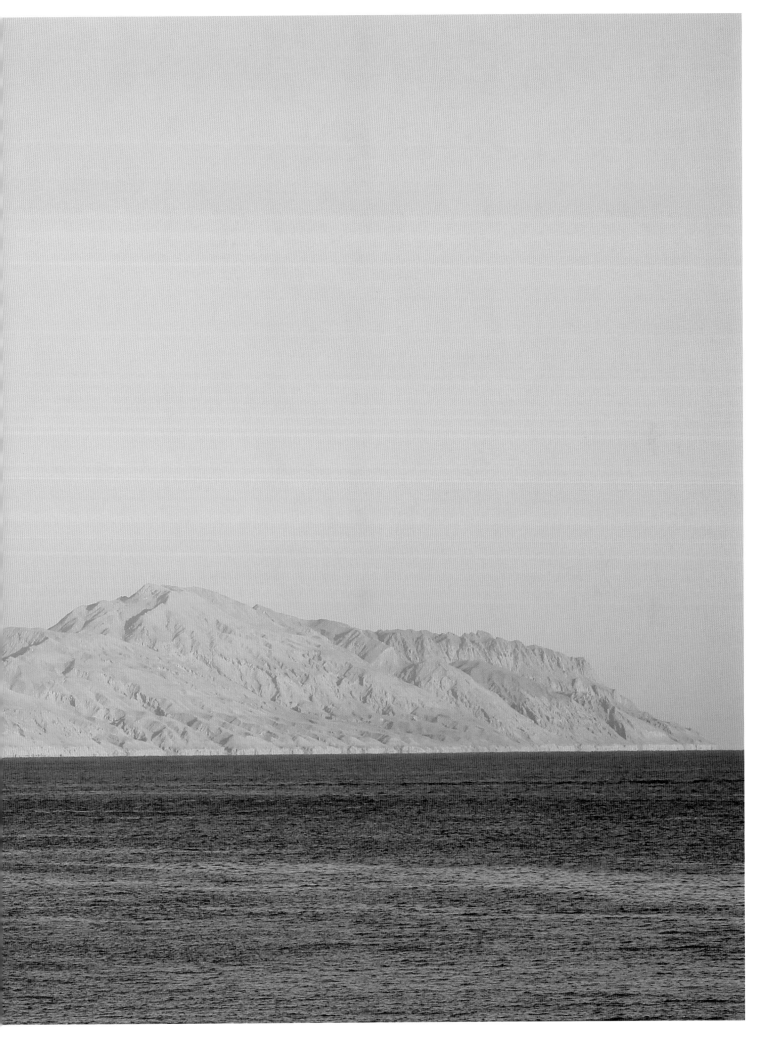

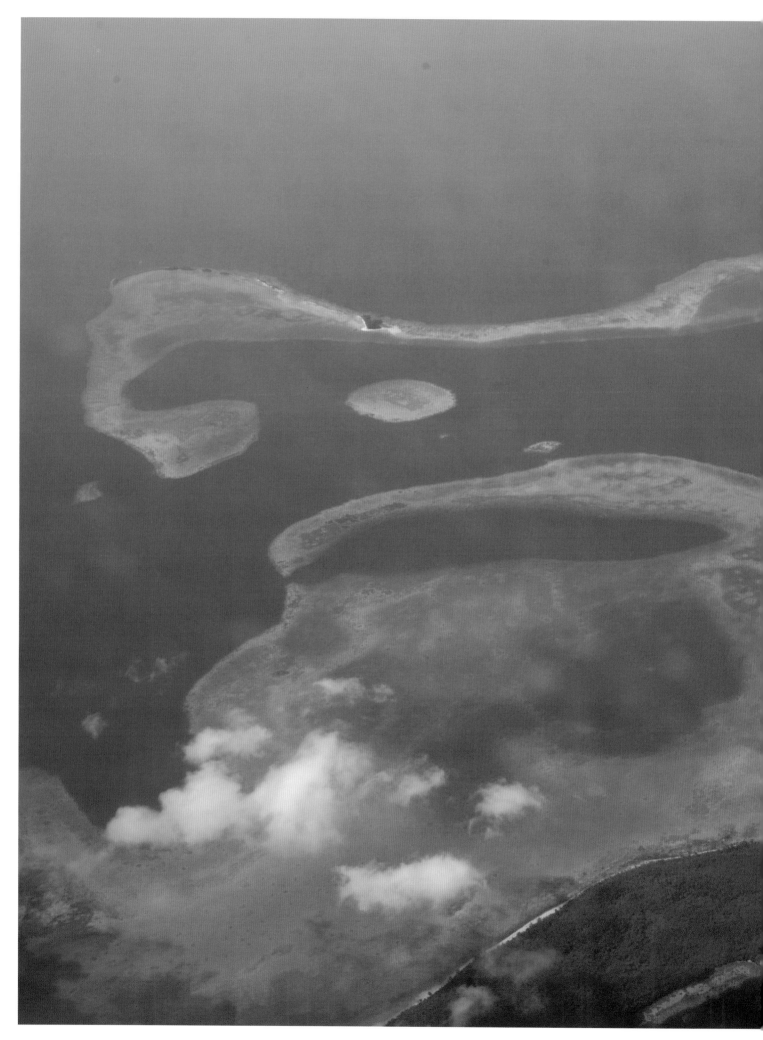

Chagos Archipelago
These Indian Ocean islands were home to the Chagossians until 1967–73, when they were evicted by the United Kingdom to allow the building of a joint United Kingdom–United States military base on the archipelago's largest island, Diego Garcia. In 2019, the International Court of Justice ruled that the UK's occupation of the Chagos Islands was unlawful.

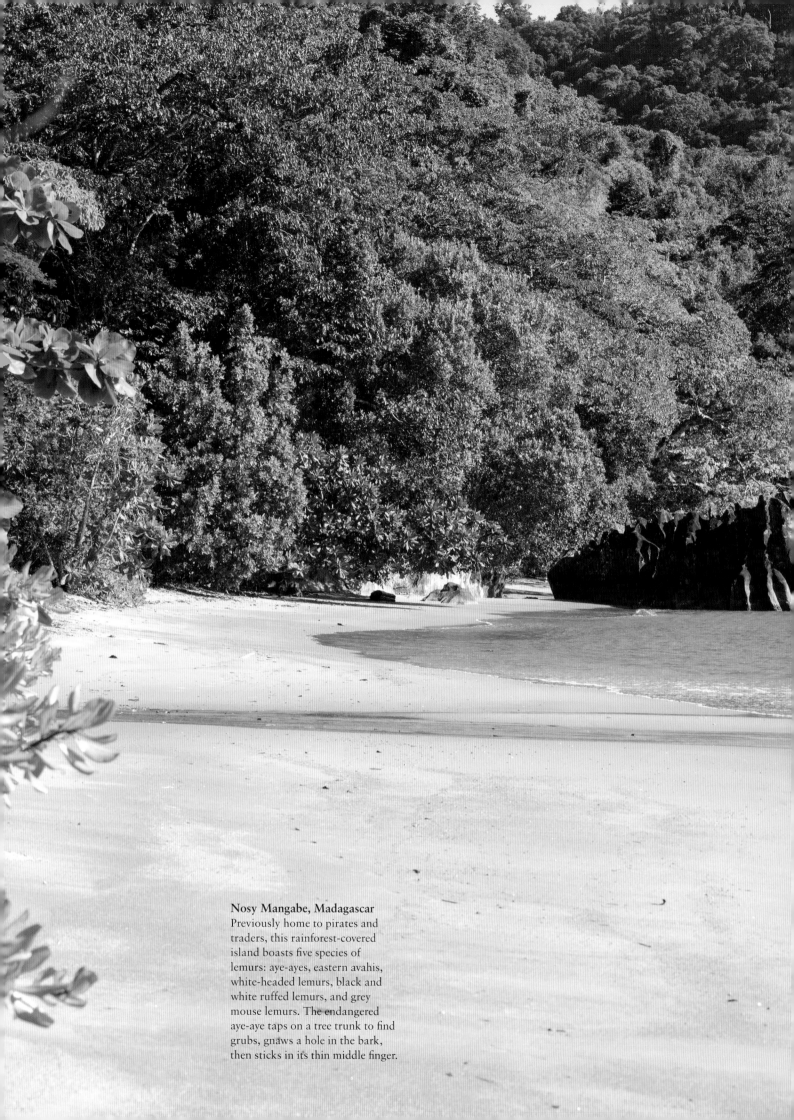

Nosy Mangabe, Madagascar
Previously home to pirates and traders, this rainforest-covered island boasts five species of lemurs: aye-ayes, eastern avahis, white-headed lemurs, black and white ruffed lemurs, and grey mouse lemurs. The endangered aye-aye taps on a tree trunk to find grubs, gnaws a hole in the bark, then sticks in its thin middle finger.

Nosy Hara, Madagascar
This islet is the only home of the Nosy Hara leaf chameleon, just 3cm (1.2in) long. It was thought to be the world's smallest chameleon until the discovery of the nano-chameleon, 2.2cm (0.87in) long, on the mainland in 2021. The leaf chameleon hunts for food among leaf litter during the day, before retiring to a low branch at night.

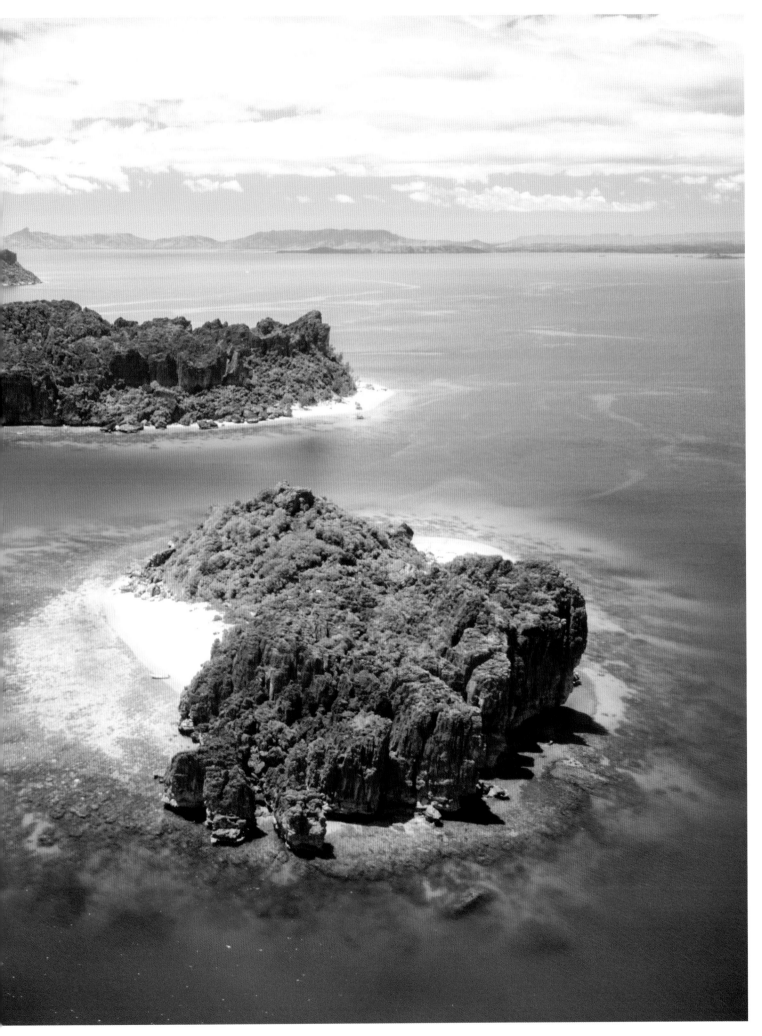

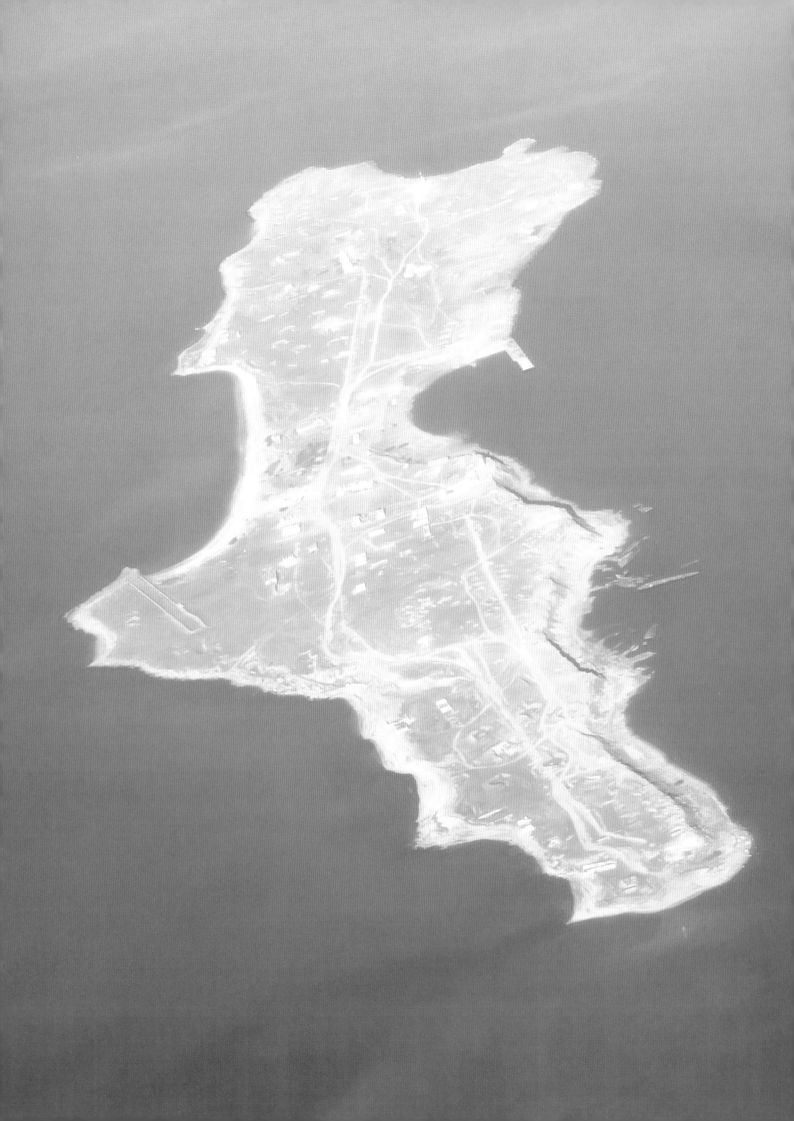

Asia and the Pacific

While many islands across the world became uninhabited due to the slow drip of depopulation, some islands have been abandoned quite suddenly as a result of catastrophe. In some cases, that catastrophe was a natural disaster, such as the volcanic eruptions on Antarctica's Deception Island, or the typhoons that battered Japan's Gajajima. Other cataclysms were inflicted on islanders by invasion or war. The great capital of Pohnpei, Nan Madol, was invaded by a conqueror known as Isokelekel, said to be the son of the thunder god Nan Sapwe. Howland Island was abandoned after Japanese bombing during World War II, while the inhabitants of Bikini Atoll lost their home to Cold War nuclear tests. The catastrophe that befell the Ngaro population of Australia's Whitsunday Island was the arrival of Europeans. Other disasters – from the depletion of coal reserves to the extermination of seals or the over-harvesting of guano – were self-inflicted by islanders guilty of perhaps the most widespread human fault: exploiting a fragile environment for short-term gain. Some catastrophes that overwhelmed islanders are the stuff of nightmares. No one is entirely sure if it was raids by headhunters, an epidemic or a sea devil's curse that caused the sudden departure of the tribes of Tetepare. The 12 survivors of the Mexican colony on Clipperton Island were able to tell their story of sickness, psychosis and murder when they waded out through the waves to the rescue boat.

OPPOSITE:
Boyuk Zira, Azerbaijan
During World War I, thousands of Turkish prisoners were held on Boyuk Zira, in the Caspian Sea, by the Russian army. Many were executed or died of starvation.

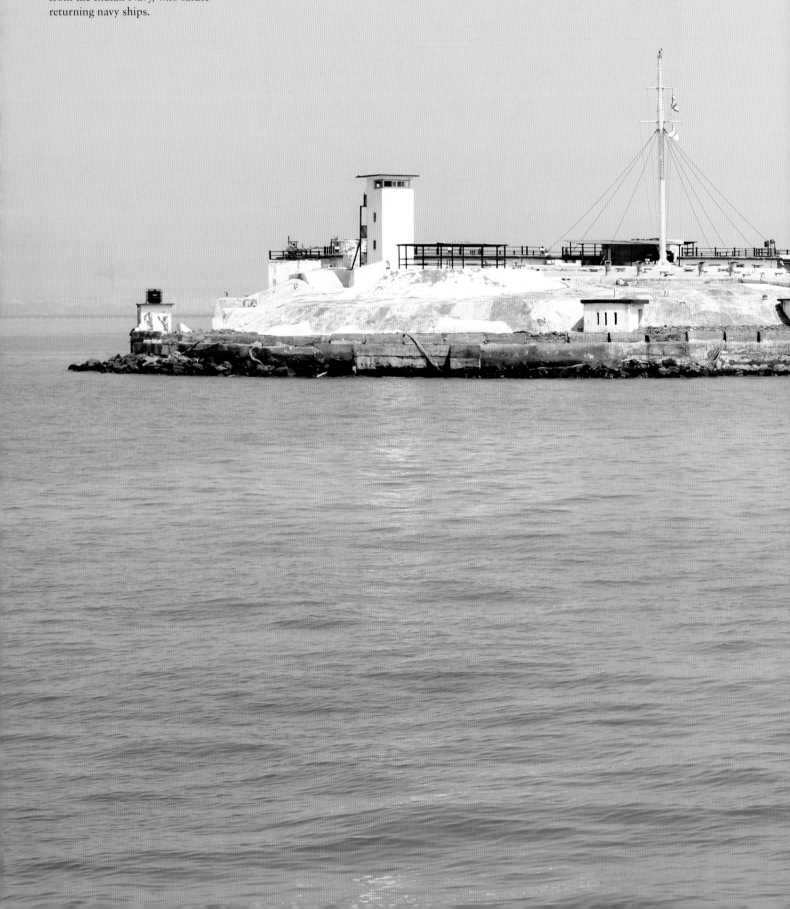

Middle Ground
Coastal Battery, India
In Mumbai Harbour, this basalt
islet was first fortified in 1682 by
the British East India Company
to guard against pirates. During
World War II, anti-aircraft
guns were added to the island's
armoury. Today, the island is
occupied by a rota of sailors
from the Indian Navy, who salute
returning navy ships.

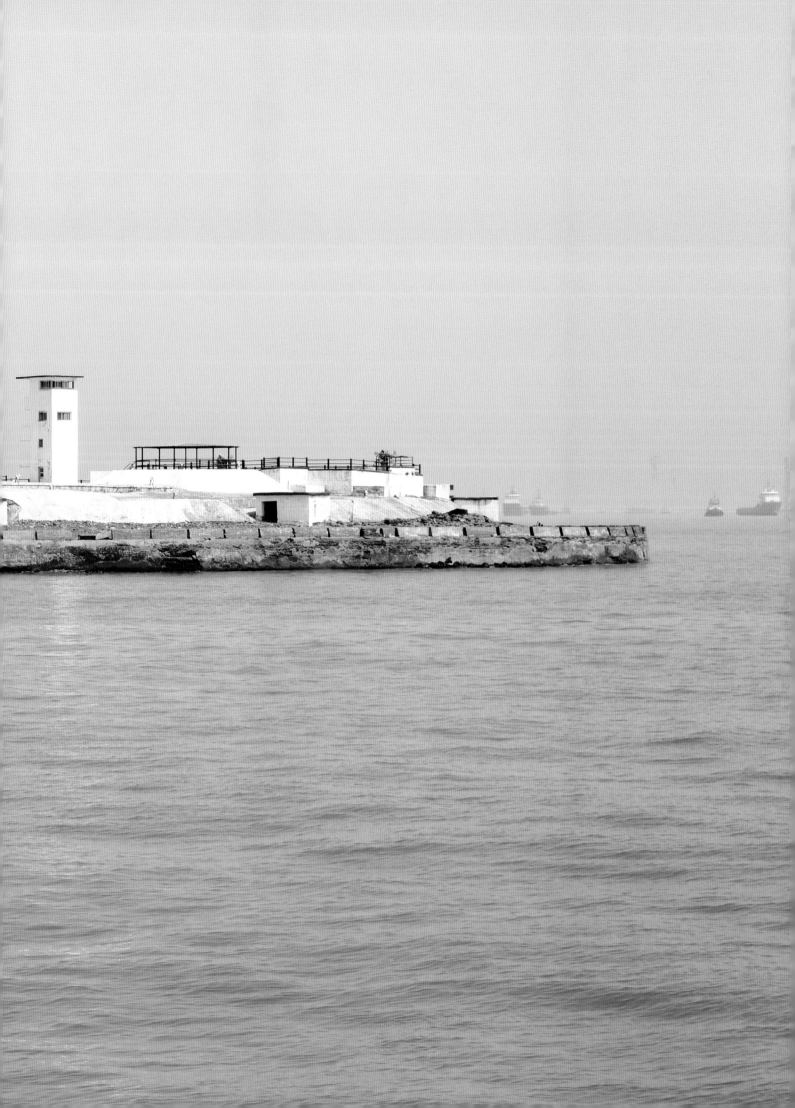

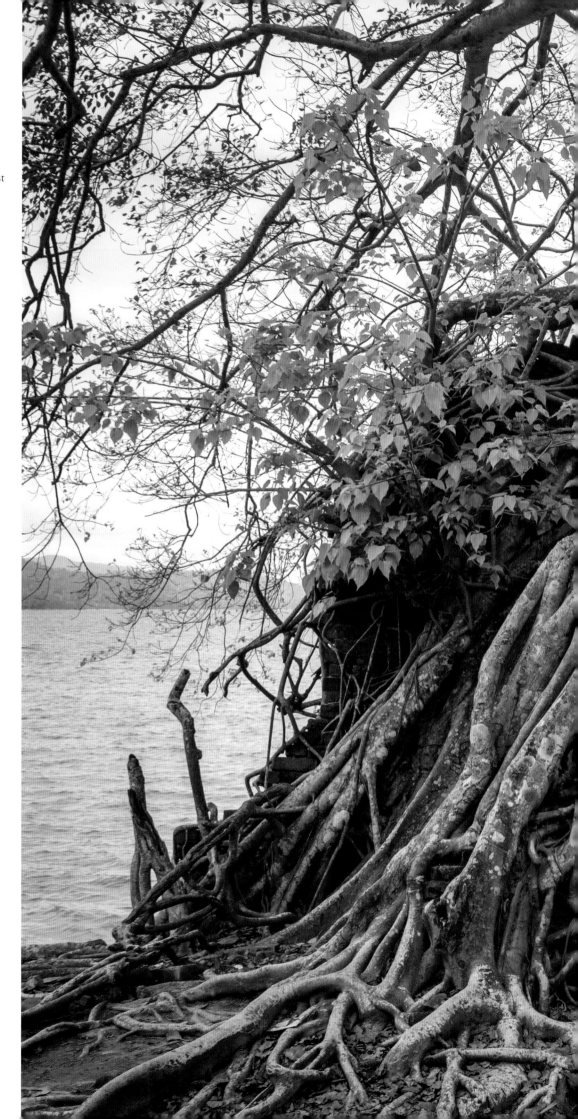

**Ross Island,
Andaman Islands, India**
Inhabited for over 2,000 years by
the Andamanese, the Andaman
Islands became a British penal
settlement, called Port Blair, in
the 19th century. Port Blair was
officially closed in 1947. In 1979,
the Indian navy set up a small post
on Ross Island, but the thickly
forested island no longer has a
civilian population. The island
is also known as Netaji Subhas
Chandra Bose, in honour of the
eponymous Indian nationalist.

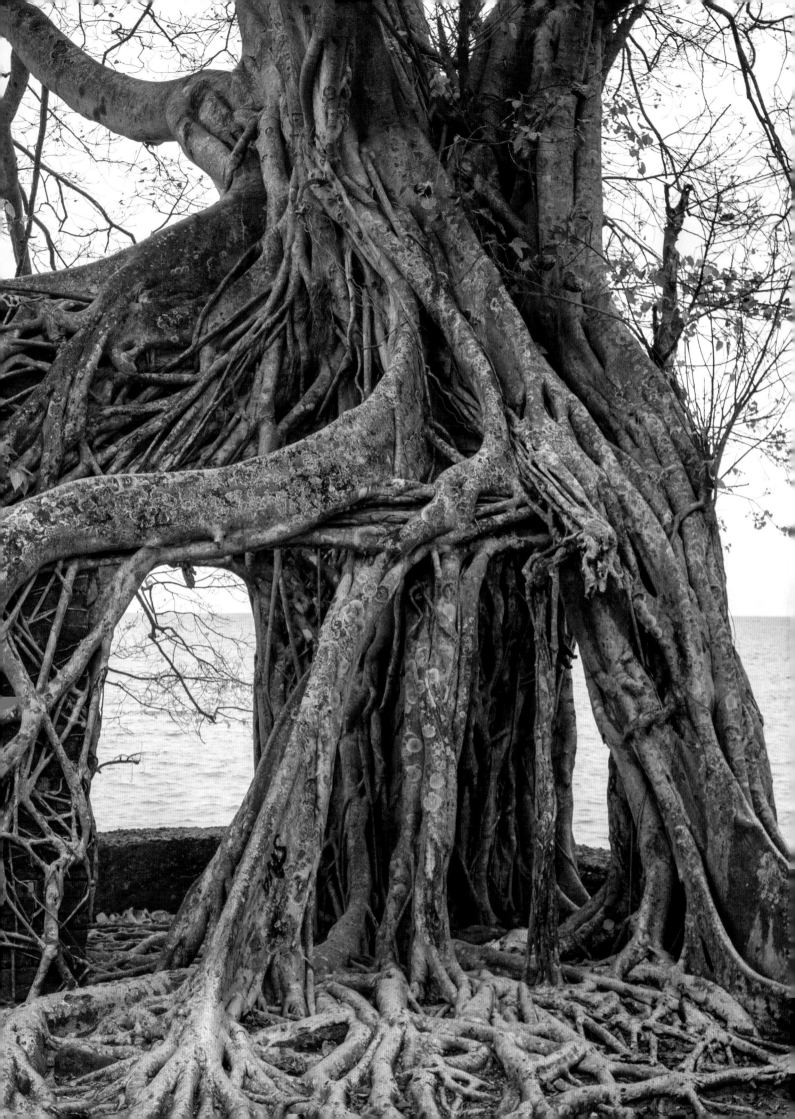

**Ross Island,
Andaman Islands, India**
Ross Island was the British
headquarters of the Andaman
Islands, with offices, shops, a
hospital, a swimming pool and
tennis courts. The settlement was
badly damaged by an earthquake
in 1941, captured by the Japanese,
then finally abandoned when India
gained independence in 1947.
Today, the ruins of the Victorian
church are being overwhelmed by
the jungle, where peafowl, wild
pigs and chitals roam.

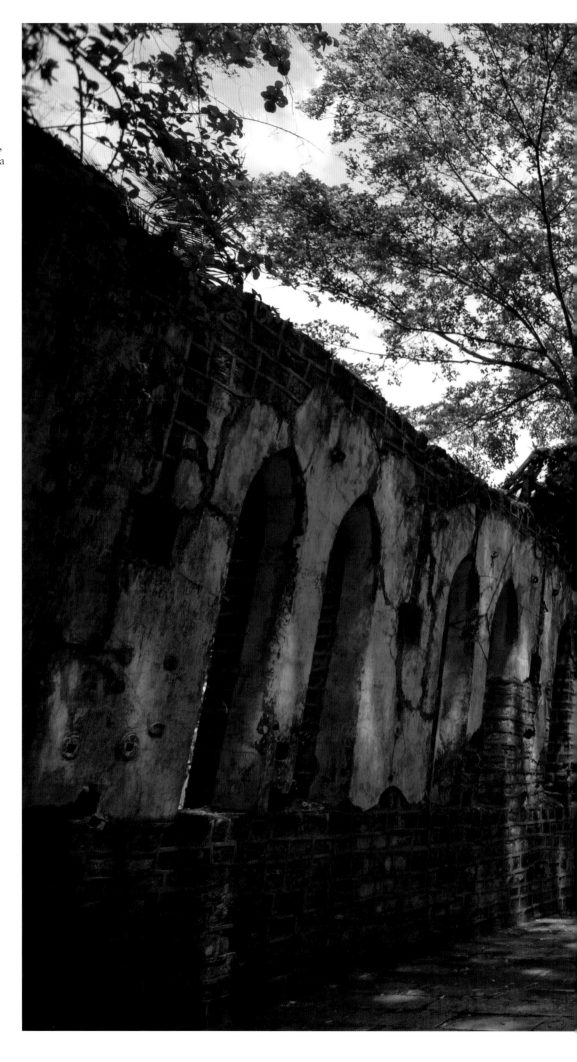

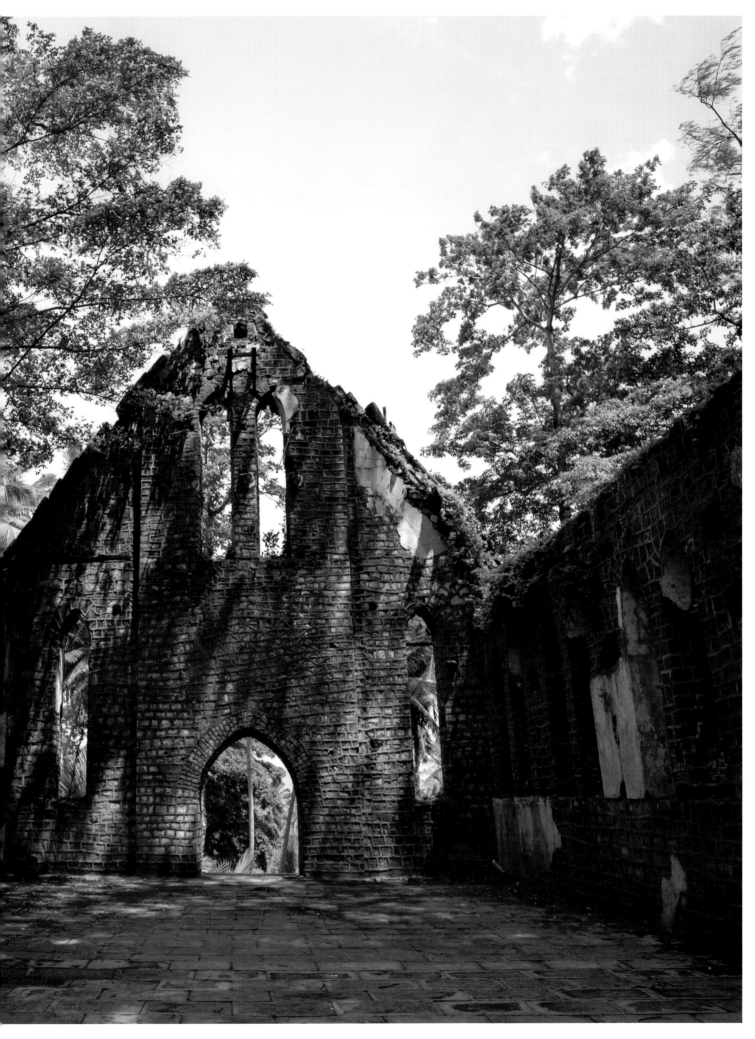

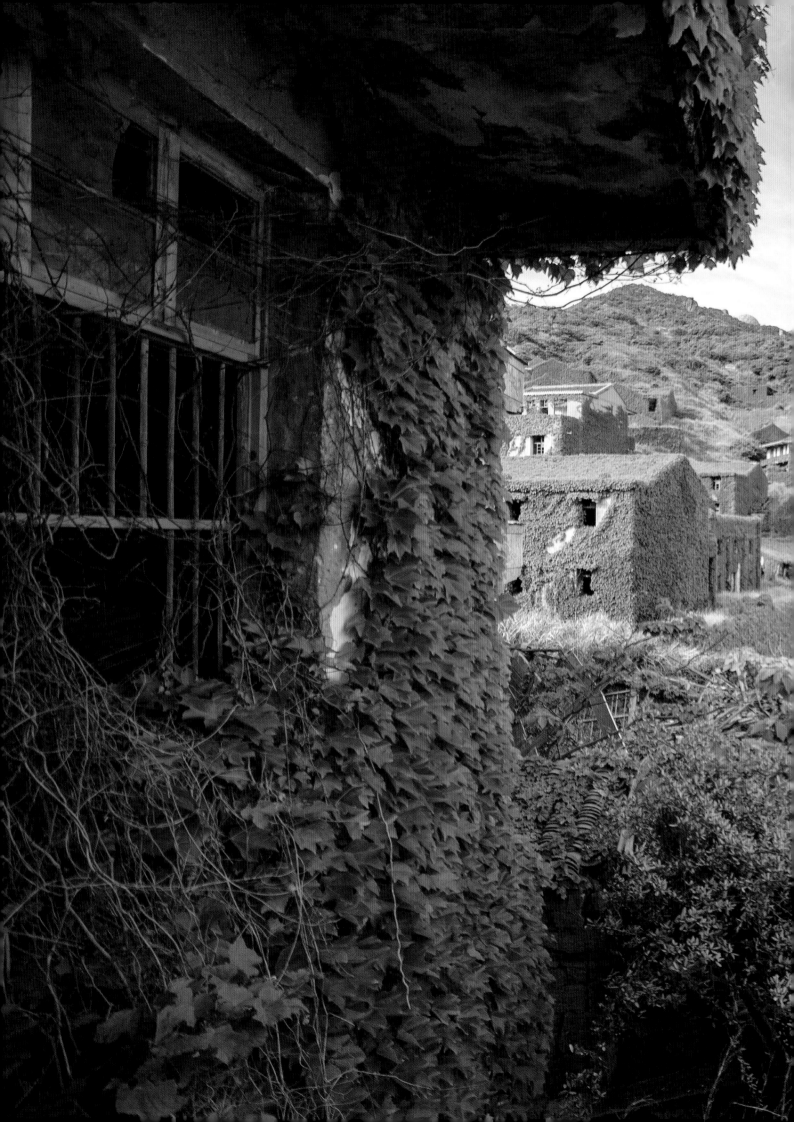

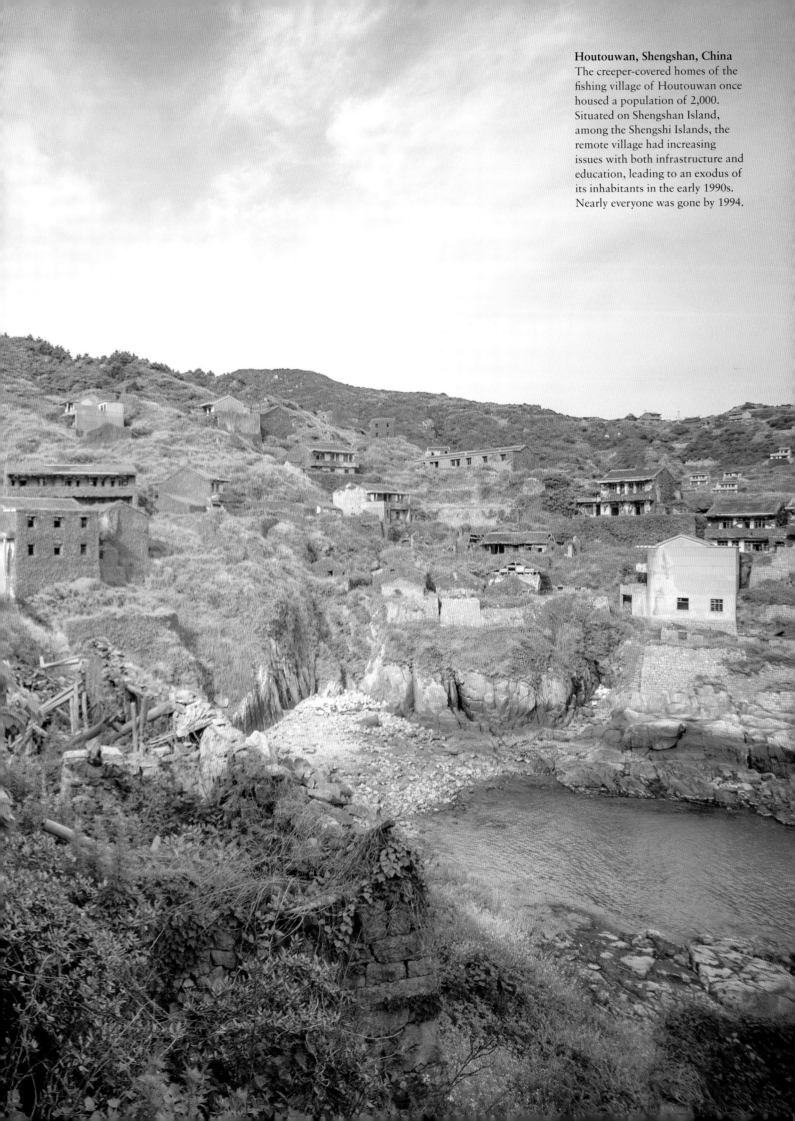

Houtouwan, Shengshan, China
The creeper-covered homes of the fishing village of Houtouwan once housed a population of 2,000. Situated on Shengshan Island, among the Shengshi Islands, the remote village had increasing issues with both infrastructure and education, leading to an exodus of its inhabitants in the early 1990s. Nearly everyone was gone by 1994.

Antipodes Islands, New Zealand
Around 850km (530 miles) southeast of New Zealand's South Island, the Antipodes Islands were probably first inhabited by American and British sealing gangs, in 1805. After wiping out most of the seals, the gangs left by 1807. The only other human inhabitants have been castaways, who survived on a diet of seabirds or were lucky enough to discover the main island's castaway depot.

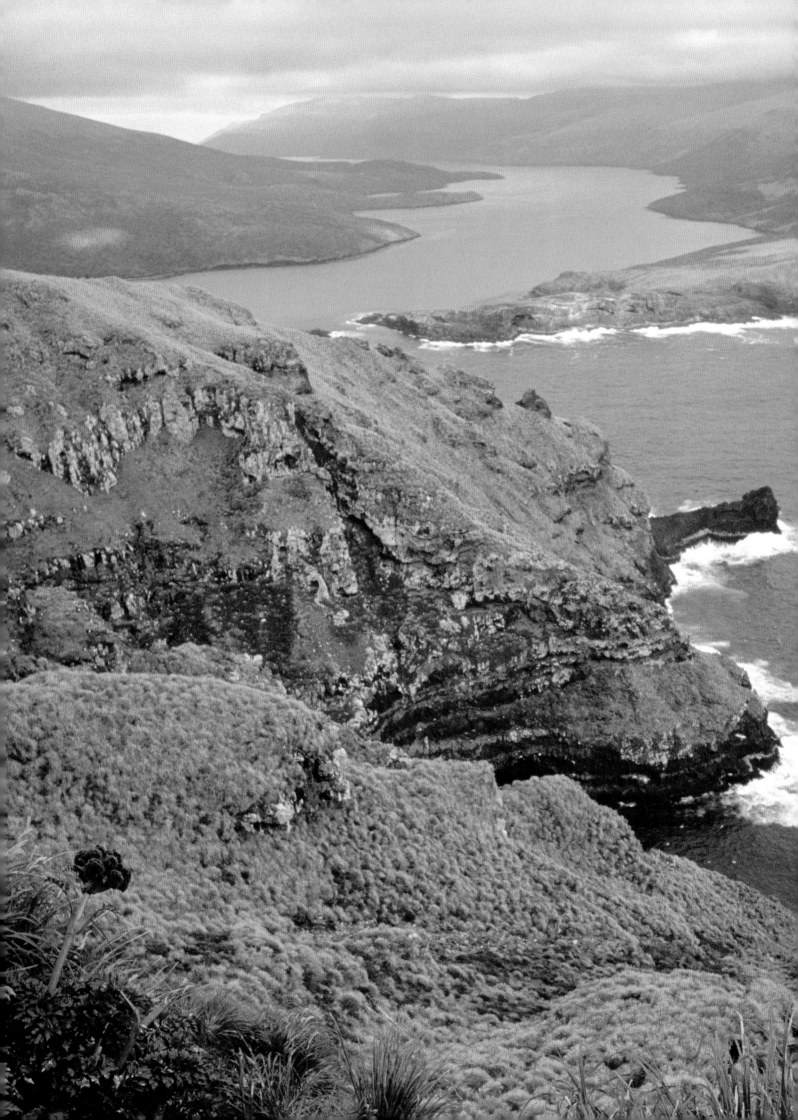

Adams Island, New Zealand
Adams Island, around 465km (290 miles) south of South Island, is the second largest of the Auckland Islands. In the 19th century, the islands saw transient settlements of European sealers, Maori and Moriori (Polynesian people who settled the Chatham Islands in around 1500). Today, the islands have been left to the seals, including New Zealand fur seals and sea lions, and southern elephant and leopard seals.

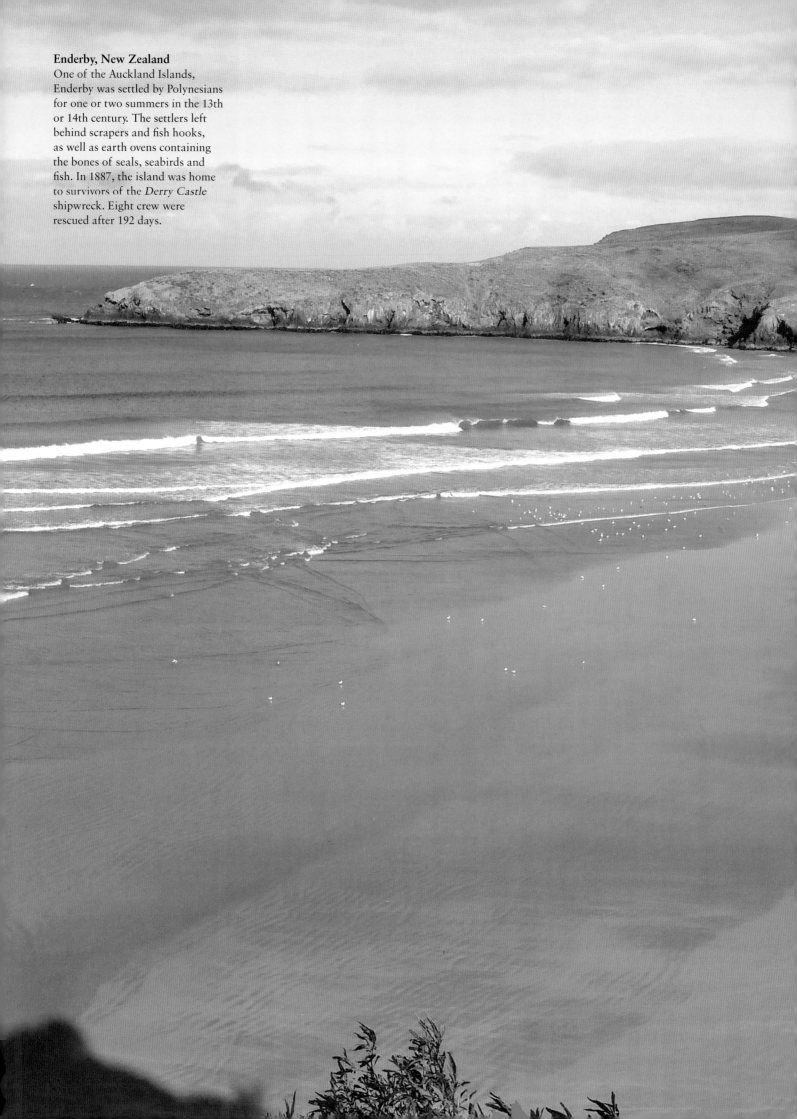

Enderby, New Zealand
One of the Auckland Islands, Enderby was settled by Polynesians for one or two summers in the 13th or 14th century. The settlers left behind scrapers and fish hooks, as well as earth ovens containing the bones of seals, seabirds and fish. In 1887, the island was home to survivors of the *Derry Castle* shipwreck. Eight crew were rescued after 192 days.

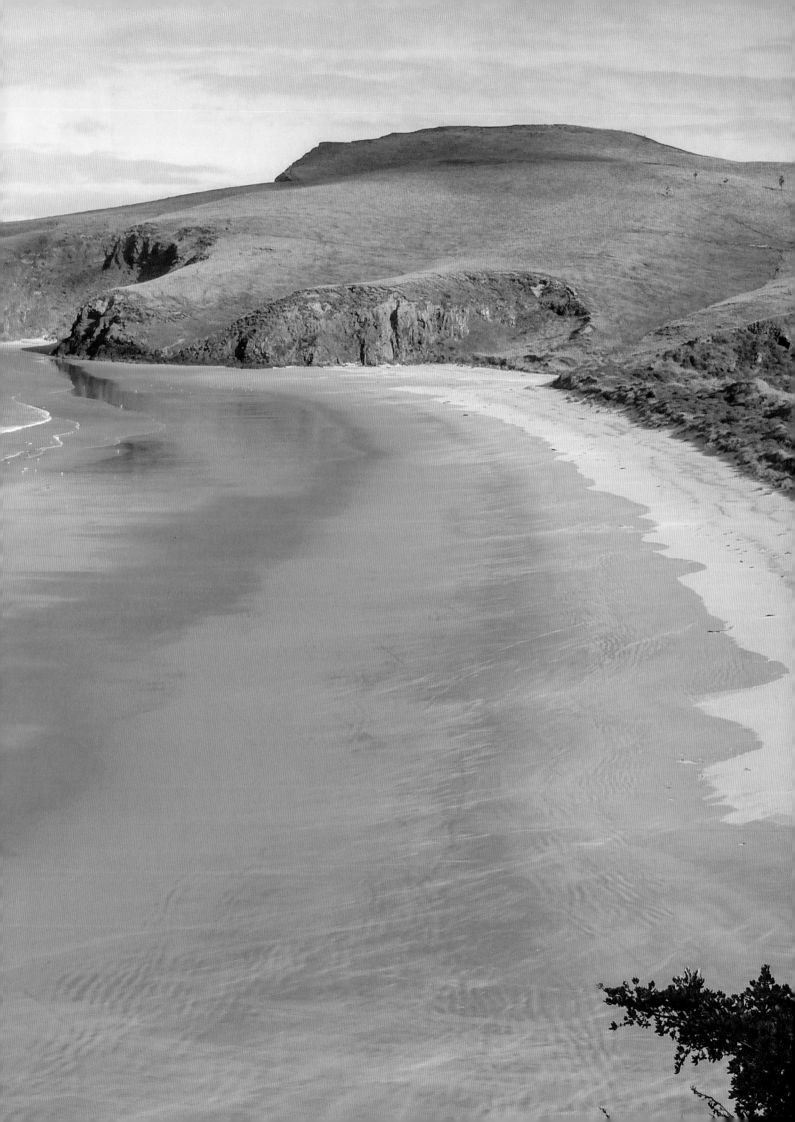

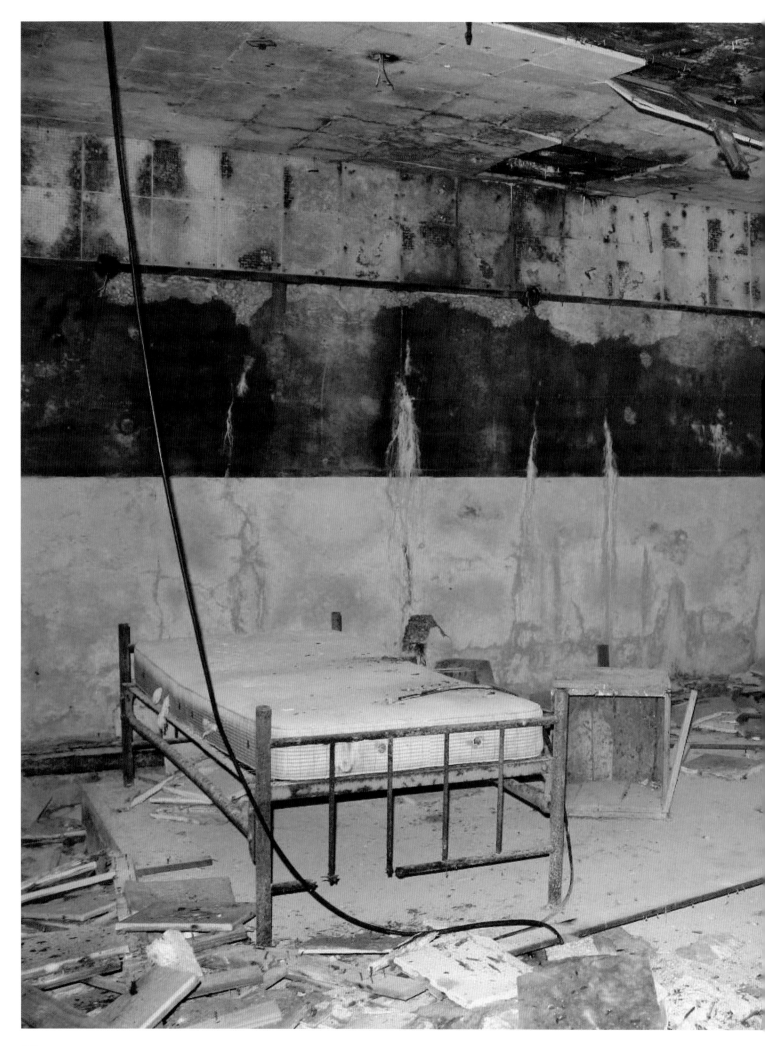

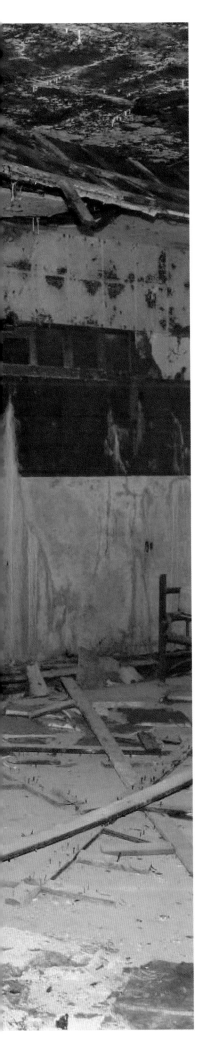

ALL PHOTOGRAPHS:

Bikini Atoll, Marshall Islands

Bikini Atoll is a roughly circular coral reef with 23 low-lying islands.
Before 1946, when the 167 islanders were relocated by the United States,
the population lived by fishing and growing taro, coconuts, bananas and
limes. Between 1946 and 1958, the United States detonated 23 nuclear
devices on and around the atoll. The Castle Bravo explosion was about
1,000 times more powerful than the bomb dropped on Nagasaki in 1945.
The abandoned US bunkers (left) remain.

Bikini Atoll, Marshall Islands
The atoll still bears the marks of its nuclear tests: the roughly circular, bay-like area in the upper centre of this photograph is a detonation crater. In 1970, about 160 Bikini Islanders were allowed to return to live on the atoll. Ten years later, their bodies were found to contain high levels of caesium-137. The atoll was abandoned once more. The United States has paid the islanders and their descendants many millions in compensation.

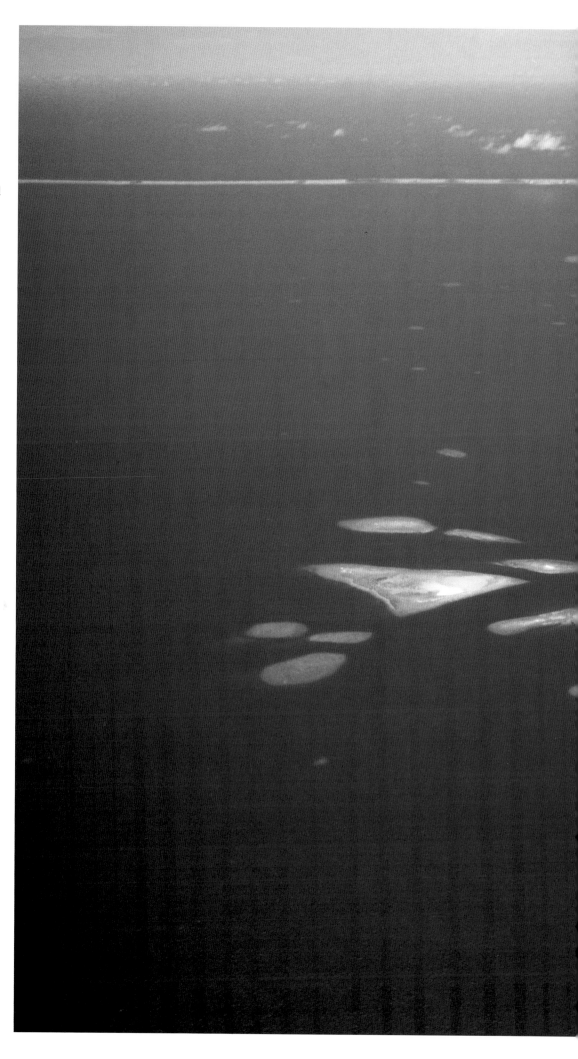

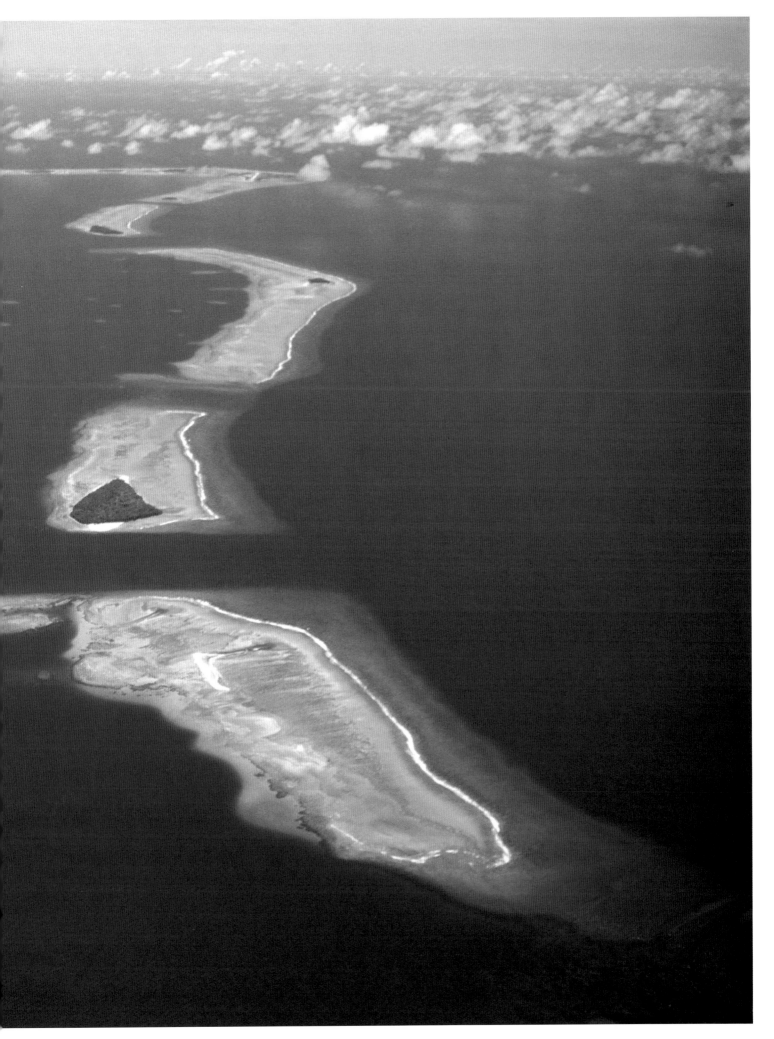

Clipperton, France
From 1897 to 1917, Clipperton was the site of a Mexican guano-mining colony, reaching a peak of around 100 men, women and children. When the Mexican Revolution put a stop to the colony's supply ships, the inhabitants started to die from scurvy. By 1915, all the adult male settlers were dead except for one, Victoriano Álvarez, who proclaimed himself king and terrorized the women and children until they killed him. The last survivors, four women and eight children, were picked up by the US Navy on 18 July 1917.

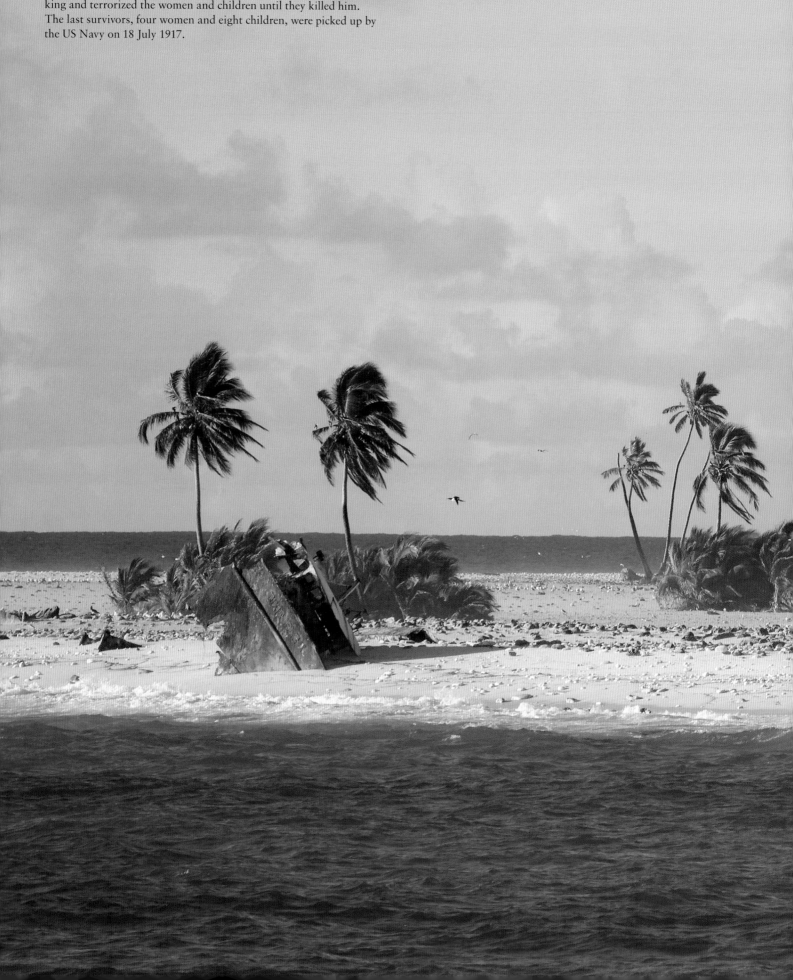

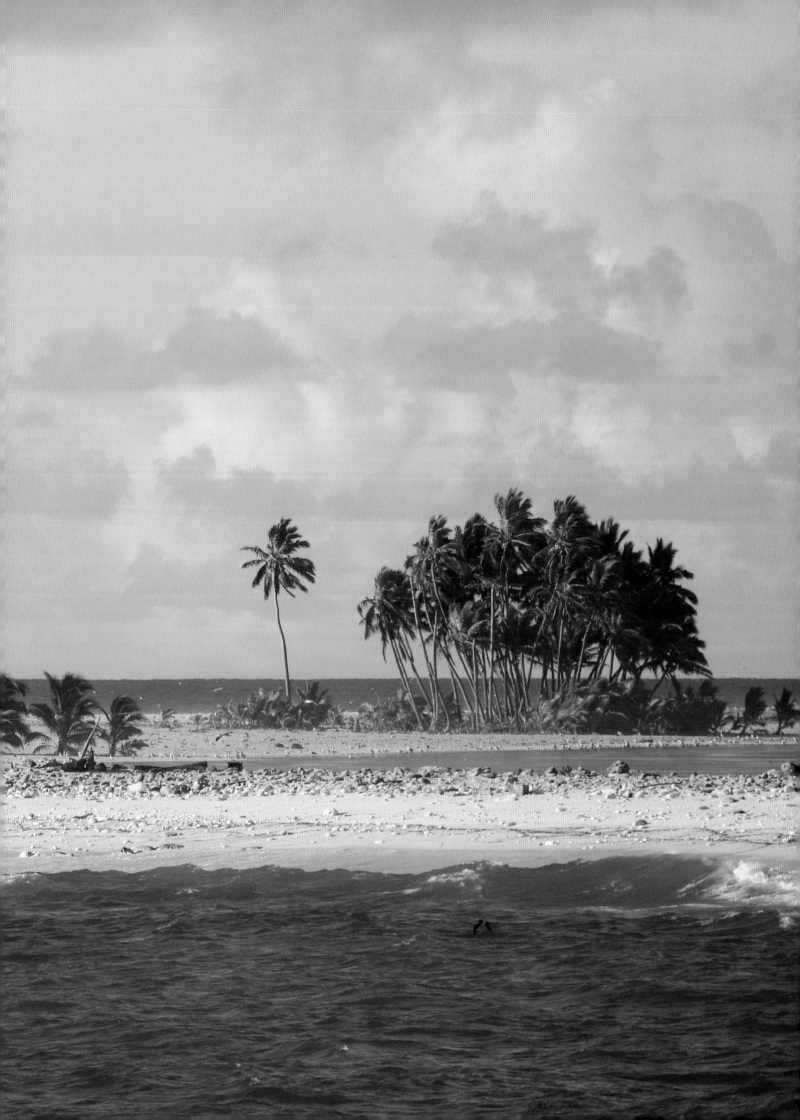

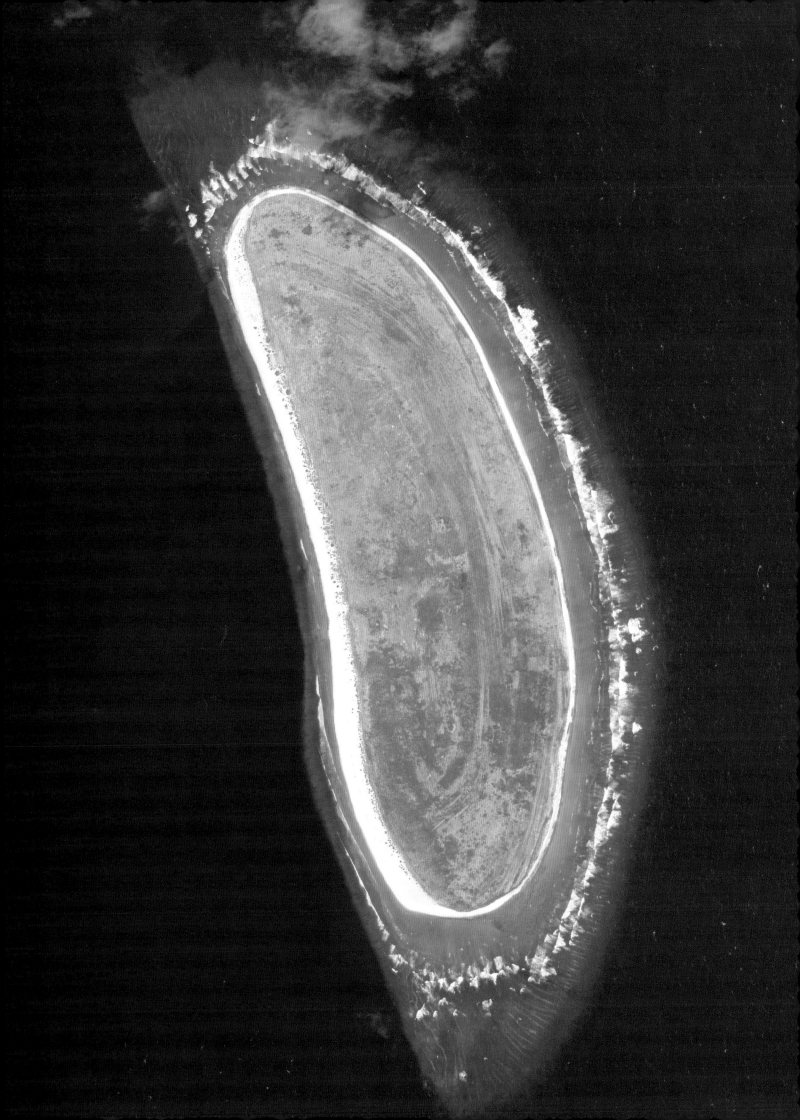

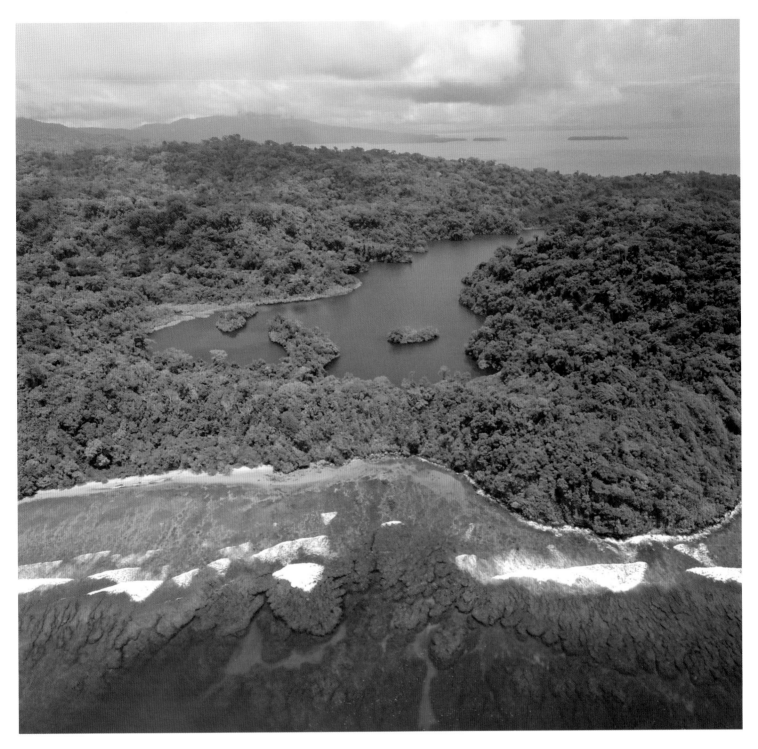

Howland, United States
This small coral island, halfway between Hawaii and Australia, was uninhabited in 1935 when the American Equatorial Islands Colonization Project set up a rotating team of four colonists from Hawaii. In 1937, the island's airstrips were the planned destination of Amelia Earhart when she disappeared without a trace. In 1941, Japanese bombs killed two of the island's four colonists. The survivors were evacuated in 1942.

Tetepare, Solomon Islands
The biggest uninhabited island in the South Pacific, Tetepare was once home to a large community with its own language, now extinct, which is believed to have been distinct from the Austronesian languages of the surrounding islands. In 1860, there was a mass exodus from Tetepare. Oral history suggests the islanders were decimated by disease, perhaps dysentery, or threatened by headhunters from other islands.

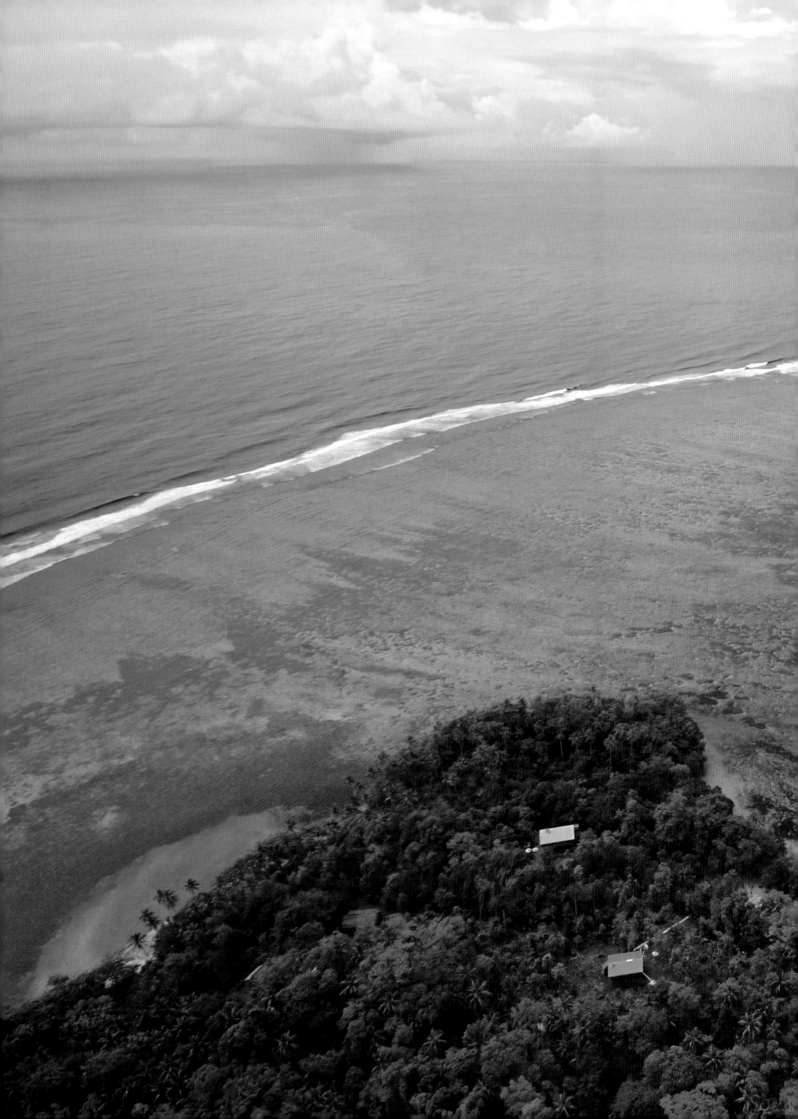

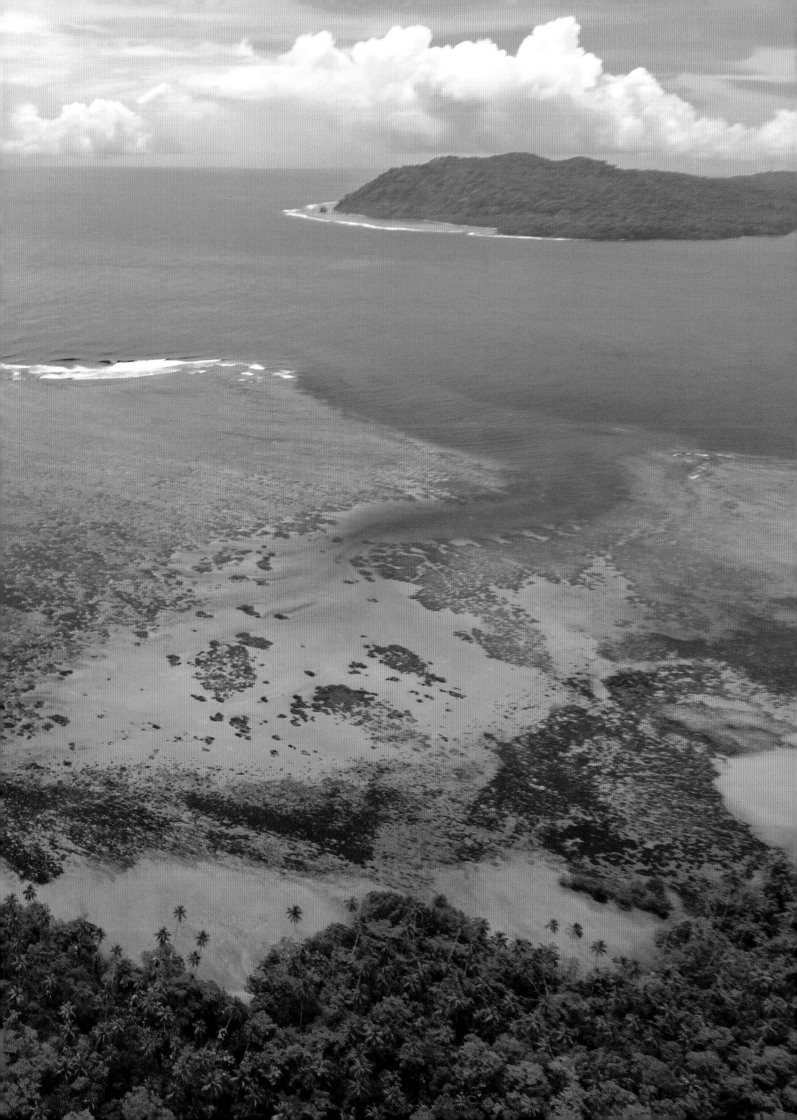

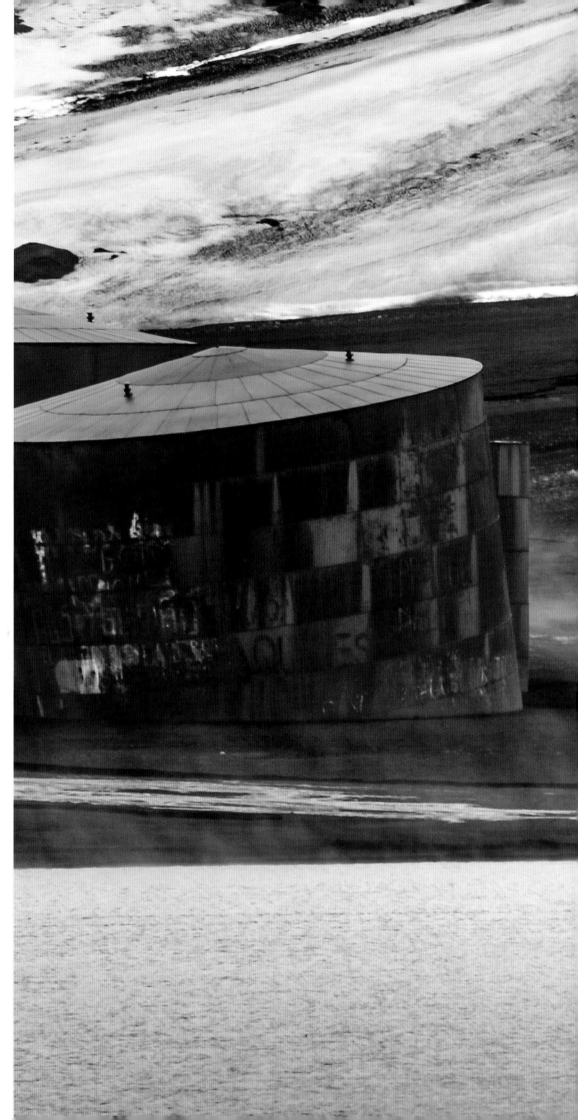

Deception Island, Antarctica
Lying off the Antarctic Peninsula, Deception Island is an active shield volcano. Its large, sheltered natural harbour made it the site of a sealing and whaling station from 1819, with the island home to several hundred men during the summer months. When whale oil prices plunged, the station was abandoned in 1931, leaving behind the rusting oil tanks.

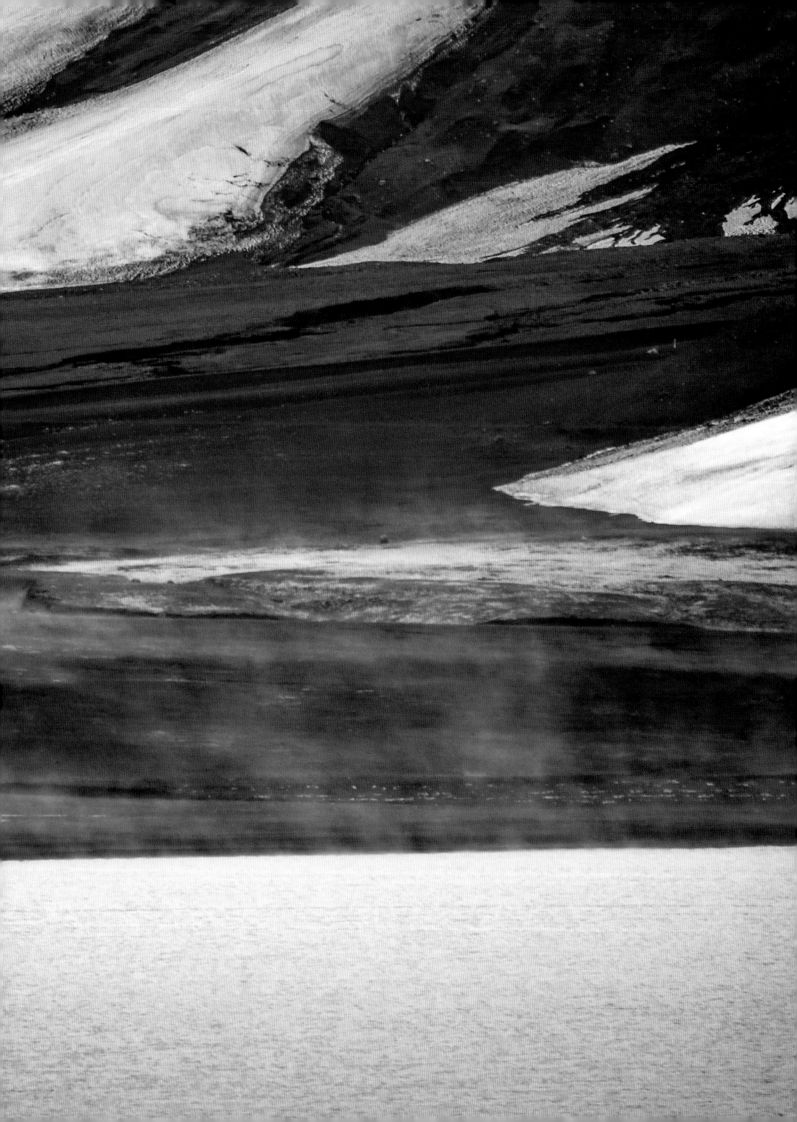

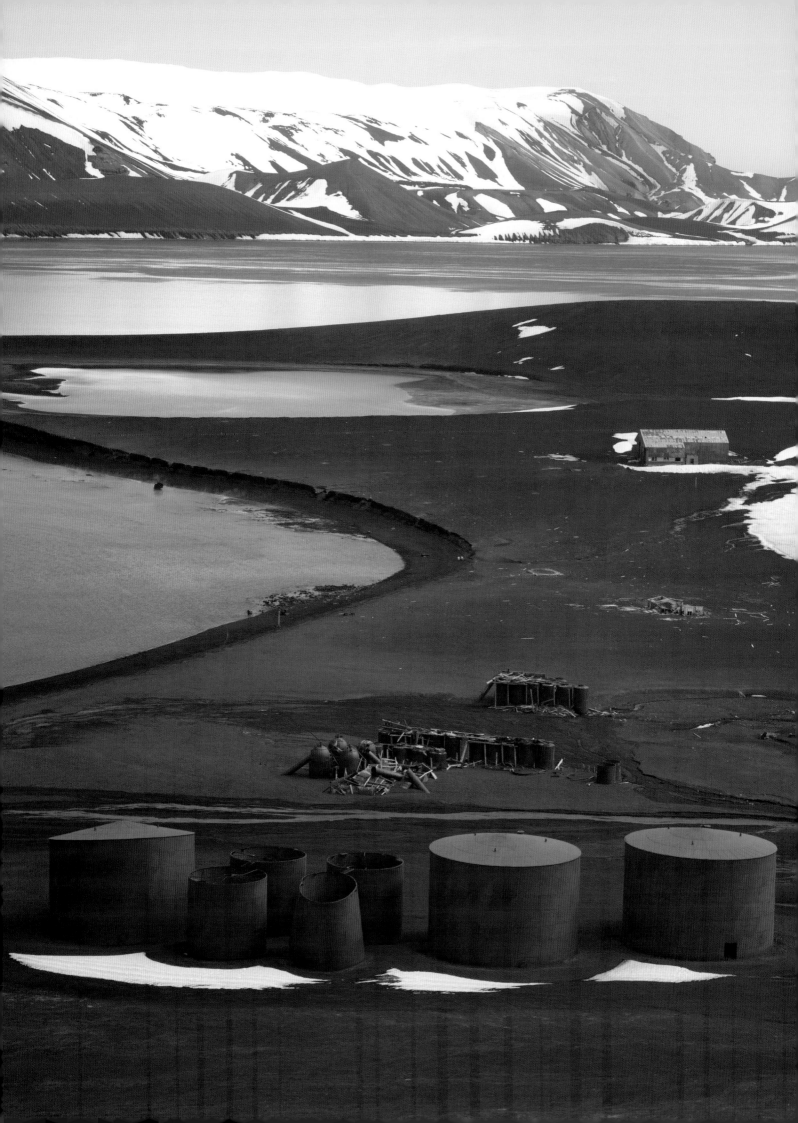

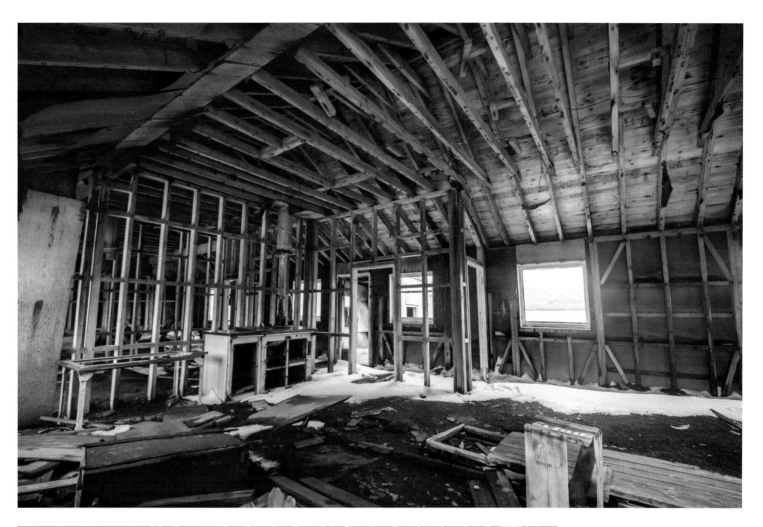

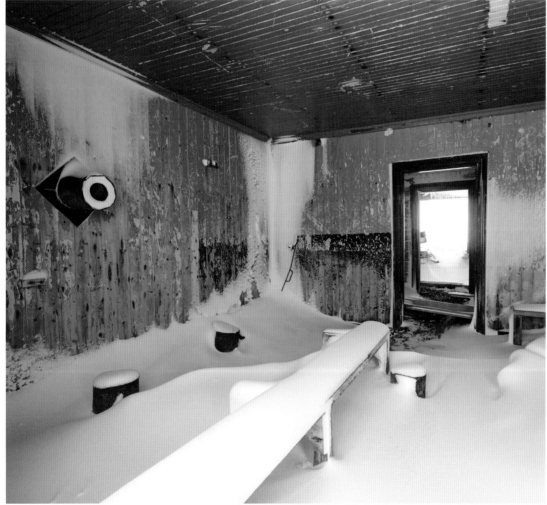

ALL PHOTOGRAPHS AND OVERLEAF:
Deception Island, Antarctica
The island is littered with the remains of previous settlements, from the boilers of Whalers Bay to an aircraft hangar, as well as British and Chilean scientific research stations abandoned after the violent 1967 and 1969 eruptions of the island's volcano. Today, Deception is home to two summer-only research stations, staffed by Spain and Argentina.

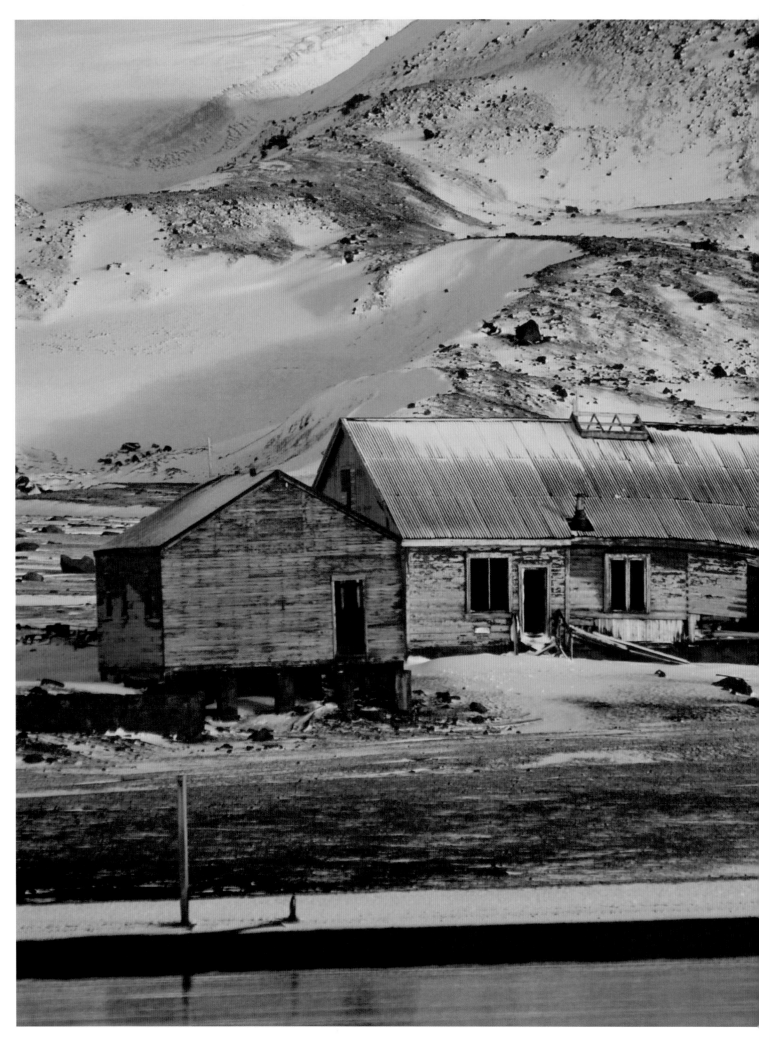

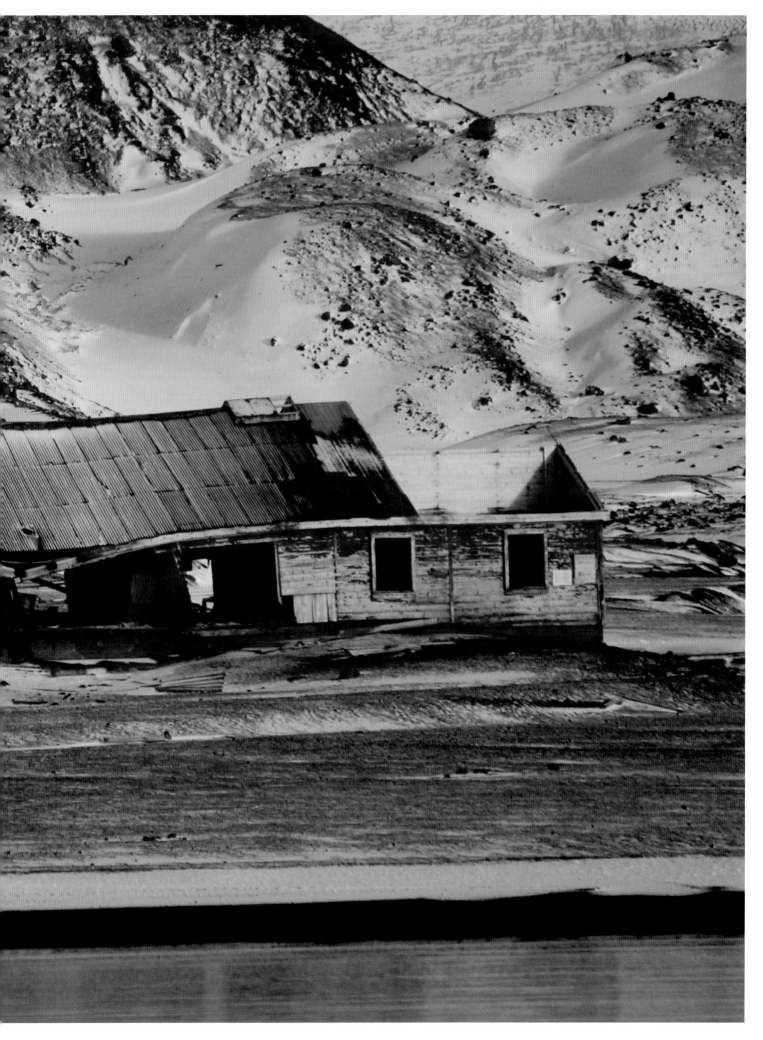

Picture Credits

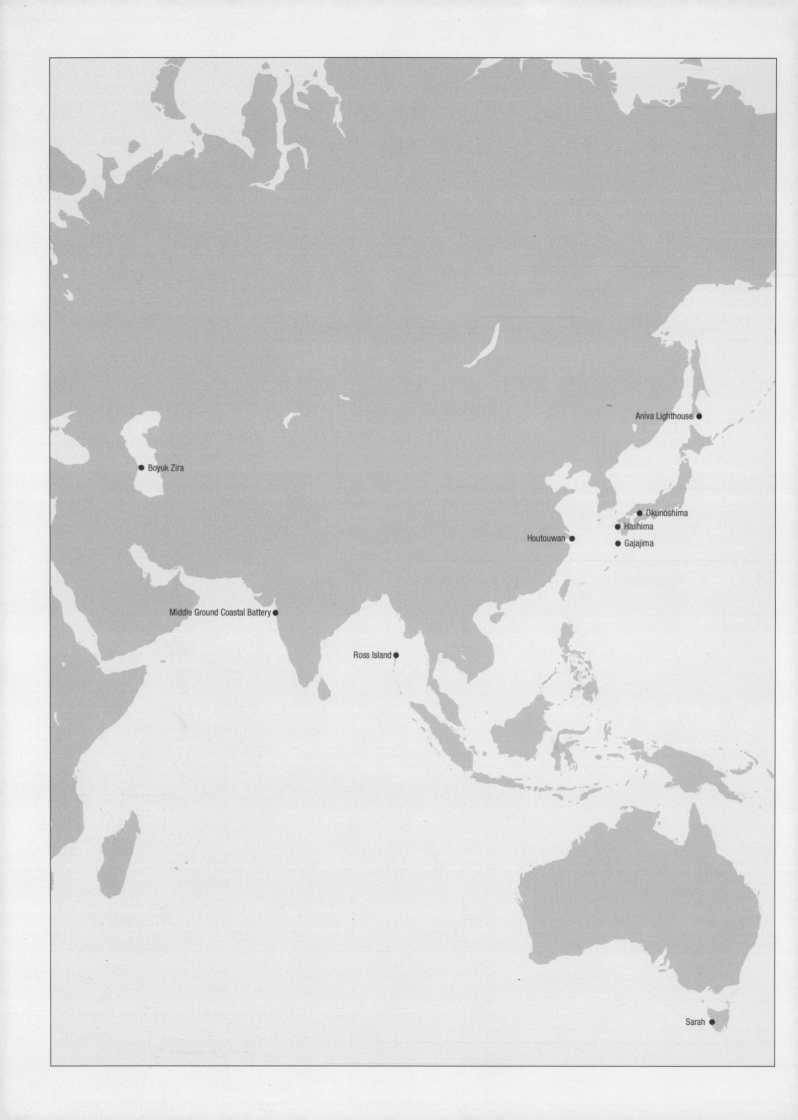

Aniva Lighthouse ●

● Boyuk Zira

● Okunoshima
● Hashima
Houtouwan ●
● Gajajima

Middle Ground Coastal Battery ●

Ross Island ●

Sarah ●